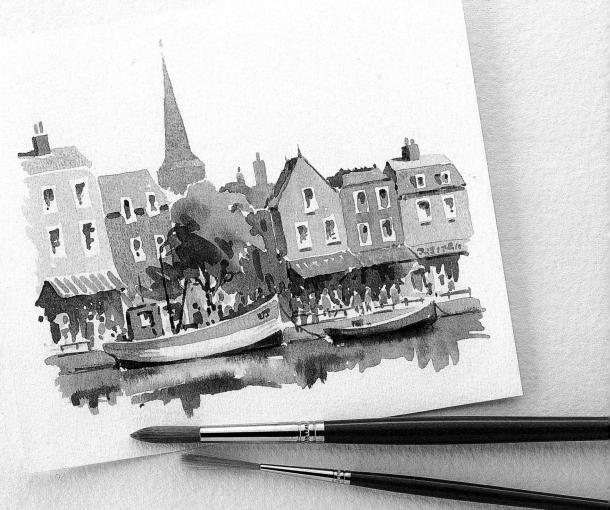

The Art of Watercolor

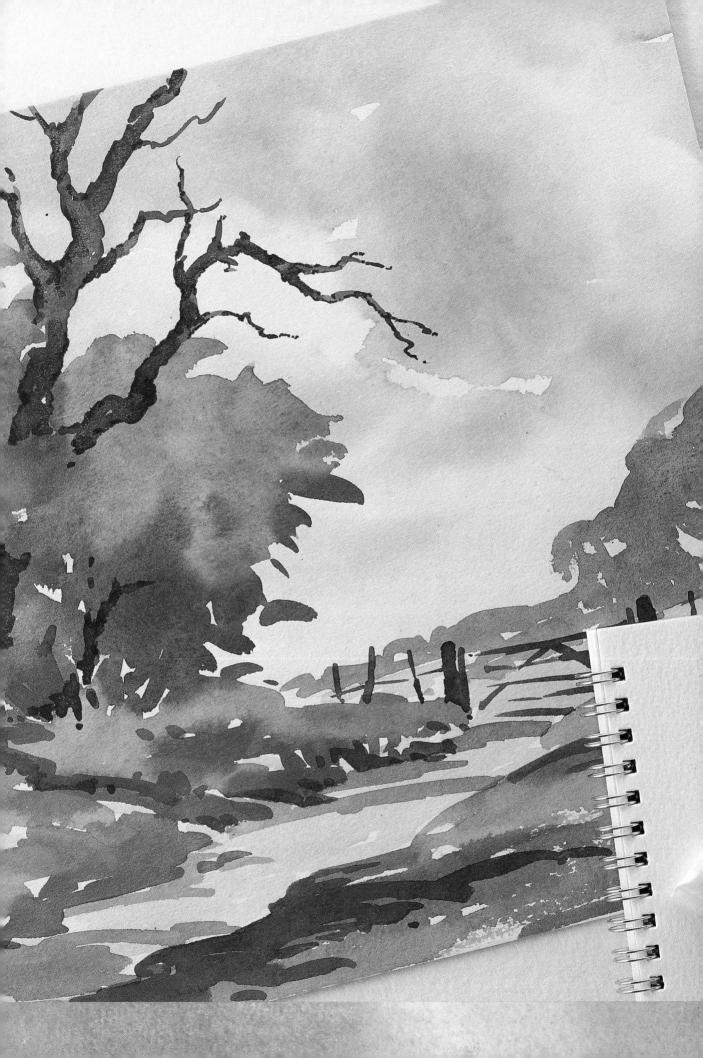

The Art of Watercolor

A GUIDE TO THE SKILLS AND TECHNIQUES

Ray Campbell Smith

DEDICATION

To my family, my friends and fellow painters, and all those who share my love of pure watercolor.

ACKNOWLEDGMENTS

I would like to thank my editor, Alison Elks, for her help and advice; my son, Paul, MA (Royal College of Art), BSc (London University), for his expert photography of my paintings; Cherry Briers, editor of *Leisure Painter*, for kindly allowing me to use material from that splendid magazine; Maureen Gray, for her skillful typing; and my wife, Eileen, for her constant encouragement and support.

A READER'S DIGEST BOOK

Designed and edited by David & Charles Publishers

First published in Great Britain Copyright © 1993, 1995 Ray Campbell Smith

All rights reserved. Unauthorized reproduction, in any manner, is prohibited.

Library of Congress Cataloging in Publication Data

Smith, Ray Campbell. 1916— The art of watercolor: a guide to

The art of watercolor: a guide to the skills and techniques/Ray Campbell Smith.

p. cm. Includes index. ISBN 0-89577-654-5

1. Watercolor painting—Technique. I. Title.

ND2420.S593 1995 751.42'2—dc20

94-35426

Reader's Digest and the Pegasus logo are registered trademarks of The Reader's Digest Association, Inc.

Printed in Hong Kong

INTRODUCTION

6

• Demonstration: Christmas Eve

12

1	MATERIALS AND THEIR USES	14	6	ALL ABOUT WASHES	72
	• Demonstration: Bluestone Farm	22		• Demonstration: The Grand Canal	80
2	COLOR—THEORY AND PRACTICE	24	7	MORE WATERCOLOR TECHNIQUES	82
4	• Demonstration: The Village Church	34	•	• Demonstration: Farm Buildings	90
0			0	NOW AND MORPHY	00
3	PUTTING IT IN PERSPECTIVE	36	8	MIST AND MYSTERY	92
	• Demonstration: Calm Anchorage	46		• Demonstration: Trees in the Mist	100
4	COMPOSITION AND BALANCE	50	9	PAINTING IN THE OPEN AIR	102
1	• Demonstration: Old Cottages	60		• Demonstration: Mr. Perkins Gardening	114
_		2.	10	TO CONTAIN	110
5	CHOOSING AND DEVELOPING SUBJECTS		10	TO SUM UP	116
	• Demonstration: The Farmyard	70		Demonstration: Fog and Drizzle	124

GLOSSARY INDEX 126

127

Introduction

Most small children love drawing and painting, and their untutored images often have an appeal and a simple charm of their own. This inborn creative urge is too often extinguished by unimaginative and unsympathetic teaching at

school. Happily, more and more people are forgetting their early disappointments and turning to art as a richly rewarding pastime and a means of self-expression. The question soon arises as to which medium to adopt. Unfortunately, many are put off even trying their hand at watercolor because of its reputation for difficulty and unpredictability; and even those braver spirits, who have really given it a try, are sometimes frustrated and disappointed with their results. This is a pity, because watercolor is a wonderful medium, ideally suited to the fresh and atmospheric interpretation of landscape subjects, and what is more, most aspiring artists can master its complexities if offered the right kind of help.

BEGINNINGS

What, then, is the way ahead? Can we pinpoint the basic difficulties of the medium and learn to overcome them? I believe we can. Of course, all sorts of factors go into the making of a successful painting, and we shall be considering them in turn throughout this book. The first and perhaps the most important skill to learn in order to produce successful watercolor paintings is the correct application of the paint.

Watercolor is a transparent medium, and its real beauty lies in the clarity and freshness of the applied paint, allowing the white of the paper to shine through. These marvelous qualities are very easily lost, and that is why one sees so many watercolor paintings in which the colors are drab and muddy and totally lacking in sparkle. However brilliant the composition, however well observed the tone values, if freshness and clarity have been lost, failure is the inevitable result. What must you do to make absolutely sure they are preserved?

It is surprising how many watercolorists dip the brush in the water jar, then into the pan of color, and apply the paint directly to the paper. If more water or pigment is required, the brush returns to the jar or pan to be replenished. This is not the way to achieve freshness and clarity. Far better results are obtained if a wash is first prepared. Pour a little water into one of the wells in the paintbox lid or mixing palette, add paint, and mix as required until the

desired color and tone (*see* Glossary) are obtained. Only then should the mixture be applied to the paper. If this simple operation is carried out properly, the resulting wash will, on drying, be fresh and clear.

The wash should be applied to the paper as quickly as possible and then left strictly alone. Painters often go on pushing the wash around, sometimes to make it fit exactly into some complex shape, all the time sacrificing freshness. Sometimes they find the tone is not deep enough and add more pigment; sometimes it is too deep and pigment has to be removed, with the result that still more freshness and clarity are lost. Until you are experienced enough to judge the tone of your washes with confidence, it is well worthwhile testing them on a scrap of similar paper. always bearing in mind that watercolor fades appreciably on drying and that a wash should therefore appear too deep in tone when first applied.

It is often believed that areas of deep tone are bound to lose clarity because of the concentration of pigment they demand, but this need not be so. Loss of clarity will only occur if the color is put on with too dry a brush, but if the paint is applied boldly in the form of a rich wash, all should be well. Of course, if too many colors are mixed together in a single wash, muddiness will result, but this is another matter and one we shall be examining in a later chapter (*see* page 72).

Some of the most admired watercolor paintings are executed very loosely, with

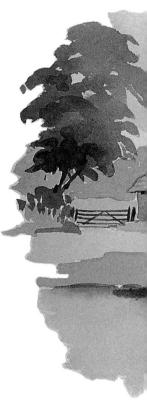

PICTURESQUE FARM

I painted this impression of a farm in about twenty minutes to demonstrate to a group of students how a fairly complex subject might be captured quickly and directly without spending too much time on details. It is an excellent discipline to set yourself a time limit, particularly if you feel your work is too tight and meticulous -the speed with which you have to work makes you concentrate on essentials and leaves no time for fiddling!

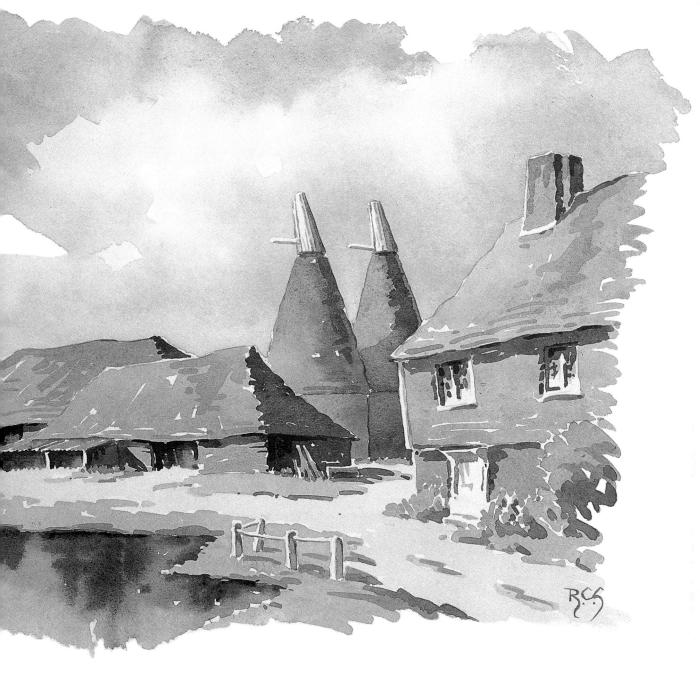

FIVE GOLDEN RULES

- 1 Plan a composition carefully.
- 2 Never use paint straight from the tube—always prepare washes.
- 3 Aim for loose, atmospheric brushwork.
- 4 Paint from light to dark.
- 5 Enjoy your painting!
 Never despair if things are not quite right the first time—
 regular practice will improve your technique.

little attempt at portraying detail. This is not only because the artists have been more concerned with feeling and atmosphere than they have with mere accuracy, but also because they know that their quickly and boldly applied washes will preserve the freshness and clarity of their work.

One of the reasons that some painters produce tired and overworked results is that they tend to experiment on their paper. They are not sure, until the paint is applied, whether it is producing the effect they want. This approach nearly always leads to modification and consequent lack of freshness.

The most important stage of all in successful watercolor painting is the mental translation of the observed image into watercolor terms, and this is where skill and

Artist's Tip

Always remember that watercolor fades on drying—your washes should look too deep in tone when they are first applied.

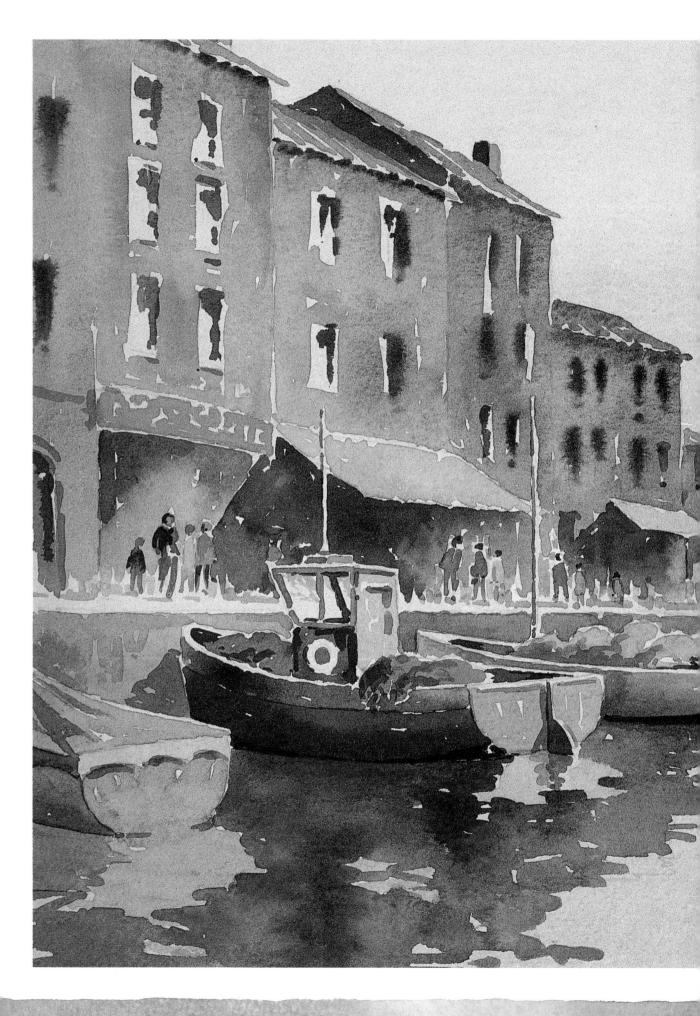

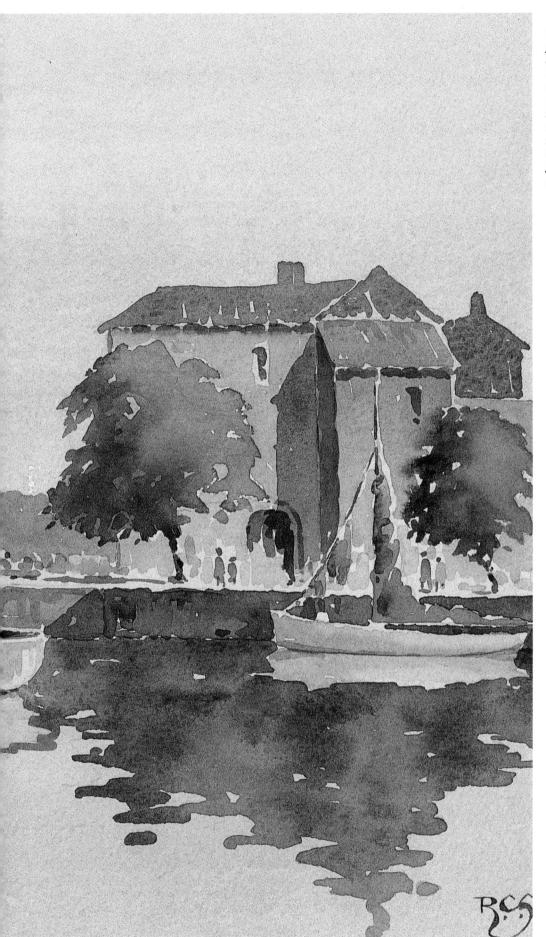

HARBORSIDE, HONFLEUR
This attractive French
port is always full of life
and color. Although
there is plenty of color in
this painting, I resisted
the temptation to cram
in too many competing
hues. The overall feeling
is one of warmth, which
contrasts with the
glimpse of blue-gray
distance.

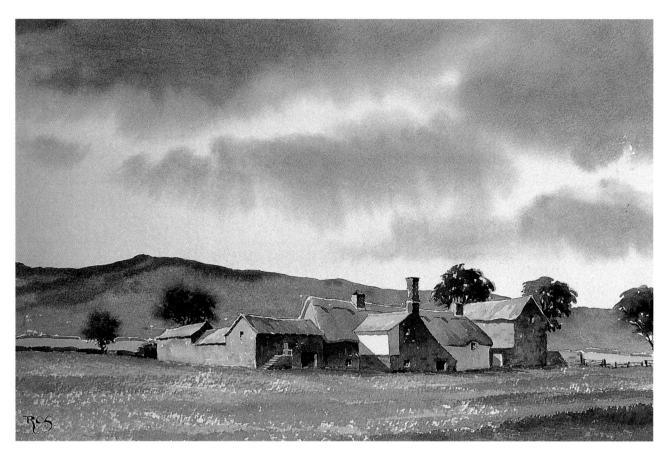

experience come into play. Beginners, ever optimistic, frequently entertain the hope that some magic in the medium itself will enable them to obtain the effect they so desire. Despite the happy accidents of art folklore, this rarely happens. The proper approach is to analyze the problems posed and think out ways of overcoming them.

To illustrate the point I am trying to make, let us consider the case of an inexperienced artist tackling a field of grass in the foreground of his painting. He will probably spend a little time mixing the right color green and will apply it over the whole area of the field. Even if he has succeeded in getting the tone and color right, he will realize at once that the result is altogether too flat and featureless. He will then start putting in little tufts of grass, to break up the excessive smoothness, and will soon find he is trying to paint individual blades of grass. The areas between his tufts, by contrast, will start to look even more featureless than before, and he will feel constrained to apply the same detailed treatment to them. Before he understands what is happening, the whole foreground will become tired and overworked and, in all probability, thoroughly dull and muddy.

There are several ways to remedy this, depending on his style and approach, but all of them require forethought and planning.

MOORLAND FARM

My object in this painting was to capture something of the brooding atmosphere of a moor under darkening storm clouds. At the same time I wanted to do justice to the splendid old farmhouse, which I sketched with some accuracy.

I applied a wash of palest raw sienna to the whole of the sky and then dropped in a mixture of burnt sienna and ultramarine for the brownish gray clouds. The slope of my board caused some downward flow, suggesting an approaching rain squall. I then added some deeper shadow, wet in wet (see Glossary), for the heavier clouds.

The shoulder of moorland was a deep wash of ultramarine and light red, with a little raw sienna added to the lower slopes and some darker shadow at the top.

The foreground was a broken wash of raw sienna and a little Payne's gray, applied with quick horizontal strokes of a large brush. When this was dry, I added some texture with a somewhat drier brush, to suggest the rough nature of the surface.

Artist's Tip

To paint successful watercolors, spend more time planning than painting—observing, thinking, and planning should be followed by quick, decisive application of paint.

Whatever he does, he should not begin to paint his foreground until he has first decided upon a plan and a strategy. If, for example, he favors a loose approach, he may decide that a broken wash, applied with bold horizontal strokes, will give him the effect he wants. The strings of little white dots of untouched paper that such a wash produces, particularly on rough paper, may suggest masses of seed heads in the grass or simply indicate texture. With growing experience, he will be able to modify the color and the tone of his wash, to represent variations in the appearance of the grass, without losing either freshness or clarity. A second texturing wash might also be applied, and although in general terms it is usually better to say what you have to say in one wash rather than two, not much freshness will be lost if the texturing wash is applied equally boldly and quickly, so that the original wash is not disturbed.

In the early stages of a painting, the bold approach may not produce precisely the effects you are aiming at, but even if the result is not quite what you had in mind, it is likely to be more effective as a watercolor painting than the overworked alternative. With growing experience, you will gradually get closer to nature, particularly if you remember that it is not a photographic image of the subject that you are after, but a fresh interpretation of it in watercolor terms.

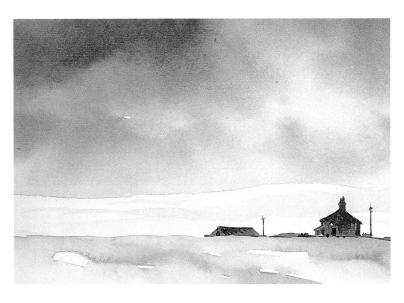

WINTER ON THE MOORS

The bold, loose application of liquid paint can help you capture dramatic sky effects, as this quick impression of lowering clouds shows. I applied a dilute wash of Payne's gray over the whole sky area, down to the line of snow-clad hills. Into this, a pale wash of ultramarine and light red was dropped to indicate the softer

clouds, and this was followed by a much stronger mix for the heavy clouds at top left.

The isolated farm buildings were placed on the right of the painting to provide tonal balance. The foreground snow, in the cloud's shadow, was a loosely applied wash of Payne's gray.

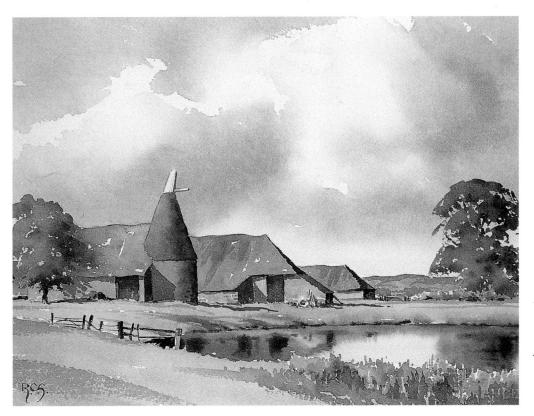

This rural subject has been treated fairly directly, with most of the passages comprising

THE FARM POND

arectly, with most of the passages comprising simple washes of transparent color. Much of the foreground is a flat wash of raw sienna to which broken washes have been added to suggest shadow and texture.

· DEMONSTRATION

CHRISTMAS EVE

In this Christmas-card scene, the crispness of the snow-covered farmhouse, the five-bar gate, and the other foreground features contrast with the misty distance in which the dim, vertical forms of evergreen trees can just be made out. The house is viewed at an oblique angle, allowing two elevations to be seen, and their difference in tone helps to give the building a three-dimensional look. The lines of the house, the hedge, and the lane all lead the eye toward the patch of radiance in the sky, beneath which I later decided to place a small, dark figure to create a focal point.

Palette

raw sienna light red ultramarine Payne's gray burnt sienna

STEP 1

I began by sketching in the principal lines of the house, the gate, and the lane. The next step was to establish the warm tones of the evening sky and indicate the misty trees, while the background wash was still wet enough. This technique is known as "wet in wet." To apply paint in this way, it is, of course, necessary to prepare the washes in advance—there is no time to start mixing up paint once the basic wash has been applied. The area of pale sky was diluted raw sienna warmed with light red, and the deeper tones were a warm gray, achieved by mixing ultramarine and light red. I applied these washes quickly, allowing them to merge softly. I then began to put in the more distant tree forms, wet in wet, using a slightly stronger mix of the same gray. I added a little Payne's gray on the

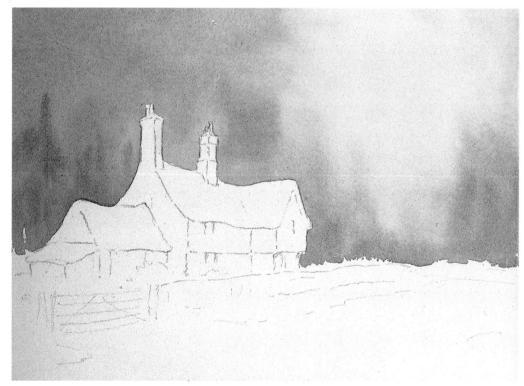

left and indicated the evergreens here with a little more definition. At this stage I decided to add the foreground bush on the right, to helb balance the main tonal weight, which lay on the left. This addition also helped to prevent the eye from following the line of the road right off the paper.

STEP 2

The creamy color of the watercolor paper was ideal for the snowanything too dead white would have required warming, to accord with the light in the sky. The snow shadows also needed some warmth, and I used a pale wash of ultramarine and light red. In wintry scenes such as this, everything has to be painted in deeper tones than usual in order to make the snow shine by contrast. The brickwork was painted in varying combinations of burnt sienna and light red. A much deeper mixture of the same colors, plus ultramarine, served for the shadowed elevations. Notice the warm reflected light on the left-facing gables.

When I had finished painting the house, its crisp treatment tended to separate it from its misty

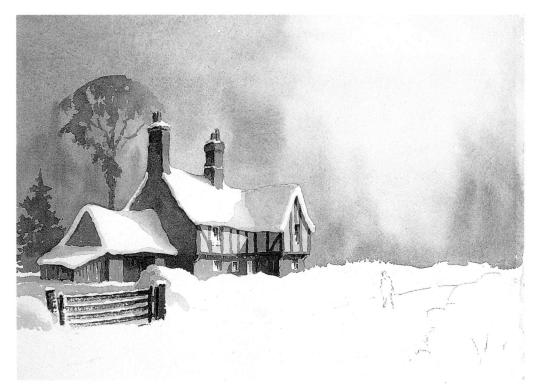

background, and it seemed to me that some intermediate forms were needed to link the two together. I accordingly

painted in the muted shapes of the evergreen and the deciduous tree on the left.

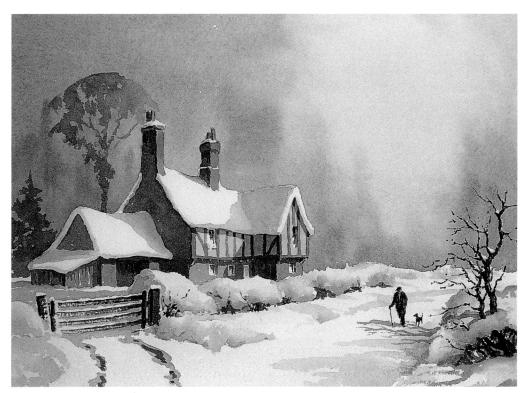

STEP 3

I prepared another wash of ultramarine and light red and applied it quickly and boldly to indicate the shadows in the snow, softening the edges here and there with clear water. This gave direction to the road and helped to describe the form of the lumpy snow resting on the hedge.

A wash of raw sienna and ultramarine was used for the glimpse of hedge under its weight of snow, and a darker mix of the same two colors served for the odd twig, the tire tracks by the gate, and the bare bush on the right. Finally, I put in the figures of the old man and his dog in still deeper tones to make them stand out against their pale background.

1 Materials and Their Uses

The first step in mastering watercolor technique is, of course, to purchase the proper equipment, and it is vital to make sure that this is not a false step. Failure to seek informed advice, or the acceptance of advice that is not entirely

disinterested, can easily result in the acquisition of unsuitable materials. unnecessary expense, or in all probability, both.

The proprietors of most art-supply stores offer sound, helpful advice, but it has to be remembered that they have a vested interest in selling the more expensive items, and these are not always the most suitable. I have come across numerous instances in which inexperienced painters have been persuaded

to buy magnificent watercolor sets containing dozens of pans of paint. These sets are not only extremely expensive, but in my view are positively harmful. The bewildering array

there are so many unrelated colors that all feeling of unity and cohesion is lost. I was once given an enormous watercolor set in a handsome wooden case containing fortyeight pans of color; I still have it in its original pristine condition. What I use instead is a simple black enamel box containing just a few pans of color, finding this ample for my needs and far more manageable and portable.

You must, however, distinguish between expensive necessities—paints, brushes, and paper—and expensive frills. It really pays to buy the best essential equipment you can afford, for watercolor painting is difficult enough without adding to your problems by using second-rate materials.

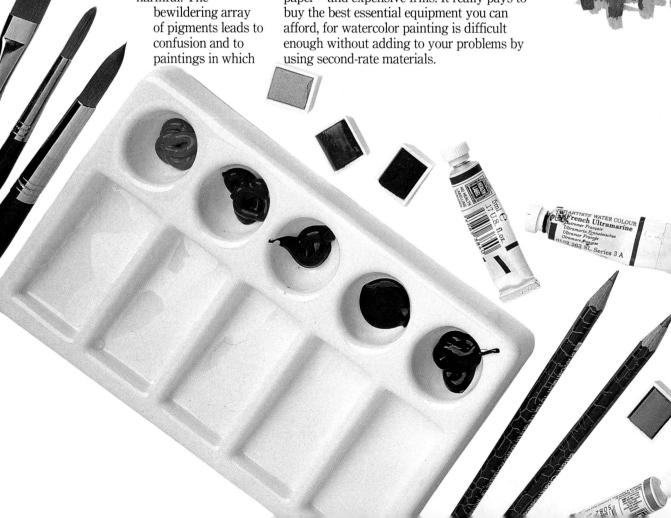

PALETTE RANGE

There is a definite advantage in using a small number of colors in your work. Not only do you get to know the handling properties of a narrow range much more quickly—and colors do vary in this respect—but where combinations of just a few colors occur in all parts of the painting, that painting hangs together far more satisfactorily. The question then arises as to which colors to buy. This is very difficult to answer, for so much depends on individual preference and taste. We all see color differently, though in most cases only marginally so, and experienced artists tend to stick to a specific range that suits their particular needs. Naturally, much will depend upon the type of subject matter you favor. Flower painters, for example, will need a selection of brilliant colors if they are to capture the more spectacular hues of nature. Landscape painters, on the other hand, are

often more interested in subtlety and frequently obtain telling effects by understatement.

My own palette for landscape work is shown on the right. To my basic five, I often add Payne's gray, burnt umber, and alizarin crimson for particular types of subject. For the brighter colors of hot climates, I add cadmium yellow and cadmium orange as well.

I remain a firm advocate of the limited palette and frequently use just three colors in my work—light red, raw sienna, and ultramarine. After all, these are simply variations of the three primaries—red, yellow and blue—and can produce an impressive array of secondary and tertiary colors. Quite simply, secondary colors contain just two primaries (green, for example, is a mixture of yellow and blue), while the tertiaries contain all three primary colors. Some of these combinations produce colors of exceptional beauty and subtlety.

My Basic Palette

light red raw sienna burnt sienna ultramarine Winsor blue

Extras:
Payne's gray
burnt umber
alizarin crimson
cadmium yellow
cadmium orange

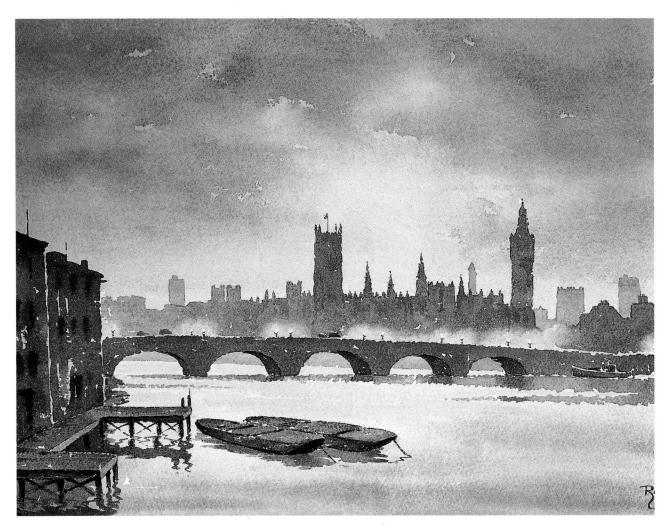

CHOOSING PAINTS

Colors vary in their durability and are coded by the manufacturers according to their colorfastness. Fortunately, the fugitive or unreliable colors of the last century have been superseded by more reliable pigments. Colors come in two qualities, artists' and students', the former naturally being the more expensive. Artists' colors contain more finely ground, and in some cases more costly, pigments and are superior in strength and clarity. The choice between the two grades is a matter for the individual, but my feeling is that one needs all the help available in the difficult yet fascinating business of watercolor painting, so I opt for the artists' quality. They are more expensive, but it has to be borne in mind that the watercolor medium is far more economical of pigment than oil or acrylic, and the difference in cost per painting cannot be very significant.

The next choice is between pan and tube color, and this again is a matter of personal preference. If you prefer pans, make sure they are kept reasonably moist by the periodic addition of clear water, for nothing

is more frustrating—or harder on brushes—than trying to coax reluctant pigment from dried-up pans. Many of those who prefer tubes squeeze out small blobs of color around the edges of their mixing palettes and wash it all off at the end of each painting session—a very wasteful procedure. My own practice is to squeeze the tube paint into the appropriate pan before painting begins. This way I always have moist paint to use, the new paint freshens up the old, and nothing is lost.

BRUSHES

Good, lively brushwork is an essential ingredient in successful watercolor painting, yet it is a skill that too many painters fail to develop. This failure often stems from too much detailed drawing, for then the painting simply becomes a mechanical process of filling in the areas between carefully drawn outlines, leaving no scope for the expressive use of the brush.

Good brushwork naturally demands good brushes, and the best obtainable are made of kolinsky sable. Unfortunately, they have become extremely expensive and

CITY BRIDGE

Just three colors were used in this impression of an evening sky—raw sienna, light red, and ultramarine. These three colors appear, in varying proportions, in all parts of the scene, and consequently the painting has a unity which the introduction of alien hues could easily have destroyed. Such a limited palette is not, of course, always possible or desirable, but when a warm sky, such as this, strongly influences the scene below, then the colors used for the sky are often all that is needed.

beyond the reach of most painters. On the credit side, alternatives have been developed, and some of these are extremely good. My favorites are manufactured from a mixture of sable and synthetic fiber, and while it has to be said that no compromise can quite match the real thing, they are excellent in their way and allow me to produce bold and lively brushwork.

The next question that has to be decided is that of size. Inexperienced painters always go for the smaller sizes, partly because they are less expensive and partly because they are believed to be more manageable. Sadly, the influence of these smaller brushes is all on the wrong side, for they tend to encourage preoccupation with detail and are virtually useless for producing the full washes upon which success in watercolor so much depends. True, in the early stages, the use of larger brushes may cause handling difficulties, but with time and practice they will wean you away from obsessive detail and toward bigger and bolder effects. In short, they will help you to loosen up and you will come to realize that feeling and verve in painting are of far more value than precision and accuracy.

MY WATERCOLOR BRUSHES

It is not possible to lay down recommended sizes for brushes, for so much depends upon the individual's style and scale of painting, but you may find it helpful to know what I normally use. Most of my work varies in size from quarter imperial $(11 \times 15 \text{ inches}/28 \times 38 \text{ cm})$, to half imperial $(15 \times 22 \text{ inches}/38 \times 56 \text{ cm})$; for this I use the brushes below.

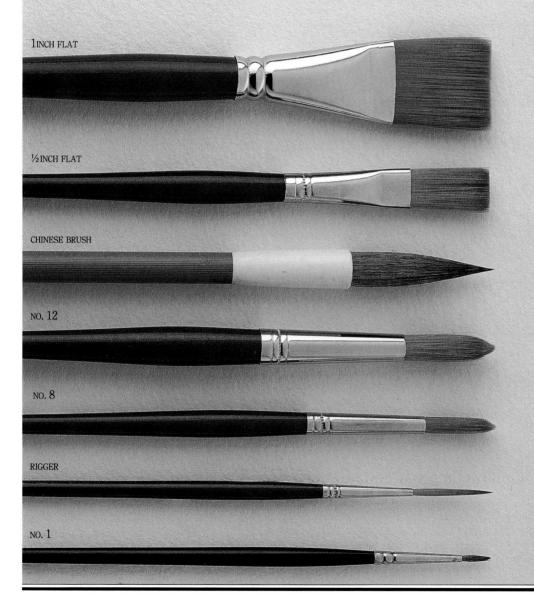

TWO 1-INCH (2.5-CM) AND TWO 1/2-INCH (1.25-CM) FLATS I use these for skies and other large passages. They are chisel-ended when bought, and I must confess I modify them by carefully rounding the sharp-angled edges with nail scissors. This allows me to achieve a pleasantly broken edge to each brushstroke.

CHINESE BRUSH
Mine is large and round,
of some antiquity. I
use it for quick, bold
modification of sky
washes while they are
still wet.

No. 12 and no. 8
I use these brushes for objects within the landscape—trees, buildings, boats, and so on. I make a conscious effort to use the larger brush wherever possible, as this prevents me from becoming involved in fiddly detail.

RIGGER
I use this mainly for its original purpose—to paint the rigging on boats

No. 1
This is used for adding my initials!

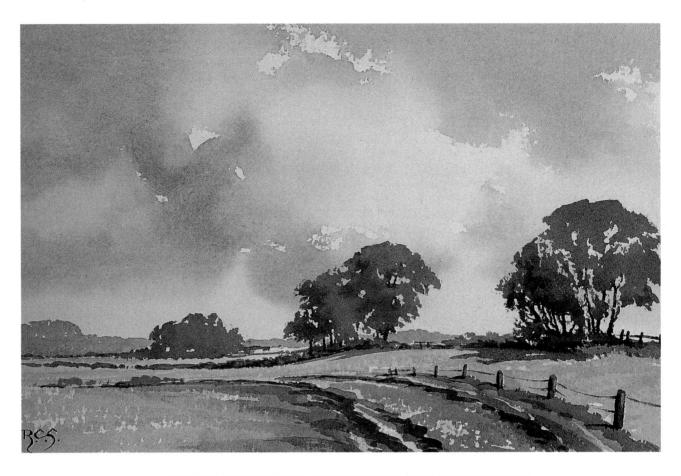

BEACHED BOAT This quick sketch was made with a watercolor pencil. The graphite is soluble in water, so the marks it makes can be softened with a wet brush.

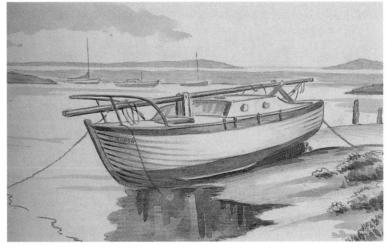

RHODODENDRON Watercolor is the ideal medium for capturing the fragile forms of flowers. I used a coldpressed paper for this quick study of a rhododendron blossom, using pale combinations of alizarin crimson, light red, and ultramarine for its subdued yet subtle pinks, and Payne's gray with a little raw sienna for the dark leaves.

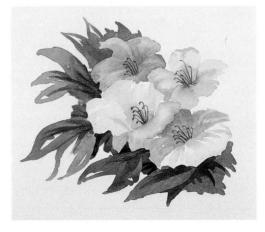

FARM TRACK

The most important part of a watercolor landscape is a fresh and lively sky. Fortunately, it is the feature we normally tackle first, so if it is a disaster, we can make a fresh start without too much loss of time. Most failures are due to timidity or attempted alteration or both, so it pays to cultivate a bold approach and resist the temptation to tidy up. In this quick study, three washesfor sunlit cloud, cloud shadow, and blue skywere applied in quick succession and then left. I made no attempt to fill in the little areas of white that often result from working at speed.

PAPER

There are many watercolor papers on the market. The best of these are made from pure cotton rag and are rather expensive, but cheaper papers made of wood pulp are available, and the best of these are admirable, representing excellent value. Papers are classified according to their surface texture and their weight. Although most papers produced today are machine made, I prefer those that have the look of a handmade finish—a random grain that I find infinitely preferable to a mechanical, repetitive type of finish.

Papers vary considerably in the hardness of their surface. The softer papers, containing less size in their dressing, are more absorbent and washes quickly sink in, making it difficult to make alterations. The harder papers are slower to dry; and although in watercolor, alteration should be avoided if possible, they permit careful changes to be made, except, perhaps in passages (areas) of pale, clear washes, such as the sky or expanses of water.

Full, liquid washes make the lighter-

weight papers wrinkle badly in use, and this gives rise to uneven drying, with its attendant problems of patchiness and "blooming." These papers have to be stretched before use. The heavier papers resist serious wrinkling, but they are, of course, more expensive. Weight is expressed in pounds (or grams) to the ream of standard size, and the principal weights are 90 lb. (190 g), 140 lb. (295 g), 200 lb. (421 g), 240 lb. (504 g), and 300 lb. (632 g).

It makes good sense to experiment with the available papers until you find one that really suits your style and then stick to it. Papers vary considerably in the way they accept paint, and you will produce better work if you are using a paper with which you are familiar.

You should always take great care of your watercolor paper and make sure its surface is protected against damage. Although good-quality paper appears robust, its surface can easily be abraded or scratched. Such damage only becomes obvious when a wash is applied and unwelcome dark marks appear.

PAPER TEXTURE

Papers are classified according to their surface texture and their weight. There are three types of surface:

HOT-PRESSED

Also known as HP or smooth. The effect of applying a heated press to the paper in the manufacturing process is to give it an extremely smooth finish with no visible surface indentations.

USES: The very smooth surface of this paper makes it ideal for pen and ink work, as its lack of texture enables the nib to glide smoothly over the surface without snagging. It is less suitable for watercolor because its lack of "tooth" can easily cause the brush to slide over the surface without making an effective statement.

COLD-PRESSED

Also known as CP or NOT (as in "not hotpressed"). This means that the paper has been finished by the application of an unheated press, which reduces the surface irregularities, but leaves some patina.

uses: This is the paper surface most commonly used by watercolorists, because it provides them with enough surface texture without the problems they may experience with the greater irregularities of the rough grade.

ROUGH

This is a more textured paper, originally prepared by omitting the pressing stage

altogether. Today, most rough papers are given their surface grain by the application of textured presses. USES: This paper is ideal for dry brushwork and the application of broken washes, as its rough surface facilitates the use of such methods. These techniques are dealt with in more detail in Chapter 7.

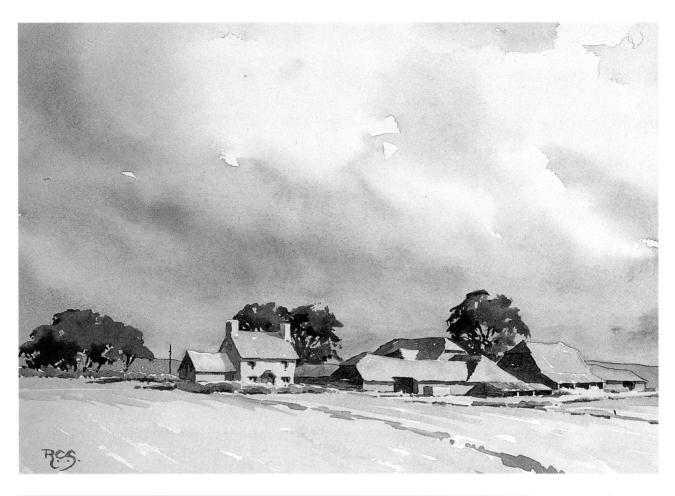

STRETCHING PAPER

Paper weighing less than 200 lb. (421 g) should be stretched before use. This prevents the paper from wrinkling when wet washes

are applied. Here are four easy stages to be followed when stretching paper:

- 1 Completely immerse the sheet of paper, keeping it as flat as possible, in cold water. Leave it to soak for five minutes.
- 2 Remove the paper, allowing excess water to drip off,
- then lay it flat on a drawing board an inch or two (2–5 cm) larger.
- 3 Carefully smooth away air bubbles with your hand or a soft cloth until the paper lies flat.

4 Secure the complete length of all four edges with brown gummed-paper tape. For extra security, some artists also fasten the corners using thumbtacks.

Once the paper is dry, it is ready to use. The painting is done with the paper still attached to the board it has been stretched on. Carefully cut it off with a knife when completely dry.

FARM SCENE

This is an example of lively brushwork on a smooth, hot-pressed paper. With a rough paper, the unevenness of the surface assists a brush held at an oblique angle to achieve a broken mark, which can represent, for example, the ragged outline of foliage. A smoother paper demands a different technique, in which the quality of the brushwork is allimportant.

In this study, a strong sun was illuminating the farm buildings, which stood out against a backdrop of heavy gray clouds to produce a dramatic tonal contrast. This was the effect I tried to capture.

EXERCISES TO TRY

Here are a few simple watercolor sketches that you may want to try out. They contain some of the basic brushstrokes and should be copied boldly and freely. I hope you will find them more fun to do than some of the exercises commonly given.

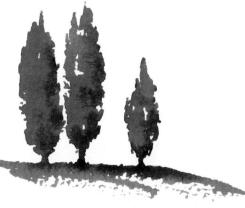

Three full, vertical brushstrokes on rough paper produced these quick impressions of cypress trees, and two horizontal strokes the ground beneath them. The addition of a little deeper tone into the wet paint indicated shadow.

The quick application of a liquid wash on rough paper produces a broken wash, useful in suggesting texture.

A continuous wash of blue-gray, with some brush drawing, decreases in tone to the right, to suggest distant trees and hedges. This technique was used for

the distance in Snow over the Hills (see page 27). The progressive addition of water to the wash will, of course, lighten the tone.

> Here, a broken wash of pale raw sienna suggests the texture of the foreground field of grain. A deeper wash of gray-green was applied

loosely on the rough paper, the texture of which helped to produce the broken edge.

· DEMONSTRATION

BLUESTONE FARM

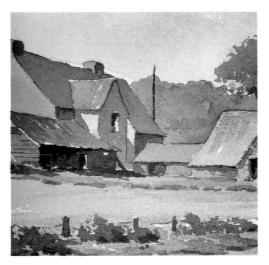

Choosing this lowland farm for a subject enabled me to indulge my love of painting skies. Here, the sky consists mainly of a lively formation of cumulus cloud—that most paintable of all cloud types—and to add emphasis to it, I have adopted a low horizon. Not *too* low, for there is plenty of interest in the group of farm buildings below their stand of sheltering trees.

Palette

raw sienna light red ultramarine Payne's gray burnt sienna

STEP 1

My first step is always to make several rough sketches of my subject and then enlarge the most promising to the size of the planned painting. This is the one I like best, and although the buildings seem strung out in a straight line, there is enough overlapping for them to relate to one another; and the farmhouse, set at an attractive angle, is facing conveniently into the painting.

I always begin by painting the sky, partly because it is usually the lightest part of the scene and partly because it strongly influences every other part of the painting. With a sky such as this, I favor a bold treatment, with some washes merging together and others remaining hard-edged, to provide interest and contrast.

Here, I began by preparing three generous washes, one for the sunlit areas of cloud, one for the cloud

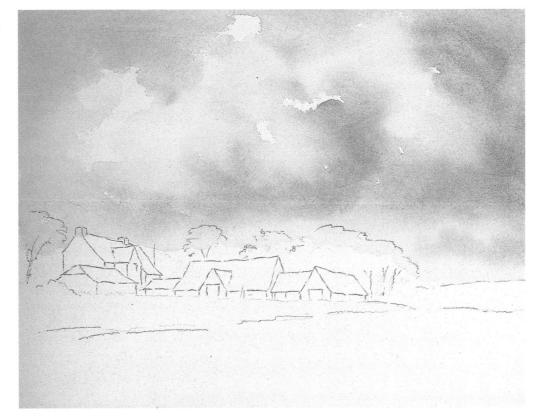

shadows, and one for the blue of the sky. The washes were respectively (1) dilute raw sienna, (2) ultramarine and light red, and (3) ultramarine with just a touch of light red. I applied them, in that order, in quick succession. Putting the heaviest cloud shadow on the right helped to balance the main weight of the composition, which is on the left. The pale sky just above the horizon was a slightly richer raw sienna wash. As soon as the washes were in place, I modified them a little with another

large brush, but resisted the temptation to overelaborate and clean up a bold, fresh effect is always better than a neat, timid one! STEP 2

With the light coming from the left and falling on the roofs of the farm buildings, I wanted to make sure that the trees behind afforded plenty of tonal contrast. I therefore prepared fairly strong washes of Payne's gray with varying amounts of raw and burnt sienna and applied them with the side of the brush to obtain the broken outline of the foliage. While they were still moist, I added stronger versions of the same mixes to indicate the shaded areas.

The far distance was a flat wash of ultramarine tinged with light red. The middle-distance bank of trees was a slightly stronger mixture of the same colors with just a hint of raw sienna added, applied wet in wet, with a little shadow applied on the right.

The basic washes for the foreground fields were very pale burnt sienna and light red for the plowed land, and a broken wash of Payne's gray and raw sienna for the rough grass.

STEP 3

I now began to paint the warm colors of the tiles, using raw sienna and light red with just a touch of green (made up of Payne's gray and raw sienna) to suggest the moss and algae that usually cling to the lower parts. When this was dry, I added a little texture in slightly deeper tones with brushstrokes that followed the slope of the roofs. I then deepened the shaded areas of some of the trees to make the buildings register more effectively. As always, I paid close attention to the shadows of the buildings, which I painted in deep tones.

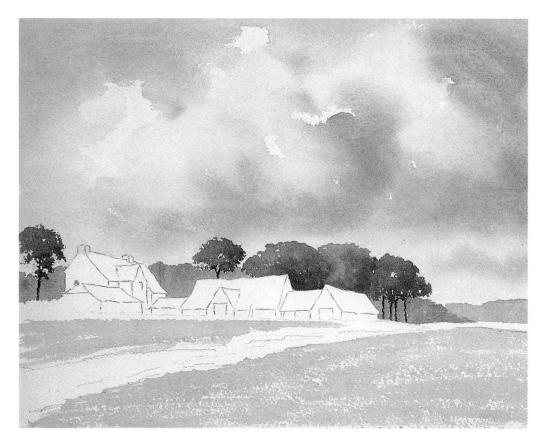

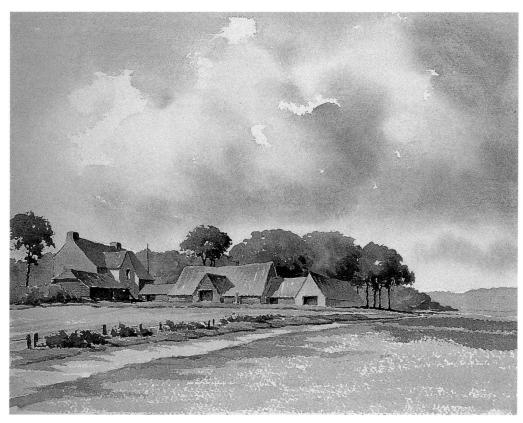

I added some cloud shadow to the field on the right and a little texturing in the form of a pale broken wash to the field on the left. The line of rough hedge and fence posts, put in with a smaller brush, and a shadow on the track completed the painting.

2 Color—Theory and Practice

Color is of vital interest to the watercolorist, for well-chosen colors can make all the difference between the success or failure of a painting. People vary in their feeling for color and in their appreciation of its subtleties; some have a natural

response to it and an instinctive understanding of its complexities, while others have to rely on a more analytical and methodical approach.

PRIMARY, SECONDARY, AND TERTIARY COLORS

We have already mentioned primary, secondary, and tertiary colors and we now need to go just a little further into color theory. We know that the three primary colors are red, yellow, and blue and we know that any combination of two of these primaries will produce what are called secondary colors. Thus, red and yellow make orange; yellow and blue make green; blue and red make violet – the orange, green, and violet being the secondary colors. These vary according to the proportions of the primaries used, and if there is, for example, more red than yellow in the first combination, a warmer orange will result.

Tertiary colors result from mixing the secondaries or from mixing all three primaries and are sometimes called broken colors. If the three primary constituents are mixed in more or less equal proportions, dull grays and browns tend to emerge, but if one primary or secondary color is allowed to predominate, rich, subtle, and often beautiful colors may result, and it is these that are of the greatest value in landscape painting.

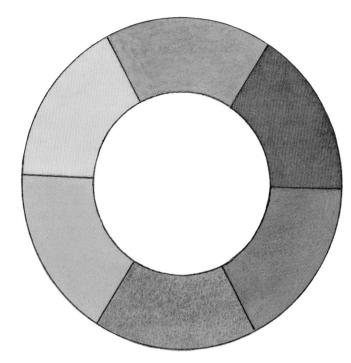

Here is an example of the simplest form of color wheel, in which the three primaries red, yellow, and blue—are separated by the three secondaries orange, green, and violet. Each secondary is obtained by mixing the two adjacent primaries. Thus, orange is obtained

by mixing red and yellow, green by mixing yellow and blue, and violet by mixing blue and red.

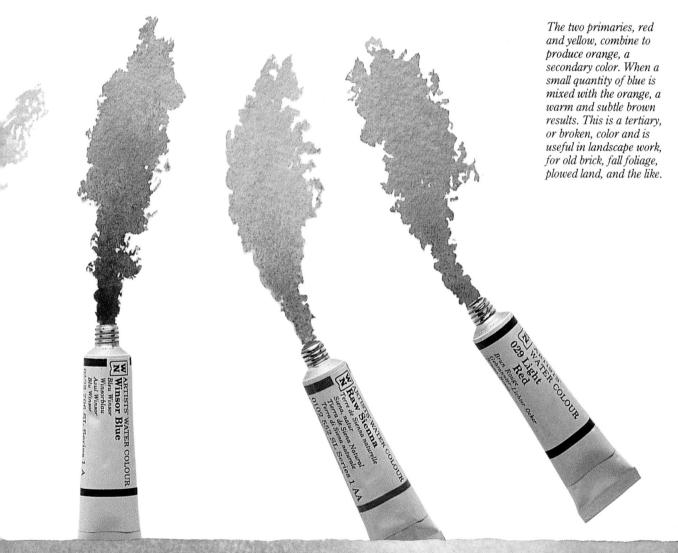

Blues and grays tend to recede, and warm colors advance. But beware! Dark colors of whatever temperature are inclined to jump forward, especially if the foreground is much paler.

Here, the pale blue-gray hills seem to recede, helped by the much deeper tones of the foreground.

This example shows how a color registers strongly against its complementary. The small, red figure stands out boldly against its green landscape setting.

COLOR TEMPERATURE

Color temperature is an aspect to be considered if you wish to achieve a feeling of depth in your work. Reds and oranges—the colors of fire—are the warm colors, while blues and grays—the colors of ice and shadows—are the cool. In painting, as in other visual arts, the warm colors seem to come forward while the cool appear to recede, and if you bear this in mind in your work, a proper feeling of recession, or apparent depth, will be achieved. It is a matter of observation that the colors of the far distance are predominantly the blues and grays, and this is how you must therefore paint them. On very clear days, the graying of the distance is almost imperceptible, and it then pays to exercise artistic license and use a little more blue than you observe, in order to create a feeling of recession. The graving effect of distance is the result of viewing the far horizon through the intervening atmosphere which contains dust and, most of all, water vapor. The mistier the conditions, the greater this effect will be.

COMPLEMENTARY COLORS

Let us now consider complementary colors. Just as realism in watercolor painting is enhanced by attention to color temperature, so the use of complementary colors can heighten visual effect. In simple terms, these lie opposite each other on the color wheel, for example, red and green, yellow and violet, blue and orange. If you wish to discover a certain color's complementary, this is what you do: paint a patch of that color in the middle of a sheet of white paper, stare at it fixedly for about a minute, and then switch your gaze to a small black dot in the middle of another sheet of paper. The complementary color will then appear, a phenomenon sometimes called the afterimage.

Knowledge and understanding of complementary colors is useful in obtaining telling contrasts, and we see many paintings in which full use has been made of their striking effect. A bright red figure in a predominantly green landscape is a frequently seen example. Vibrant effects can

Artist's Tip

In watercolor painting, remember always to work from the lightest tone to the darkest. Never attempt to paint a light color over a dark wash—it simply won't work and will produce a muddy effect.

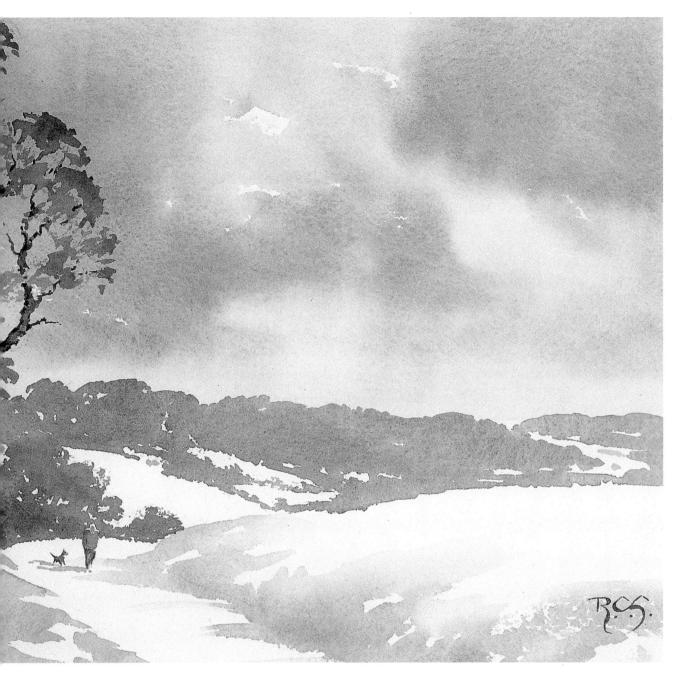

be obtained by placing small areas of complementary colors side by side instead of mixing them, though this is a technique with more relevance to oil painting than to watercolor. Some of the French Impressionists, notably Seurat, extended and developed this technique, which became known as pointillism.

USING COLOR

Let us now get down to the practicalities of using color. One of the first things we must do is rid ourselves of preconceived notions of color—notions often inherited from our childhood. To young children, tree foliage is always bright green, tree trunks are uniformly chocolate-brown, water is

SNOW OVER THE HILLS

This winter scene illustrates several ways of reducing a landscape to a few quick and simple steps. For example, the sky—a rather heavy one to provide tonal contrast with the snow-was basically achieved by dropping a warm gray of ultramarine and light red into a pale base wash of raw sienna. In such liquid conditions, the light red tends to separate, to give a warm edge to the clouds. The distant trees and hedges

were established in a single step with a wash of ultramarine and light red. A little local color was added here and there to give variety, and some extra water was used to lighten the tone on the right to aid recession. The foreground snow shadows were, once again, ultramarine and light red in pale tones, softened in places with clear water. I used light red for the solitary figure to make it register against its mostly green background.

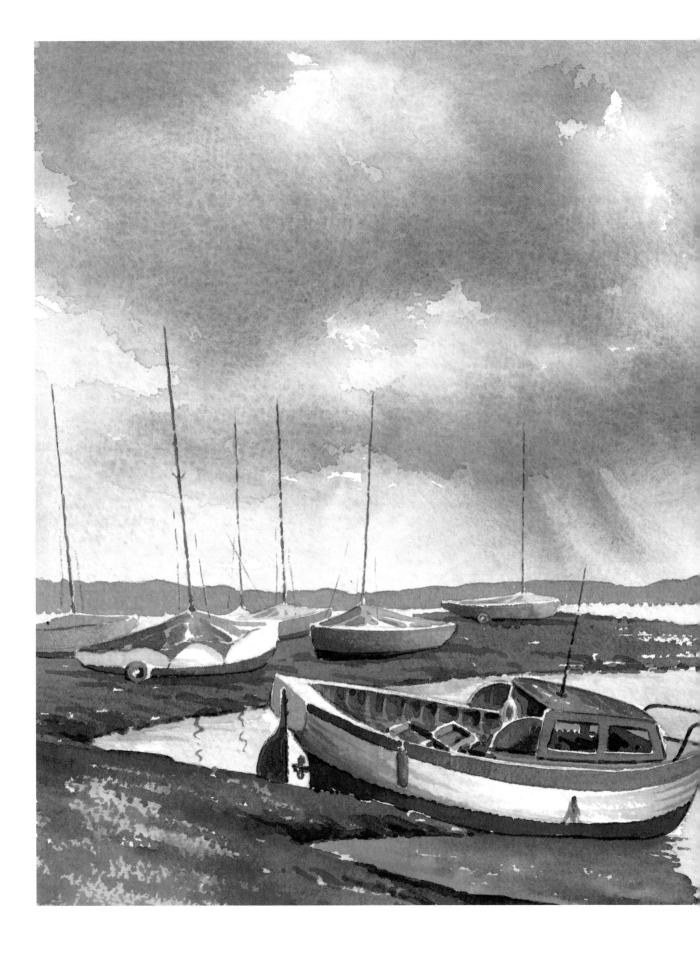

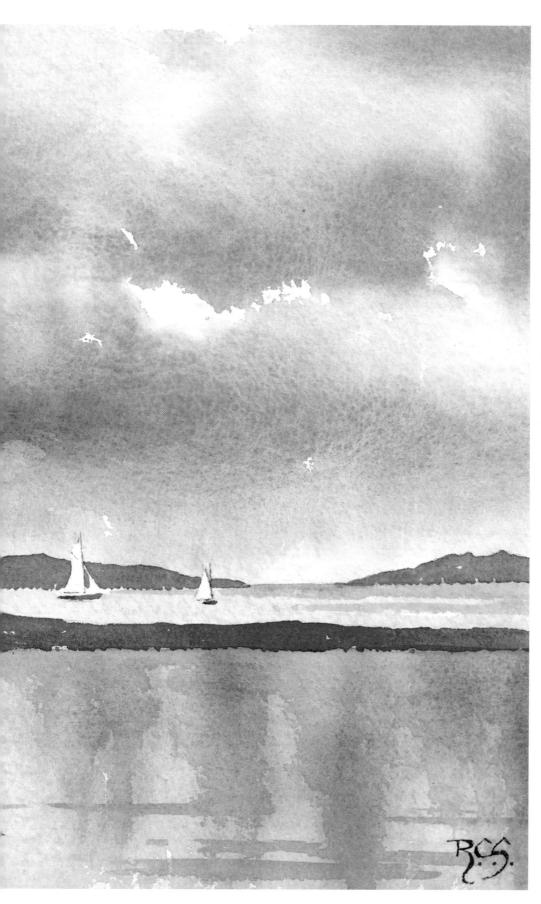

WORK AND PLAY Here, the gaily colored sailboats are contrasted with the solid lines of the fishing boat in the foreground. I seem to be using the word contrast a great deal, but it is a vital ingredient in painting in all sorts of ways. Here are some additional examples: $tonal\ contrast-the$ placing of lights against darks and vice versa; color contrast—the placing of complementary colors in close proximity; textural contrast—the placing of rough surfaces against smooth. They can all be seen in this painting the dark accents of the foreground boat against the pale water, the light red sailboats against their greenish setting, and the rough foreground grass against the smooth

surface of the water.

FRESH WATERCOLORS: THE ULTIMATE AIM

The most important "rule" of watercolor painting is to keep colors fresh and vibrant, and to avoid like the plague any hint of muddiness. Dullness and muddiness creep in when too many colors

are combined in a wash, or when the remains of a wash of uncertain parentage are pressed into service. The beauty of watercolor is most apparent when the paper shines through a fresh and vibrant wash, and this beauty is all too easily lost by overworking or by using muddy colors.

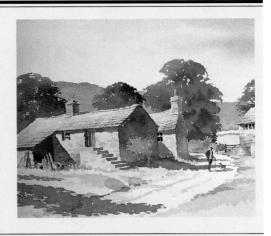

invariably bright blue, and this is how they paint them. These early color conventions are all too often carried unquestioningly into adult life and go some way to explaining the landscape paintings one frequently sees in which everything is an unrelieved green. Far better to ignore the colors we expect to see in our subject matter and look for what is actually there. If we look hard and analytically, it is often surprising what colors can be discovered; even though there may be only the merest hint of them, it may well pay to emphasize them, for this can give a painting more interest and character. This is particularly true of summer landscapes in which the color green can be too dominant for comfort.

LIGHT

It is vital to remember that everything is influenced by the quality of the light. The light from a warm evening sky affects the color of every object on which it falls, and foreground foliage painted in cool green will look completely out of place. Some artists

avoid this danger by carrying the warm sky wash down over the whole painting. The bits of that initial wash that remain untouched in various parts of the finished painting give a warmth and a unity to the whole. A similar type of unity can be achieved by using a tinted paper, but, unless you keep a large and varied stock, the chances of finding a sheet of the perfect color are not very great. An overall wash, which varies to take account of the lighter colors that predominate in various parts of the painting, is another useful starting point and one that has the advantage of muting the rather intimidating white of the untouched paper.

It is not only the part of the landscape in full sunlight that is influenced by the sky—the shadows, too, are affected by the quality of the light and need careful study. If the sky is blue, the shadows will reflect that color, and it is a bad mistake to indicate shadows with a wash of uniform gray. Warm light from nearby objects in full sunlight also has an appreciable effect, and the lively $\rightarrow p.3$

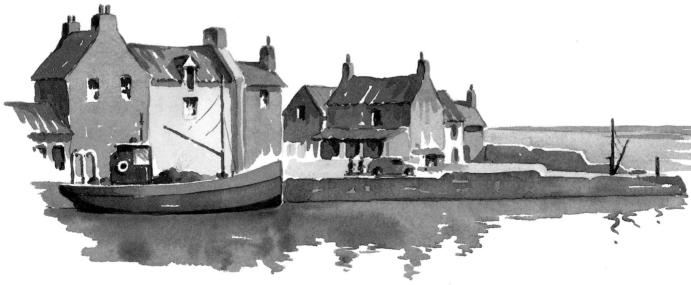

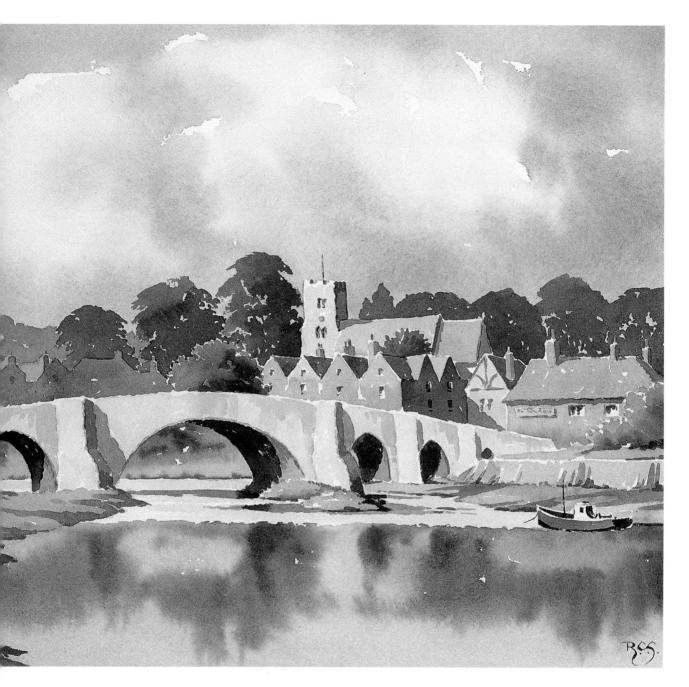

EXERCISES TO TRY

Here are a few experiments in color you may wish to try:

- 1 Apply a horizontal wash to represent a field of fresh, sunlit grass (try raw sienna with a touch of Winsor blue).
- 2 Add a hedge and a few trees in deeper tones—perhaps various combinations of raw sienna, burnt sienna, and Payne's gray.
- 3 Now add a small figure dressed in red, and note how it stands out against the green background.
- 4 Try mixing some subtle, warm browns, using only primary colors, and with these add some fall foliage to your watercolor sketch.

ARCHING BRIDGE

This painting was built up with a series of flat, transparent washes that allowed the white of the paper to shine through. The church, the houses, and the trees were all painted in this way, and only in some closer features, such as the bridge, the bushes, and the foreground grass, did I permit myself any added texturing. Pale bands of disturbed water separate the scene above from its reflection, which is treated softly to provide contrast—a

mirror image would have been altogether too complicated. The soft effect was obtained by adding vertical strokes of various colors to a wet base wash of pale gray.

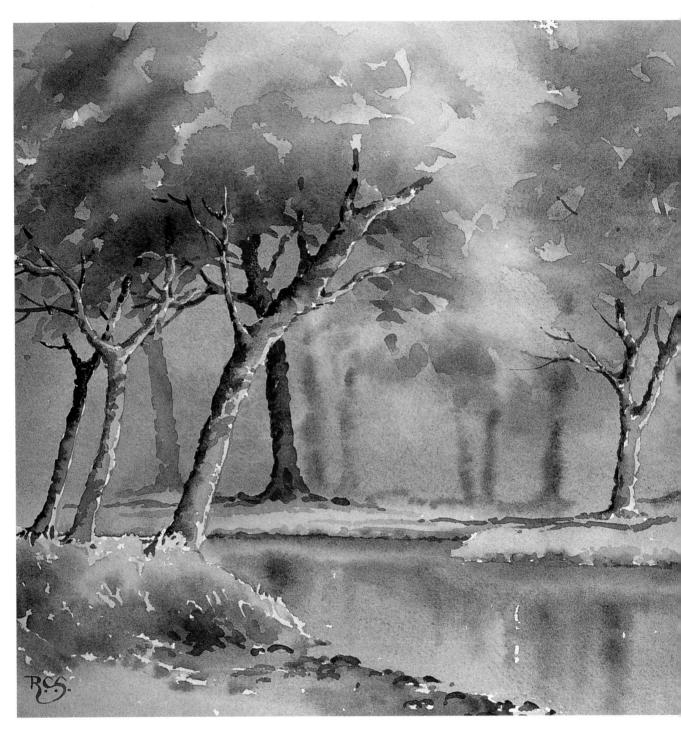

WOODLAND STREAM

An appreciation of color is of particular importance to the watercolorist. The medium relies on subtlety and understatement rather than power and richness for its effect, and this demands understanding, judgment, and sensitivity on the part of the artist. At the same time, there is no excuse for watercolors that are

wishy-washy, and the painter must be prepared to apply strong color when the occasion demands.

Woods make fascinating subjects, particularly when there is some water on hand to provide reflections. Unfortunately, many inexperienced painters are deterred from trying by the baffling complexity of leaves and twigs—they have not learned the art of simplification or the power of suggestion. Here, all that detail has been resolved into broad areas of tone and color, treated boldly and loosely, and only the tree trunks, which are fairly simple forms, have been given any detailed treatment.

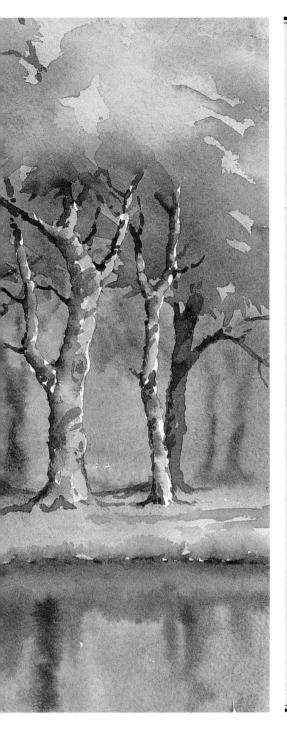

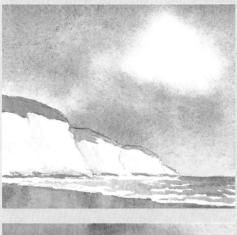

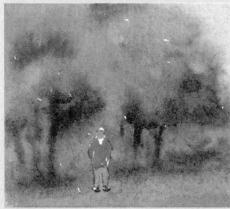

THE IMPORTANCE OF CONTRAST

TONAL CONTRAST: The placing of lights against darks and vice versa. In this watercolor sketch, the white cliffs contrast with the gray sky, while the shadowed expanse of sea on the right contrasts with the patch of luminous sky just above the horizon.

color contrast: The placing of complementary colors in close proximity. Here, the red of the jacket stands out boldly against the complementary green of the background. Notice that the blue-gray of the slacks provides no such contrast.

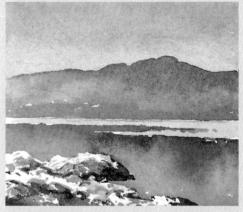

TEXTURAL CONTRAST: The placing of rough surfaces against smooth. The rough texture of the foreground rocks makes a useful foil for the expanse of smooth water.

treatment of reflected light will breathe life and beauty into shadowed areas.

TONE

Choice of color and judgment of tone go hand in hand. In art, tone simply implies lightness or darkness and is not concerned with color, as in popular usage. It is vitally important to get your tonal values right, and if you do, your paintings will still have form and meaning when photographed in black and white. A complicating factor is the disconcerting way watercolor has of drying

several tones lighter. A wash that looks perfectly effective when first applied may look weak and unconvincing when dry, and allowance has to be made for this.

Tonal contrast is an important ingredient in successful painting, and you should always be on the lookout for opportunities to place lights against darks and darks against lights. In the last analysis, sensitive appreciation of color and sound judgment of tone will only come with careful observation, conscientious practice, and experience, but the reward will be well worth the effort.

· DEMONSTRATION

THE VILLAGE CHURCH

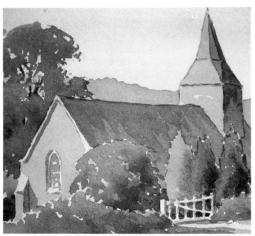

foreground. It also helps to provide tonal balance to the painting.

This is one of those unspoiled villages where time seems to have stood still. It makes a delightful subject for the landscape artist, with its simple church, weathered barn, and sandy lane, which leads the eye right into the center of the composition. The soft colors of the afternoon sky add warmth to the old tile and brick of the cottage on the right, and these in turn lend warm, reflected light to the shadowed side of the wooden barn. The hills form a pleasing backdrop of blue-gray, while the deep tones of

shadowed side of the wooden barn.
The hills form a pleasing backdrop of blue-gray, while the deep tones of the late-summer foliage contrast effectively with sunlit stone, wood, and tile. The dappled shadow of a large tree off the painting to the left falls across the village green and adds a touch of interest to what would have been a rather empty

Palette

raw sienna light red ultramarine Payne's gray burnt sienna Winsor blue

STEP 1

The octagonal spire of the little church needed careful drawing, but the rest presented no troblems

The warm color of the lower sky was a weak mixture of raw sienna and light red, while the cloud shadows were ultramarine and light red, with rather more red toward the horizon. The clear sky was bale Winsor blue with a little added raw sienna. When I had prepared these washes, I applied them as quickly as possible with large brushes. As the color of the lower sky was very pale, there was no need to paint around the spire, the chimney, or the trees. I might well have brought this warm wash down over the whole of the paper in the manner I describe in Chapter 7.

STEP 2

Once again I tackled the trees at an early stage so that uninhibited brushwork might capture their broken outlines. I used washes of Payne's gray and raw sienna for the greenish trees, with added Payne's gray for the shaded areas. Plenty of burnt sienna was added for the russet-colored trees and for the warmer parts of the hedge. The distant hills were then established using a flat wash of ultramarine with a little light red, and I had no difficulty in carrying this right up to the ragged outlines of the trees. A little raw sienna was added to the lower slopes.

The village green was a broken wash of Winsor blue and raw sienna, and when it was dry, I added some texture with a large brush charged with a deeper mixture of the same colors. A wash of Payne's gray and raw sienna was applied with horizontal strokes to indicate the dappled shade on the left and the shadow cast by the line of the hedge.

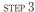

The pale stonework of the little church was raw sienna, modified slightly with burnt sienna and ultramarine. Various combinations of burnt sienna and light red were used for the sunlit old tiles and brickwork, with a touch of green in the lower parts. Notice how these pale washes contrast with the deeper tones of the background trees and the shadowed elevations of the buildings. I painted the shaded side of the old barn in deep tones of ultramarine and light red with a little green

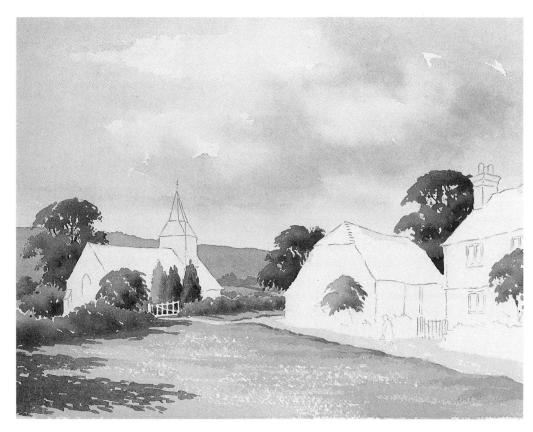

added at the base and took care to paint around the outline of the white gate, which makes a crisp accent against its dark background.

Finally, I added the small blue figure that appears to be moving, slowly, into the center of the painting.

3 Putting It in Perspective

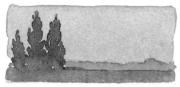

A fundamental problem that faces all painters is how to convey in two dimensions a scene that exists in three. In early times, artists had to rely entirely on observation and convention, and consequently the perspective of many of their

paintings was by modern standards somewhat eccentric. In Renaissance times, a system of linear perspective was developed, based on geometric constructions, and an understanding of this ingenious yet basically simple theory enabled artists to solve their problems without difficulty. In practice, experienced artists still rely mainly on observation, for a drawing based entirely on geometry would appear somewhat mechanical and unnatural. At the same time, a knowledge of perspective construction makes it possible for them to check their work and iron out any difficulties that may arise.

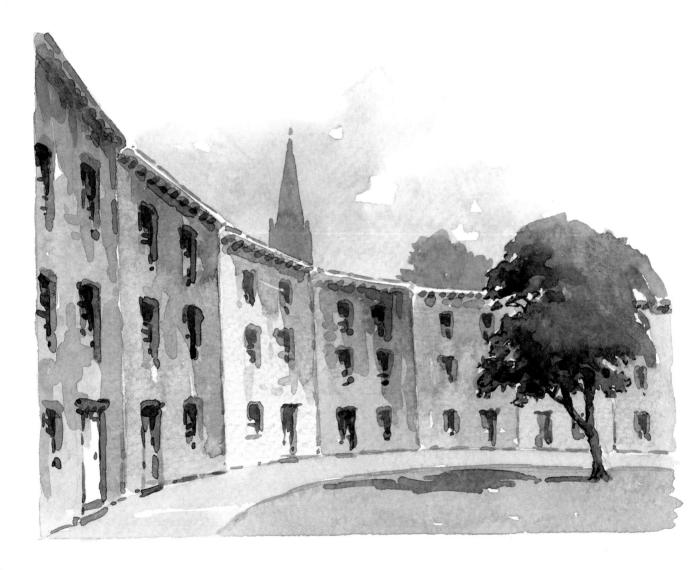

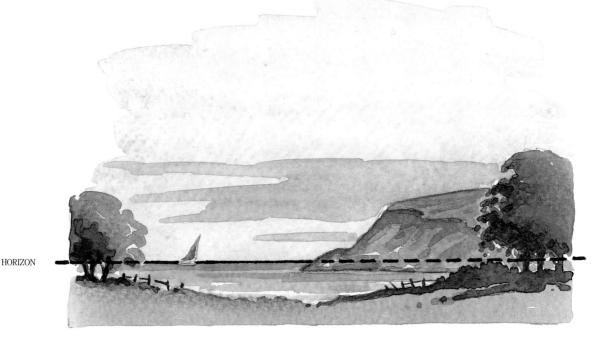

In this watercolor sketch, the sea horizon coincides with the true horizon. In the right-hand half of the illustration, the true horizon is obscured by the cliff and foliage. Here, the difference between the true and the observed horizons is obvious, but this is not the case in much flatter terrains.

LINEAR PERSPECTIVE

The theory of linear perspective is based upon the observable fact that objects of similar size appear to get smaller as they recede into the distance. Let us consider the case of a straight line of fence posts, all of equal height, on a level plain. They will appear to get smaller as they recede, until they become so small they disappear altogether. The lines connecting their extremities will be straight and will converge at a point on our eye-level line, or horizon, known as a *vanishing point*. These lines are

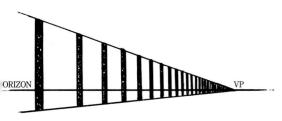

in fact parallel, since the posts are all of equal height, and yet the effect of perspective is to make them converge. Notice that one of these lines, the one joining the tops of the posts, is *above* eye level and slopes *down* to the horizon. The other, which is *below* eye level, slopes *up* to the horizon.

We must be quite clear what we mean by the term *horizon*, or *eye-level line*. Only in cases of a large expanse of calm water or a totally flat plain will the observed horizon be identical with the true horizon. In practice, mountains, hills, buildings, trees, and so on obscure the true horizon, which then becomes an imaginary line.

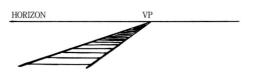

If we take the case of a straight run of railway track, also on a completely level plain, we will find the two lines converge, meeting at a vanishing point on the horizon, as in the figure above. From these models we can conclude that all lines that are parallel and on the same level plane will meet, when extended, at vanishing points on the horizon. Because the track is below eye level, the perspective lines slope up to the horizon. $\rightarrow p.40$

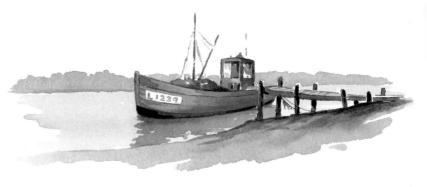

HORIZON

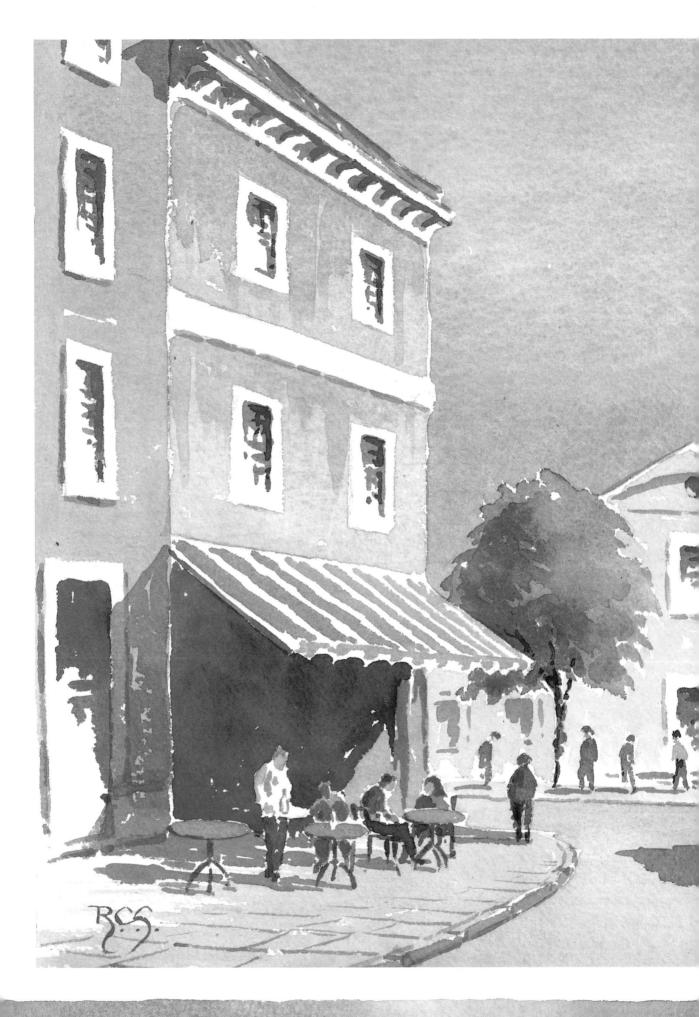

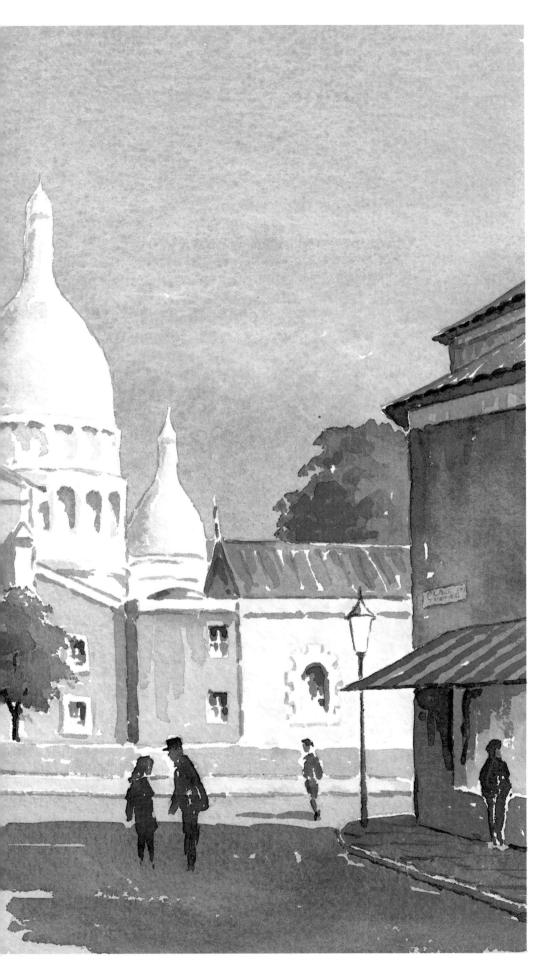

MONTMARTRE

I was attracted by the manner in which the white limestone of the church—Sacré Cæur—stood out against the deeper tone of the sky, and I was determined to preserve this contrast. The sunlit area of the stonework is just the white of the paper, and the sky is a mixture of ultramarine and light red. The wetness of the road allowed me to introduce more color and interest into the foreground than if I had been faced with dry asphalt.

Pairs of parallel lines, set at an angle to each other, will converge on the horizon, but at different vanishing points. A building, in the form of a solid rectangle, shown below, illustrates this point. Its perspective has been checked by extending, to the horizon, the pairs of parallel lines marking the tops and bottoms of the two side walls. If the drawing is correct, these perspective lines will meet at two vanishing points on the horizon, as here.

Notice that the rectangular windows also conform to this construction. Another point to note is that these parallel lines appear much steeper in buildings that are nearby than in those that are more distant. In the latter case, these lines will appear much more horizontal and will meet only at vanishing points well beyond the limits of the paper.

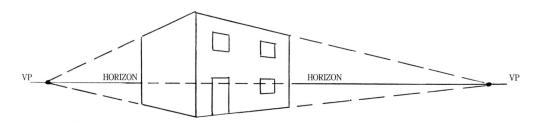

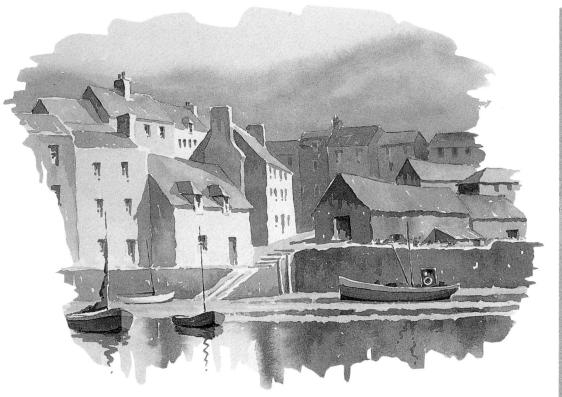

PEACEFUL HARBOR

This vignetted watercolor sketch of a jumble of harborside buildings called for a certain amount of care with perspective. When buildings are set at odd angles, they have different vanishing points. The lines of older buildings are often so irregular that the laws of perspective cannot be interpreted too literally. Careful observation of

light and shade will give your paintings of buildings additional interest as well as a three-dimensional quality and a feeling of solidity. Always look for color in shadows, and do not be content with an overall gray. If you look carefully at the shadows in this painting, you will see they contain a variety of colors and, here and there, evidence of warm, reflected light.

BY THE LAKE

The effects of aerial perspective are apparent in this watercolor sketch. The distant mountains are blue-gray in color, and this makes them recede. The foreground colors, by contrast, are warmer and much stronger, and this brings them forward. Notice how the rainstorm makes the hill behind appear even paler and mistier. Notice, too, how

the far shore and even the nearer shore are virtually straight lines the combined effects of distance and a low viewpoint.

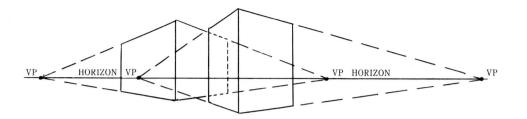

In the diagram above, the two buildings are set at different angles, so each house has a different pair of vanishing points, though these points are, of course, all still on the horizon, or eve-level line. In all these constructions, the vertical lines remain vertical and are not affected by perspective. This is because our line of sight is level. Only if we are looking up or down will the vertical lines appear to converge.

It must be remembered that buildings have to be regular in shape and level in construction for this system of linear perspective to work. Older buildings, with very irregular and wayward lines, do not conform in this respect, and then we have to rely on observation. There are other cases, too, where geometric construction cannot help us, and here again, the only answer is careful observation; there is, for example, no $\rightarrow p.44$

Artist's Tip

If you cannot check the perspective of the subject matter with linear constructions, it sometimes pays to view your work in a mirror—the nature of the perspective error (if there is one) may at once become apparent.

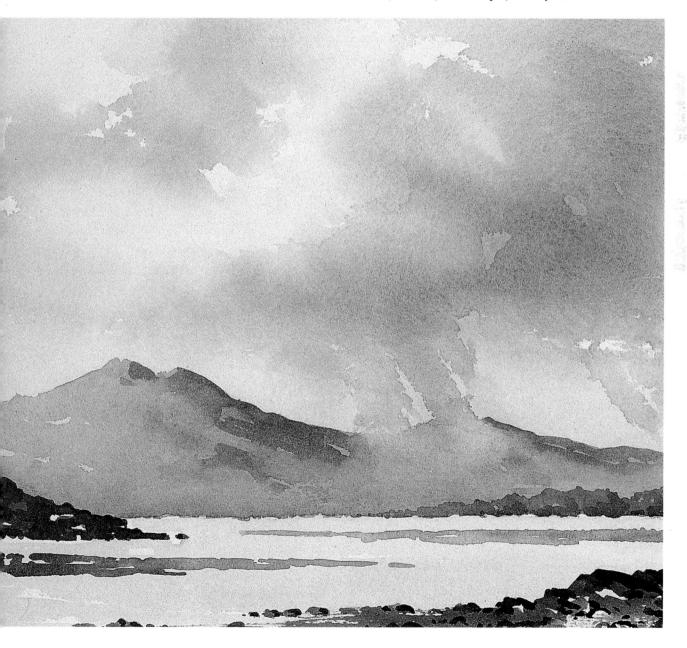

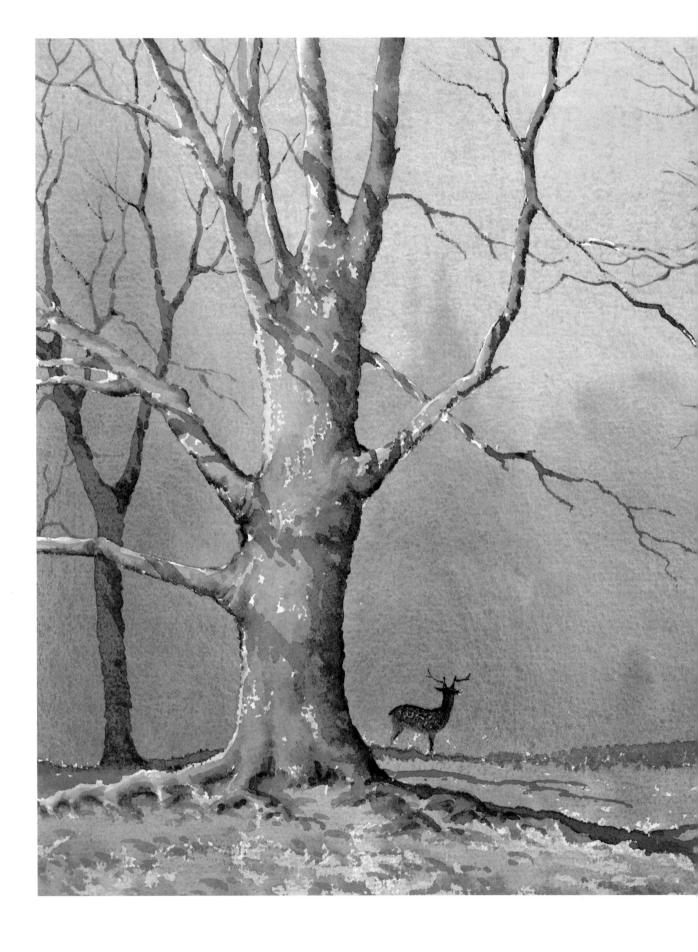

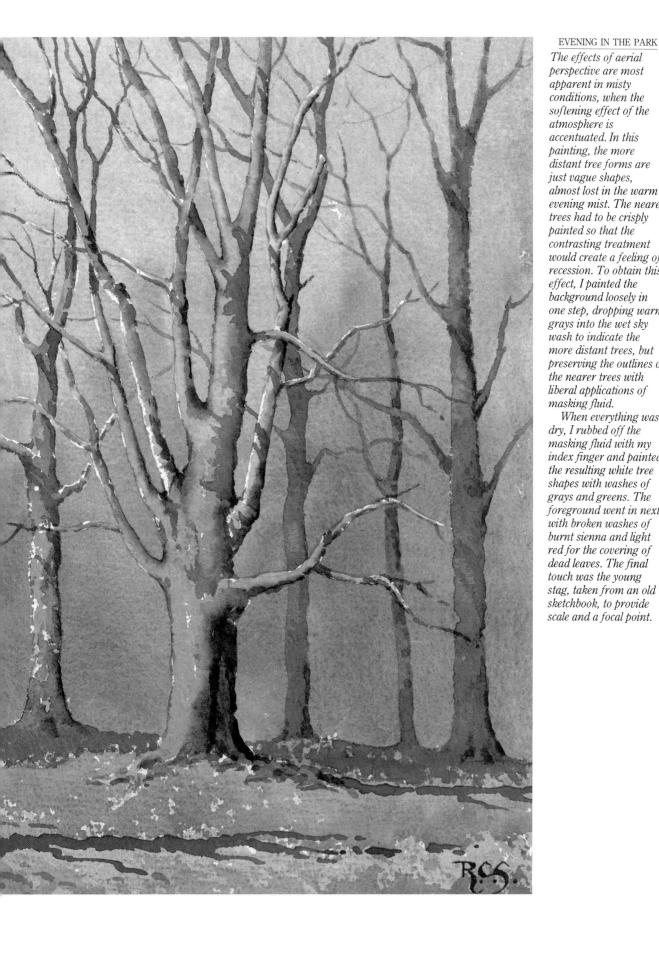

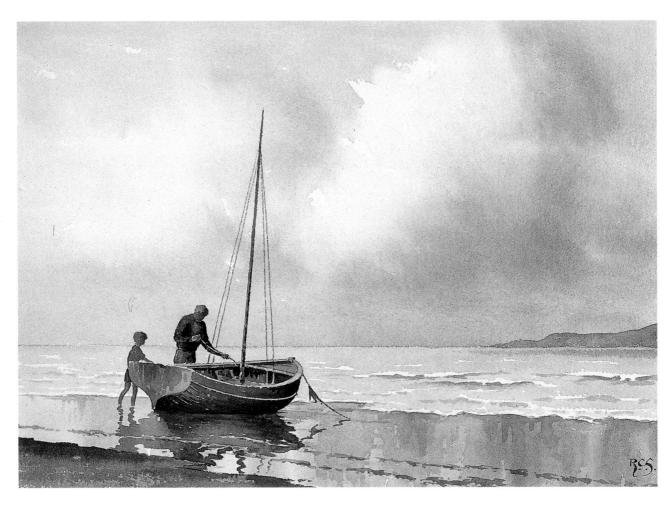

construction by which you can check the accuracy of your drawing of the lines formed by the banks of a river, but you will quickly realize that something is drastically wrong if the water in the painting appears to be flowing uphill!

AERIAL PERSPECTIVE

If your drawing is correct, your work will appear to have depth, and objects will appear to recede convincingly into the distance. The effects of linear perspective will be strengthened by what is known as aerial perspective. The effects of aerial perspective stem from the fact that the atmosphere contains dust and water vapor, as we have already noted, and this softens the colors, the tones, and the outlines of distant objects. Objects in the distance appear to lose their real colors, which are replaced by soft blues and grays, while tonal contrasts are much reduced or often lost altogether. This progressive softening and graying of objects as they recede into the distance contrasts with the warmer, stronger colors and far more definite tonal contrasts of the foreground. Aerial perspective reinforces the effects of linear perspective and diminishing scale in suggesting recession and depth. It is

achieved simply by the sensitive use of tone and color.

If you have to rely upon your own observation and judgment, you can usually solve problems of proportion by measuring relative distances and size by the timehonored method of holding a pencil at arm's length. Distances can then be measured and compared by moving the thumb along the pencil's length. A common fault is to give features such as distant fields or stretches of water too much depth. If you measure their depth and compare it with that of foreground features, this error will immediately become apparent. A related fault is that of giving a distant shoreline far too much vertical variation—the effect of distance will make it appear almost a straight line.

Never begin painting if you are unhappy with the perspective of your preliminary drawing. Paint has an uncomfortable habit of accentuating faults rather than obscuring them! Some artists deliberately distort perspective to create dramatic emphasis, and this is perfectly legitimate. More questionable, to my mind, is the practice of violating the laws of perspective merely to convey a bogus naiveté.

EBB TIDE

On one visit to the coast, I was attracted by the reflection of the boat and the figures in the shallow water and wet sand. Notice how their strong, warm colors contrast with the soft gray of the distant headland, and how the straight line forming the base of that headland contrasts with the wavier horizontals in the foreground.

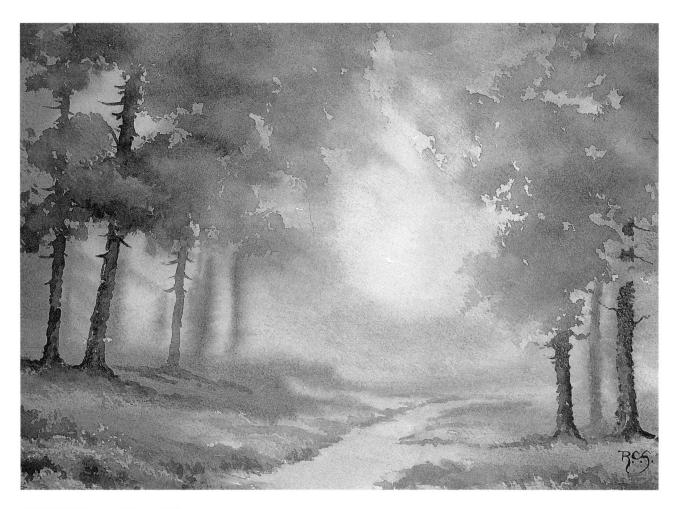

EXERCISES TO TRY

It is useful practice to draw a few solid rectangular shapes, with an indication of the true horizon, or eye-level line—and then test your accuracy in the manner described below:

- 1 Draw a rectangular building at an angle, showing two elevations, so that it is all *above* eye level.
- 2 Repeat, but with the whole building *below* eye level.
- 3 Repeat, with your eye level about halfway up the rectangular building.
- 4 Check the accuracy of your drawings with the perspective construction. Did your vanishing points fall on the true horizon?

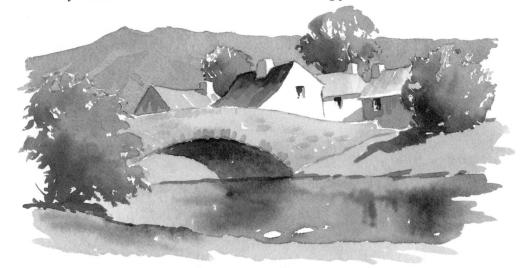

MISTY WOODLAND

In foggy or misty conditions, the effects of aerial perspective are much more apparent, as you would expect. In this study of misty woodland, only the nearest features are at all hard-edged, and the rest quickly lose definition as they recede.

This painting began with a pale wash of liquid raw sienna, plus a little light red, in the center of the paper. To this, slightly deeper surrounding washes of gray-green were added. As this variegated wash began to dry a little, the forms of nearer trees were added, wet in wet, and as the paper was still damp, they had soft edges. Only when everything had dried did I put in the foreground trees, which of course retained their hard edges.

DEMONSTRATION

CALM ANCHORAGE

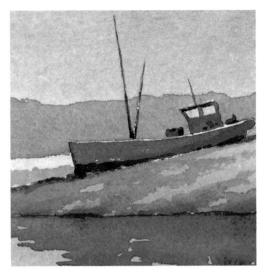

Coastal scenery has a great deal to offer the watercolorist, and sheltered inlets with boats at anchor have a particular appeal. In this scene, the tumbledown fishermen's huts add to the attraction and, with their old brick and tile and rusty corrugated iron, are a source of rich, warm color which contrasts effectively with the blue-gray of the distance, to create a strong feeling of recession. Although most of the tonal weight is on the right, the moored yacht on the left provides adequate balance. Notice how the distant shore is virtually a straight line.

Palette

raw sienna light red ultramarine burnt sienna Winsor blue

STEP 1

The warm colors and soft cloud formations of the early evening sky appealed to me, so I once again decided upon a low horizon, roughly onethird of the way up the paper. There were many more boats than I have included, but I felt this simplification was justified, producing a balanced composition. The near spit of land and the distant line of low hills serve the useful purpose of linking the various boat shapes together, while the vertical masts connect the planes of sea, land, and sky. In a composition such as this, in which these elements form three horizontal bands across the paper, masts can perform a useful connective function.

Once I was satisfied with the lines of my sketch, I mixed four washes for the sky: very dilute raw sienna warmed with light red for the sunlit areas of

cloud; two grays, a warm and a cool (from mixing ultramarine and light red in different proportions) for the cloud shadows; and pale Winsor blue for the area of clear sky. I applied these washes quickly and directly with large brushes. A few odd chinks of white paper remained untouched, but I made no attempt to cover them up as I felt they prevented the sky from appearing too smooth and bland. I

brought the warm gray of the lower sky down over the distant hills, but painted around the huts on the right.

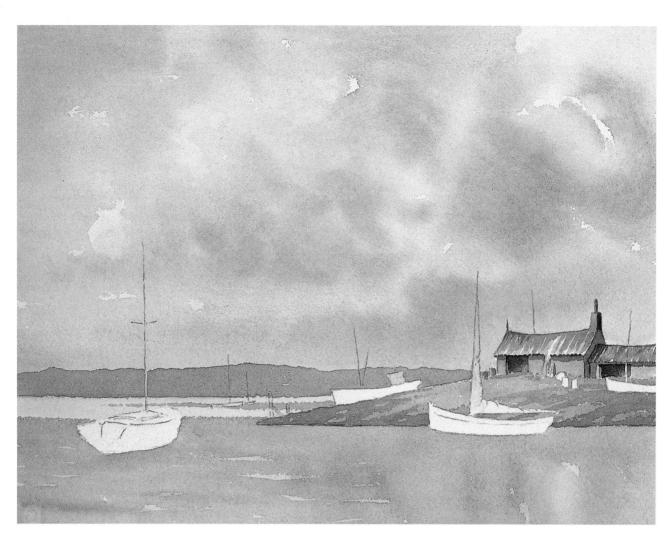

STEP 2

Once the sky had dried, I applied a pale wash of ultramarine and light red to represent the distant estuary, and a deeper wash of the same colors for the far shore and its thin line of reflection below. The nearer, smoother water was a warm gray with some soft wet-in-wet vertical and horizontal additions in cooler gray. The fishermen's huts went in next in warm tones, mainly burnt sienna and light red, to represent brick, tile, and rusty corrugated iron. Notice how the brushstrokes follow the slope of the roofs. The rough grass was a pale mixture of raw and burnt sienna plus a little ultramarine, and when it was dry, I added a texturing wash of the same colors.

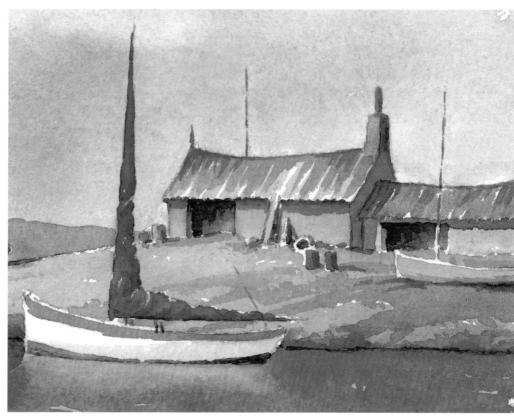

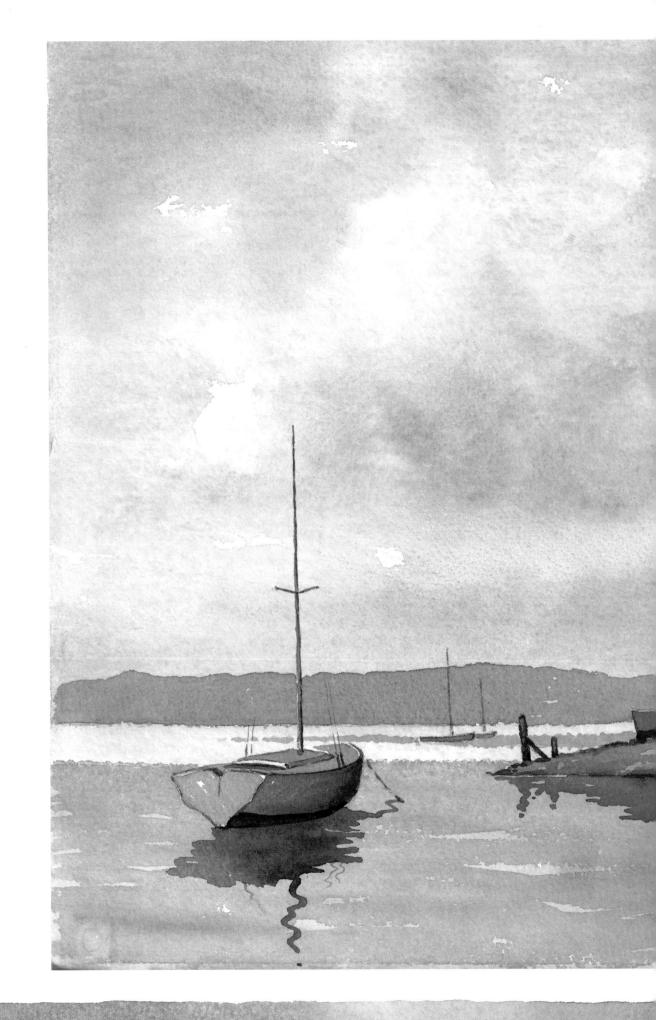

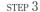

I now started painting the boats in a variety of tones and colors, the moored yacht on the left in a fairly deep color to provide tonal balance, and the boat just below the hut in pale tones to help it register against its somewhat darker background. When all this detail was complete, I prepared pools of color for the reflections, which I planned to tackle in single washes, varying the color as I went. The colors corresponded with those of the objects above, but were generally deeper in tone, with a green tinge that echoed the local color of the water. When painting reflections of this type, remember that the distant ripples are more foreshortened than the nearer ones due to the effect of perspective.

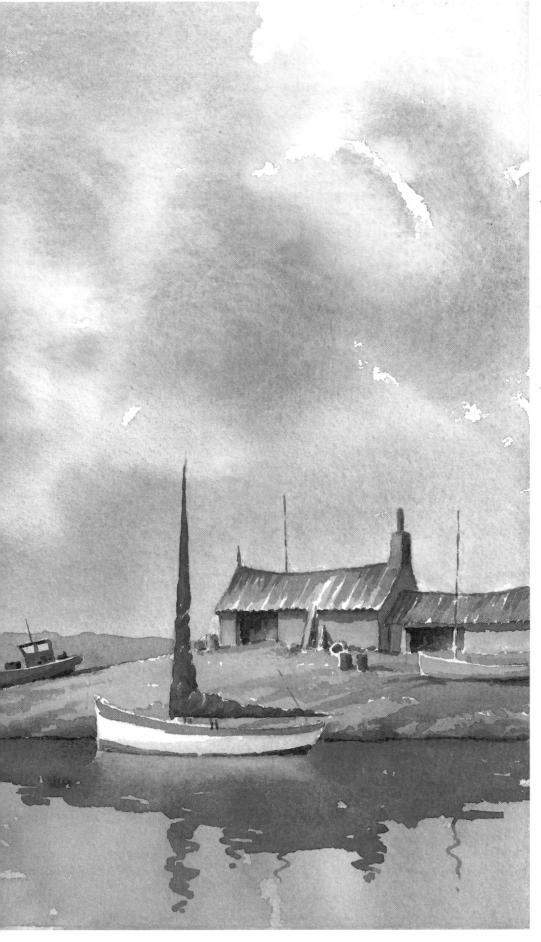

4 Composition and Balance

However skilled one's watercolor technique may be, the resulting painting can never be satisfactory if the composition is faulty. The vital importance of good composition is universally recognized, and yet it is a goal that many competent

painters find hard to achieve. Let us consider for a moment just what composition is and try to strip away some of the accumulated mystique.

Quite simply, composition is the arrangement of the elements of a painting on paper or canvas. Good composition results when these elements are arranged in a harmonious and pleasing manner. People vary widely in their ability to recognize or formulate good composition, but in my experience most people who are attracted to art have a natural feeling for form and balance and, if they are encouraged and taught well, soon begin to develop a sound sense of design.

THE POSITIVE APPROACH TO COMPOSITION

There are two approaches to the study of composition, one positive and one negative, and both have their value. The positive approach is naturally more concerned with what to aim at rather than what to avoid, and we shall deal with this first. Let us begin by considering more fully what we mean by *good composition*; it is the pleasing and harmonious arrangement of the shapes, the colors, and the tones of a painting within the rectangle of the paper or canvas. If we look

at a painting, concentrating on form and trying to ignore subject matter, we can begin to see it as a design rather than a picture, an arrangement of shapes and colors that together make a pattern. Patterns can be pleasing and satisfying or the reverse, or perhaps something not very striking between the two extremes. The first step in improving the composition of your work is to recognize that the arrangement of the elements on the paper needs far more care and consideration than it normally receives. Thus we need to give much more thought to what has been called picture organization.

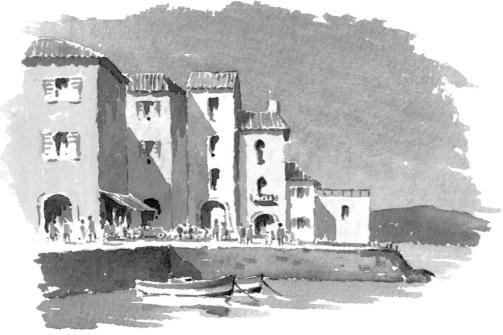

FARM BUILDINGS In this painting, the farm buildings overlap and so relate to one another, while the deeptoned trees behind provide useful contrast. The variety of building materials adds to the interest, and the old brick and tile, and the painted and rusty corrugated iron, all provide opportunities for using rich color. The winding farm track leads the eye into the painting, and the deep-toned tree on the left and its equally deep reflection in the pond help to balance the composition.

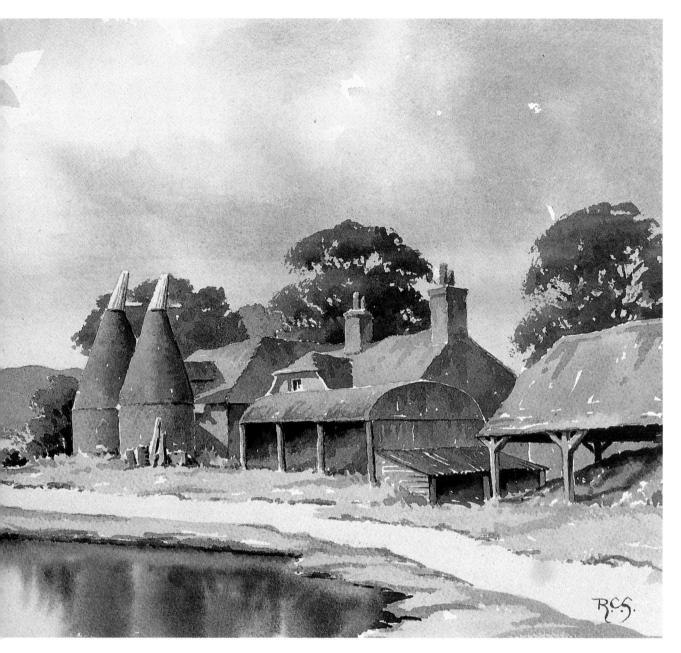

PRELIMINARY WORK

Design is easier to assess if it can be considered without the complicating intrusion of subject matter, and this consideration is best applied when your planning is still in a fairly fluid state—it is much too late once the drawing is complete and the painting has begun.

I always make several rough sketches of my subject from various angles, using a viewfinder (*see* page 65), in an attempt to discover the most suitable vantage point and the most attractive arrangement of the elements of that subject. This is the stage at which to think about design. One way to concentrate attention on the pattern of the chosen sketch is to outline in black, perhaps with a broad-tipped marking pen, the various elements in that sketch, remembering that

negative shapes (the shapes between objects) are just as important as positive ones (the shapes of the objects themselves). These elements will all vary in size, shape, and tone, and the resulting pattern will be much easier to assess in terms of balance and harmony if you regard it simply as a pattern. It would be more helpful still if the rough layout has color as well; I know several artists who add both color and tone to their rough work to help them in their search for good composition. However, I find a great deal can be learned from black and white alone. If the bold design that emerges has balance and harmony, these qualities will be apparent in the finished painting, though in a less obvious form. If, on the other hand, the pattern is less pleasing and lacks balance, that is the time to reassess its arrangement

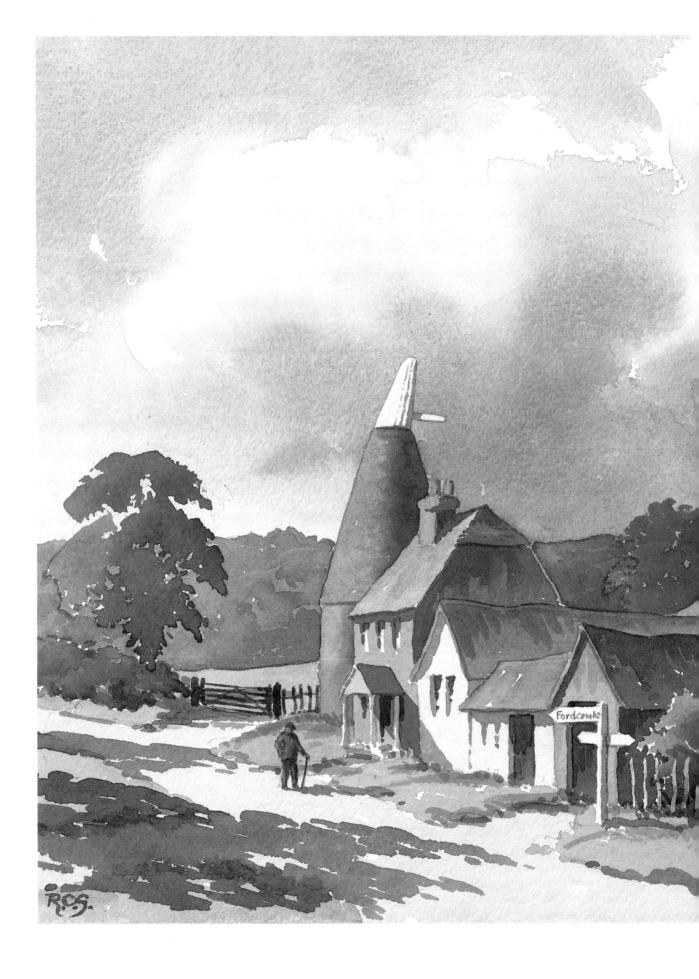

This is another example of a group of farm buildings with a variety of shapes, colors, and textures combining to form a pleasing, rather than a perfect, composition. There is an attractive overlap of shapes and plenty of tonal contrast, but there is, unfortunately, nothing to stop the eye from following the line of road straight off the painting to the left. A larger sheet of paper would have made possible the inclusion of a group of trees, which could have performed that useful function and acted as a "stop."

and organization. A little experimenting and trial and error at this stage is well worth the effort. The urge to get on with the painting is strong, but it must be firmly resisted until you are certain your composition is both pleasing and balanced.

USING THE GOLDEN MEAN

In the past, when many artists worked exclusively in the studio, it was common practice to base compositions upon definite geometric forms, and although the underlying constructions were usually softened and modified during the painting process, the basic framework remained—as can be seen in many of the great paintings of the past.

One development of this geometric approach to composition was the use of what became known as the divine proportion of the golden mean, or golden section. This concept, originally invented by the Greek geometrician Euclid, was an attempt to divide a line in an aesthetically perfect manner. Today, artists rarely plan their work on a rigid Euclidean framework, but it is true that many of the more satisfying compositions of the masters have significant points close to the golden mean, also known as the golden section.

THE GOLDEN MEAN 13

A line is divided into two parts so that the ratio of the smaller to the larger is equal to the ratio of the larger to the whole line. In practice, this means dividing the line in the ratio of approximately 8 to 13. If the lines forming the sides of a rectangle are divided in this ratio, the construction will appear as above.

If the dividing points on these lines are then joined to corresponding points on the opposite sides of the rectangle, their intersections, at points 1, 2, 3, and 4 in the diagram, are held to be of special significance, and the theory states that important points in the composition should be placed on or close to them.

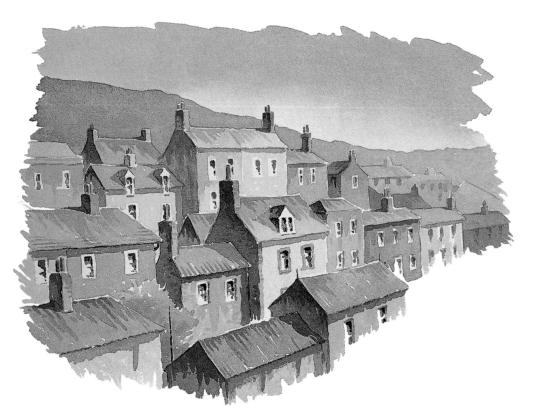

Even when the buildings in a painting are

TOWNSCAPE

arranged in straight lines and are all facing in the same direction. variety of form and diversity of color in the buildings themselves can combine to produce interesting patterns. In this painting, the high viewpoint aids the composition, and the diversity of colors and tones adds interest.

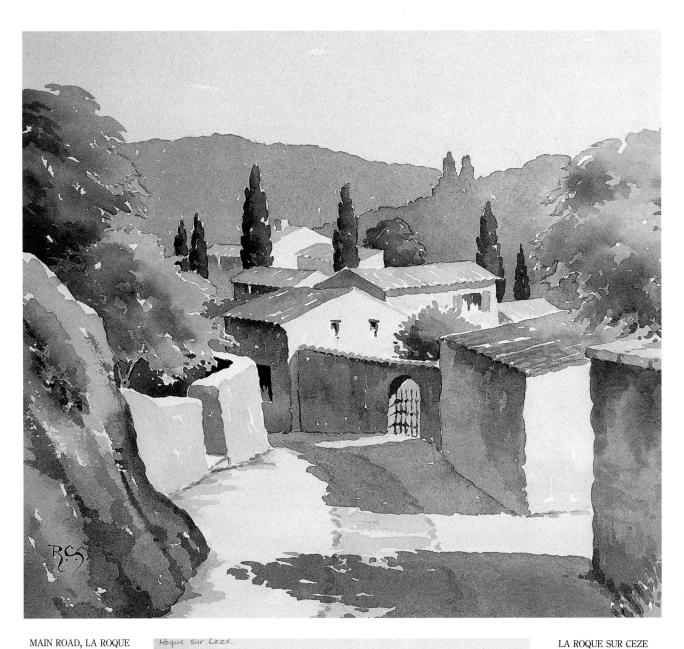

The jumble of tiled buildings in this delightful Provence hill village offers the artist a wealth of attractive compositions. Here, the sunlit and shadowed elevations of the buildings produce an interesting pattern, while the lateral shadows help to break up the rather large expanse of foreground road. The vertical forms of the cypress trees contrast pleasantly with the mainly horizontal lines of

the tiled roofs.

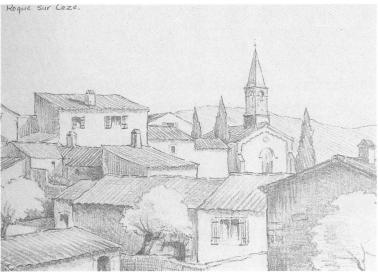

This panorama of jumbled, tiled roofs was the view from a bathroom window. I sketched it quickly with a pencil and made the most of the verticals of the belfry and cypress trees. I later used this sketch as the basis for a watercolor in which one of my objects was to do justice to the rich colors of the tiles and the warm, reflected light in the shadows.

THE NEGATIVE APPROACH TO COMPOSITION

The negative approach to the formulation of good composition naturally hinges on things to avoid, and some artists find a list of unambiguous "don'ts" of greater help than the more nebulous precepts of the positive approach.

What, then, should we try to avoid in our quest for sound composition? A number of examples of poor arrangement are illustrated in the left-hand column below, with my suggested corrections on the right. There are

many ways in which you can disobey the laws of composition, but those I have shown seem to occur most frequently. Perhaps I should not use the term *laws* in this context, for these precepts do not have the force of the Ten Commandments. I can think of many successful paintings that break the rules, but there is nearly always a good reason for this, and it still makes good sense to observe them whenever possible.

Faults often creep in if you begin to apply paint before fully working out your composition, so do not let your keenness to start painting tempt you to cut corners!

FAULT

Horizontal line placed halfway down the paper; this is often the horizon.

SOLUTION

The horizon looks better if placed either higher or lower, depending on the focus of interest.

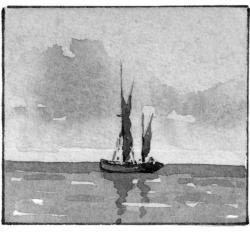

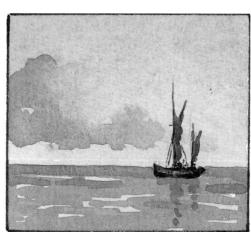

FAULT

Dominant vertical feature halfway across the paper.

SOLUTION

It is much better to move the object to one side of the center.

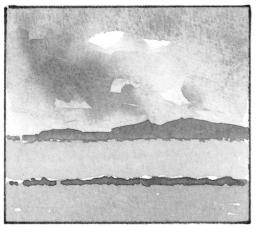

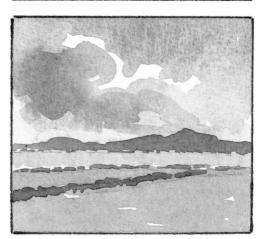

FAULT

Large area divided into two equal strips, such as a foreground field.

SOLUTION

A division that creates larger and smaller sections is more pleasing to the eye.

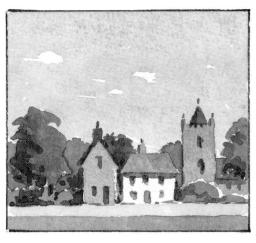

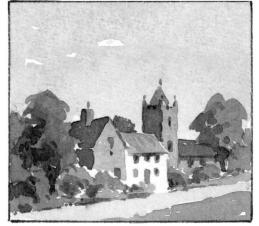

FAULT

Objects appear to be strung out in a straight line, without a connecting link.

SOLUTION

Adopt a viewpoint from which there is some overlapping and some relationship between individual objects.

FAULT

A dominant line emanating precisely from the corner of a painting.

SOLUTION

Revise the composition so that important lines no longer originate in the corner of the painting. Modify lines of excessively regular fencing.

Important feature (for example, a building) positioned so that it appears to be resting on the bottom edge of the paper.

Simply plan ahead to avoid this situation—place the object some way above the bottom.

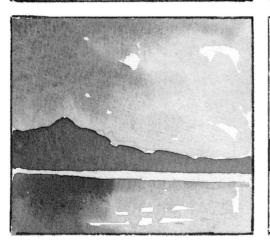

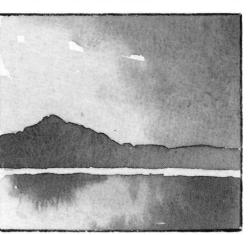

FAULT

All the tonal weight appears on one side of the painting.

SOLUTION

If the deep tones all occur naturally to one side of the composition, balance them by including some tonal weight on the opposite side—for instance, heavy cloud shadows.

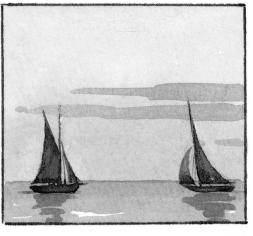

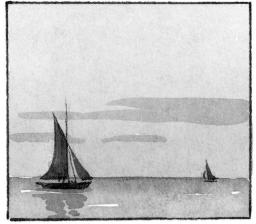

FAULT

Two competing centers of interest.

SOLUTION

Concentrate attention on one center of interest, and sacrifice anything else that might detract from it.

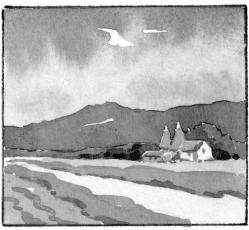

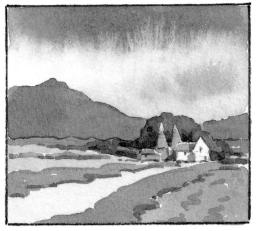

FAULT

The viewer's eye is drawn away from the center of interest by the compositional lines.

SOLUTION

Arrange the painting so that all elements draw the eye toward the center of interest.

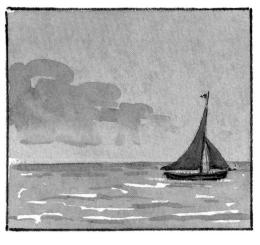

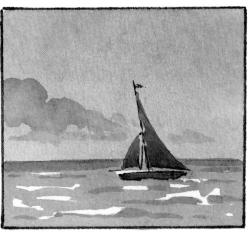

FAULT

The viewer's eye is drawn off the paper, here by the sailboat.

SOLUTION

Turn the boat around so that it sails into the picture!

Quite a lot to remember! The danger is that the careful observation of so many rules may lead to dull, conventional compositions, and that is just as bad as employing compositional ploys that are obvious and totally lacking in subtlety. In striving to achieve balance, do not overdo it and end up with too much symmetry. Remember that rules *can* be broken, but only if there is good reason to do so. Above all, in aiming for harmony and balance, do not sacrifice interest and impact.

Now try this "negative" approach for yourself. Cover the captions opposite, and see how many compositional faults you can find in the top painting. Then look to see how many are present. The lower painting demonstrates how an artist can improve the same view by applying a few basic rules of composition. Have a close look at what I have done before going on to try out a few compositional exercises.

(Above)
There are several
compositional
shortcomings in this
sketch of a village street.
The flat, four-square
view lacks interest and
results in the buildings
being strung out in a
straight line. The strong
vertical of the church

tower is at the very center of the group, exactly behind the half-timbered gable. The pale, unbroken strip of the foreshortened road cuts right through the composition and carries the eye off the paper at both ends.

(Below)
Here, the oblique
viewpoint results in a
more pleasing
arrangement, with the
buildings overlapping
one another and so
forming more positive
relationships. We can see
the shadowed sides of
several houses, so there

is more opportunity for tonal contrast. The church tower has been moved to the left and is balanced by the tree on the right, which also stops the eye from sliding off the paper at that point. The road is no longer a straight strip of uniform width, and it

is broken by the shadow of the tree. Even the red mail truck is moving into the picture instead of out of it.

EXERCISES TO TRY

Using a 2B or a 4B pencil, test your natural skill at composing a pleasing and balanced arrangement:

- 1 Make a quick sketch of a group of buildings and trees in your neighborhood.
- 2 Are you satisfied with the composition? If not, list any compositional faults you can spot.
- 3 Repeat the critical process, this time using the list of ten things to avoid mentioned on pages 56–58. Have any more faults come to light?
- 4 Redraw your subject, correcting any faults in your sketch.

OLD COTTAGES

The unplanned and unregulated growth of villages often resulted in attractive groupings and pleasing natural compositions. This village group, clustering around its medieval church, is a delightful example, and the varying angles and asymmetrical lines of the old stone cottages produce a pleasing pattern, which is helped by the gravestones and bushes in the foreground and the darker-toned trees in the background. The church is in shadow and is balanced by the shaded sides of the cottages on the right, while the gravestones, in sunlight and in shadow, add interest to the foreground.

gravestones, in sunlight and in shadow, add interest to the foreground I made several quick sketches from various angles, and each had its advantages, but I finally decided that this view produced the most pleasant

Palette

raw sienna light red ultramarine Payne's gray burnt sienna Winsor blue

STEP 1

composition.

It was a warm afternoon in late September, and the cloudless sky simply required a variegated wash of pale Winsor blue with a little raw sienna lower down. I sometimes introduce imaginary clouds if I feel the sky needs extra interest, but here there was a lot of detail in the scene below, and a very simple sky made a pleasing contrast. I prepared two washes, one of Winsor blue, the other of raw sienna. With a 1-inch (2.5-cm) flat brush, I began applying the blue at the top, as described above, and about halfway down started dipping the brush in the raw sienna wash, producing a gentle gradation of color. There was still some blue in the

lower sky, as intended. I had no difficulty in painting around the

outlines of the various chimneys, but if you find this a problem, they

could easily be preserved with the aid of masking fluid.

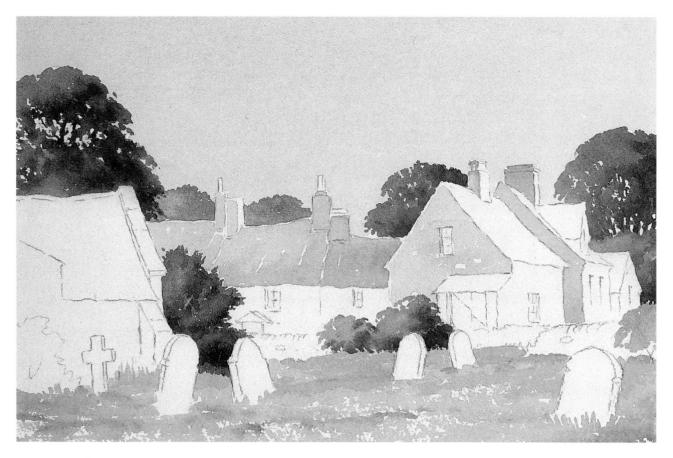

STEP 2

The stone walls and tiles were a pale honey color, which called for a subtle mixture of raw and burnt sienna, light red, and ultramarine. Their tone was only a little deeper than that of the

sky, but this did not matter as there was plenty of deep-toned foliage behind them. The more distant trees were blue-gray with just a hint of warmth, but two of the nearer ones were distinctly autumnal in coloring, and for them I used raw and burnt sienna and Payne's gray.

The greener, righthand tree was just raw sienna and Payne's gray. I applied broken washes of these colors, using the side of the brush in order to take full advantage of the roughness of the paper, and added deeper tone, wet in wet, on their shadowed sides. The foreground bushes were tackled in a similar manner, but the yew

tree contained a higher proportion of Payne's gray. The foreground grass was a broken wash of Winsor blue and raw sienna.

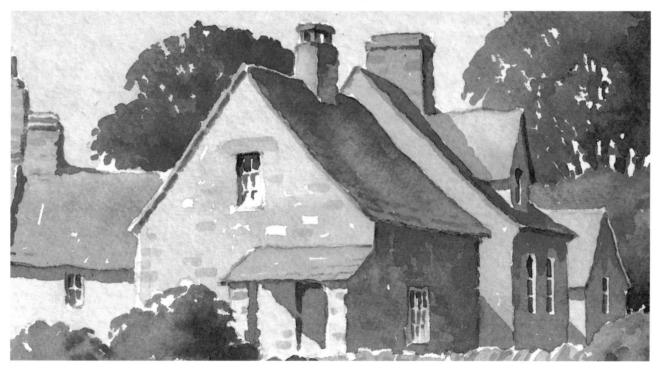

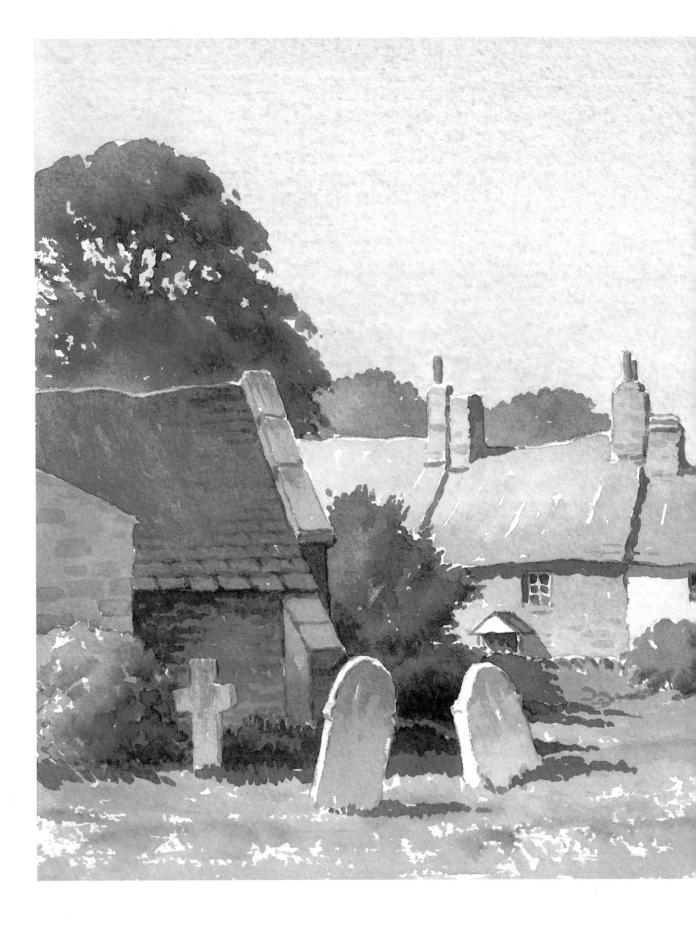

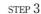

My next step was to paint the cottage walls in a variety of pale tones and add deeper accents for the shadows cast by chimneys, roofs, and eaves. The shaded sides of the cottages and the church on the left, went in next in washes of ultramarine and light red, modified here and there with burnt sienna and green. I added a few random stones to the cottage walls and the merest suggestion of the courses of the stone roof slates. The church, being nearer, received slightly more detail. I treated the gravestones very simply, with a little dry brushwork indicating their green weather staining. The shadows on the grass were a mixture of Payne's gray and raw sienna, and they helped to pull the foreground together.

5 Choosing and Developing Subjects

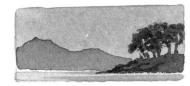

Beginners can make life difficult for themselves by choosing unsuitable subject matter. They are naturally attracted and impressed by magnificent views and grand panoramas, but lacking experience, they do not always appreciate the demands such

subjects can make. They try to include everything in the complex scene before them, only to find their painting quickly becomes overworked and labored. There is no reason why they should not choose impressive landscapes as their subject matter, but if they do, they should realize that the key to success lies in simplifying and concentrating on the broad effect rather than recording detail. Watercolor is the ideal medium for capturing the atmospheric tones and colors of the landscape, but its beauty and freshness are all too easily lost through worrying over unnecessary detail. It is often better to select a small part of a spectacular view than to attempt to capture the entire panorama.

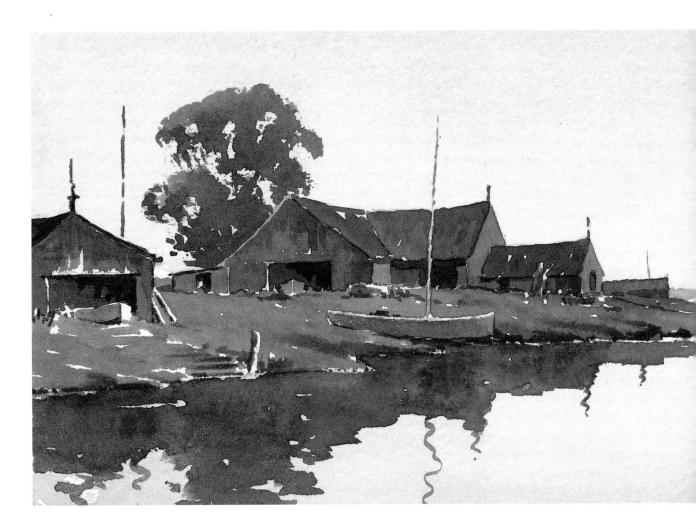

CHOOSING SUBJECTS

Students who experience difficulty in finding suitable subject matter for painting sometimes ask me how I go about choosing subjects for my own work. It is not an easy question to answer. To some extent, if you can cultivate an inquiring mind, subjects choose themselves, and in time experience will tell you the type of subject that lends itself to watercolor treatment. It is a mistake to set out on a painting trip with too fixed an idea of what you hope to paint, for that ideal subject can be frustratingly elusive. Far better to train yourself to be receptive and sensitive to artistic stimuli of all kinds, for if you succeed in doing this, you will never be short of subjects to paint.

The best advice I can give on the question of choosing subjects is to paint what appeals to *you*. Do not be put off by the knowledge that a particular subject has been painted many times before by other artists and may be regarded by some as hackneyed. It will be an artistic cliché only if your treatment is too conventional and uninspired, not if you have something fresh and personal to say about it. At the same time, you will probably do better to find something more

VIEWFINDER

A simple viewfinder can be an invaluable aid to separating promising compositions from their complex settings. The type of viewfinder I have in mind is simply a piece of cardboard—perhaps a piece of mat board—with an opening about the size and shape of a postcard cut from the center.

When it is held up against a broad panorama, it helps you to isolate likely subjects by blotting out their surroundings. You can vary the extent of the view within the frame simply by moving the viewfinder toward or away from your eye, and the resulting variation in scale relative to the frame

will help you discover a pleasing composition.

The usefulness of this simple device is not confined to panoramic landscapes —it can be equally helpful in locating likely sections of more modest scenes. If you have not yet used a viewfinder, I would urge you to try one.

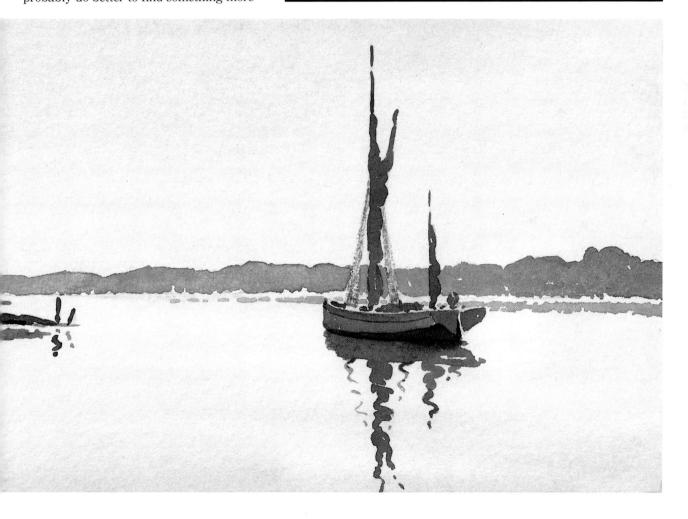

original for yourself. Do not confine your search to picturesque subjects that you know will prove popular (and, perhaps, salable), instead, look for interesting compositions that may well be formed by everyday objects.

I was recently giving a lecture to the members of an old established art club, and it soon became evident that there had been a club outing to a local well-wooded beauty spot. There were a number of paintings of excellent standard of this woodland scene, and it was interesting to see how many of the members had placed a small figure, dressed in red, against the predominantly green background—no ignorance of complementary color theory there! The majority of the paintings were perhaps a little predictable, with a woodland path leading the eye into the heart of the leafy landscape, flanked by carefully placed trees on each side. I could not escape the feeling that the artists had been so impatient to get down to their paintings that not enough time or thought had been given to the search for more interesting and powerful compositions.

The painting that caught my eye was a glimpse of a sun-dappled glade, viewed

through the tracery of a nearby bush and the bold verticals of a few saplings in the foreground. The arrangement of the passages of sunlight and shadow produced strong tonal contrasts, which reinforced the lively and original composition, and although the painting was perfectly representational, I was struck by its strongly developed pattern before becoming aware of its subject matter. The artist, as I expected, had a strong feeling for design, and this was equally apparent in the other paintings he showed me.

Such original and highly individual treatment of a familiar scene is usually the result of thorough observation and a determination to get the feel of the subject. If, on the other hand, the observation is cursory and superficial, the resulting painting will in all probability be tame, uninspired, and rather obvious—however skillful the painting technique. When an artist has studied his subject profoundly and made an effort to look beneath the surface, his painting will have far greater depth. It will reveal something of what he felt, and this can invest the most ordinary subject with magic.

Artist's Tip

Watercolor painting is an attempt to capture the living atmosphere of a scene, using inanimate materials but brought to life by the painter's skills and imagination. Whether you paint in the field or back in a studio, it is vitally important always to keep in mind what inspired you to tackle a particular subject.

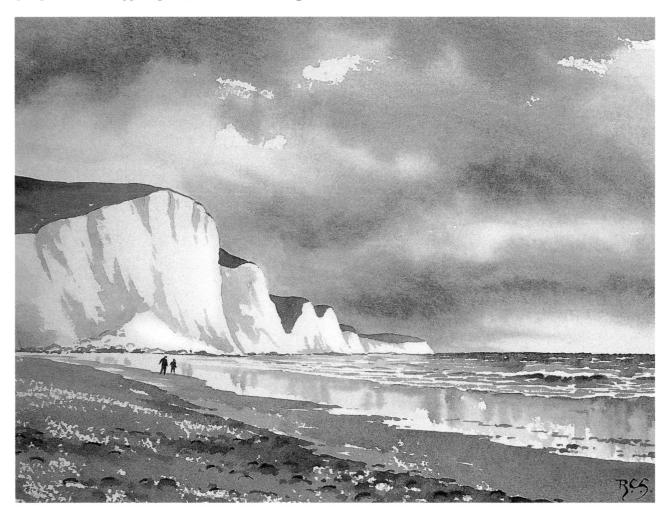

Painting is not simply a matter of reproducing accurately what we see before us—the camera can do that much more quickly and efficiently than we can. It is rather the attempt to capture the very essence of a scene through light, color, and composition. Whatever it is that moves you to paint a particular subject in the first place must be preserved at all costs, and no painstakingly added detail must be allowed to obscure it. If you aim for spontaneity and simplicity and make up your mind to omit irrelevant detail, your original idea is much more likely to shine through and convey to others something of your personal reaction to the subject.

This personal reaction to a subject can be profound, and you should take advantage of it. It may sometimes happen that you come across a scene that cries out to be painted but, despite all your good resolutions, you do not even have a sketchbook with you. Even the briefest sketch on the back of an envelope is better than an opportunity irretrievably lost, and

Purphis / Treey Doracles

Crease of Market States

Crease of Market Sta

VILLAGE STREET

you should do everything you can to get something down on paper. The sketch of the village street (above) was made at breakneck speed with a borrowed fountain pen, but with the scribbled color notes, it enabled me to produce a satisfactory watercolor.

WHITE CLIFFS In this painting I

adopted a very low viewpoint in order to emphasize the height and grandeur of this impressive formation. I also opted for a dark sky, to contrast with the shining white of the chalk cliffs. The expanse of glistening sand is a foil for the adjoining stretch of darker, drier sand and also accommodates the brilliant reflections of the white cliffs, against which the two tiny figures stand out boldly to provide scale.

Apart from its pale, gray shadows, the chalk cliffs are just untouched paper. The sea is very simply treated, with the white of the watercolor paper representing the lines of breakers. A broken wash, with a few random pebbles added, suggests the rough texture of the rocky foreground beach.

THE CASTLE

A low evening sun was just catching the ramparts of this splendid old castle when this view was painted. The sky behind was several tones deeper than the pale sea, and the dramatic scene made a perfect subject for bold and decisive treatment. The sky was ultramarine and light red, with the proportion of the warmer color increasing toward the horizon, and I applied a variegated wash, taking care to leave chips of white to denote the shining stonework of the castle. I soon realized the

sky needed to be darker than I had made it, so once it was dry, I applied a second wash, this time leaving a few wispy clouds. The sunlit stonework was just pale raw sienna, while the shadowed areas were various deep combinations of ultramarine, light red, and burnt sienna. The strip of wet sand reflected the deep tones of the castle and the lighter gray of the sky, and provided foreground interest.

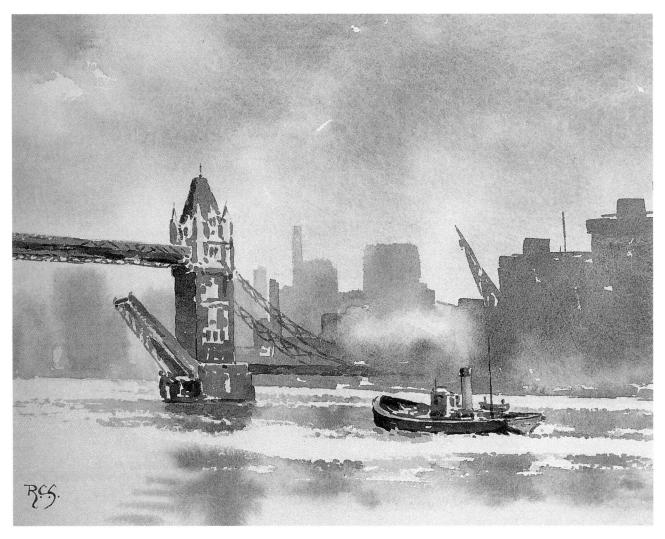

DEVELOPING SUBJECTS

Once I have decided upon my subject and spent some time studying it in depth, my approach is to make several quick sketches from different vantage points, as already described. It usually happens that one of these will produce a more interesting composition than the others, and I concentrate on it, adding tone, eliminating superfluous detail, and if necessary, varying the positions of some of the elements to produce a better balance. Some painters have a deep-seated antipathy toward altering subject matter in this way, but I have no such inhibitions. Unless there is some special reason for preserving accuracy, the demands of a harmonious composition are paramount, and if this means moving a tree or a building, so be it.

Rough preliminary sketches not only help you to work out your composition, they also assist you in planning your tonal balance and in exploring your subject in depth. How much of this information you then transfer to your watercolor paper is another matter. In the early stages, a fairly

detailed drawing will give you confidence, but, as we have already noted, the less drawing there is, the greater the chances of expressive brushwork giving your painting character and panache. A lot will depend upon the type of subject. Groups of buildings, bridges, boats, and so on call for a certain amount of fairly accurate draftsmanship if perspective and compositional errors are to be avoided. Simple landscapes of fields, hedges, and trees are another matter, and just a few lines, noting the position of the horizon and the main elements, are all that are needed.

The rough pencil drawings opposite are typical examples from my own sketchbook. You may find it helpful to make some sketches yourself of scenes from your neighborhood, featuring a street corner, a stretch of river, a farm, a pastoral scene, or anything else that takes your fancy. Tackle each subject from several different vantage points, and decide which yields the most pleasing composition. As your experience increases, you will rely less on careful drawing and more on expressive brushwork.

Artist's Tip

Shadows can be a problem—they change so quickly. The best plan is to sketch in the positions of the shadows at the very beginning of a painting, and then keep them in this position throughout, whatever the movement of the sun may do to change things.

CITY MIST

Misty landscapes are particularly fascinating for the watercolorist. and I resolved to keep this one as simple and direct as possible. I quickly painted the sky in pale, pearly colors and carried the wash down to the far bank of the river. I then began putting in the shapes of the distant buildings, using ultramarine, light red, and burnt sienna in varying proportions. The sky was still damp at this stage, so the shapes were soft-edged and misty on the left, but became more definite and deeper in tone as the background wash began to dry out. I fed in some clear water just above the tug to represent smoke.

The river itself was even more loosely suggested, and when it was dry, I painted in the bridge and the boat in deeper tones, but very loosely, to fit in with the rest of the painting.

Peaceful river scenes
usually lend themselves
well to the technique of
watercolor, for its fresh,
transparent washes are
ideal for describing
smooth, limpid water.
This painting was made
on the spot one fine day
in the fall. I was
attracted by the diversity
of colors—the russet of

the trees on the left, the gray-green of the willows, the blue-gray of the line of distant trees, and the greenish color of the smooth reflections. I worked quickly with the objective of capturing atmosphere rather than detail.

EXERCISES TO TRY

It is all too easy to concentrate exclusively on a type of subject that has a particular personal appeal. Here are a few suggestions that may encourage you to widen your horizons:

- 1 Seek out the type of urban subject that would not normally appeal to you, and make a sketch of it.
- 2 Make a quick watercolor study of the same subject.
- 3 Make a second watercolor study of the subject at dusk, with lights beginning to appear.
- 4 Use a viewfinder to isolate promising compositions in your neighborhood, and make sketches of those you like best.

THE FARMYARD

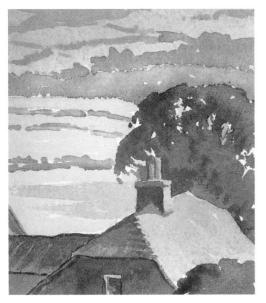

This group of farm buildings is nestled beneath a steep escarpment that affords a splendid vantage point for an interesting and unusual view of the subject. This type of viewpoint calls for particular attention to perspective, and I drew the outlines of the buildings with care. The positions of the trees and foliage were indicated, but their forms were roughly sketched, as I planned to capture their broken outlines with the brush.

This high-level view has another advantage: the painter can look down on the roofs and fields, which helps them to be seen as constituents of a strongly defined and satisfying pattern.

The geometric shapes formed by the roofs, the spaces between them, and the patchwork of fields beyond combine to produce this interesting design.

Palette

raw sienna light red ultramarine Payne's gray burnt sienna

STEP 1

A viewpoint from which one can look down upon the subject presupposes a high horizon, and here it is little more than a quarter of the way down the paper. Notice how the depth of the fields decreases with distancethe effect of perspective. If you tackle a subject such as this and wish to check the perspective of the buildings by the method described in Chapter 3, remember that it is the true horizon you need and not the apparent horizon. In this painting, the true horizon is considerably below the outline of the

distant hills.

Because the sky
occupies a comparatively
small area, its treatment
must be restrained.

STEP 2

My next step in the painting was to establish the distant hills, which I did with a pale wash of ultramarine and light red, with raw sienna replacing the light red toward the bottom. where the local color of the grass was barely apparent. I brought this wash down to the strip of warm-colored woodland, and when it was dry, added, quickly and directly, some indication of distant woods and lines of hedge with a slightly stronger version of the first wash.

I put in the dark forms of the trees before tackling the patchwork of fields. Even though these fields were much lighter in tone than the trees, some evidence of the underlying wash would still have been visible if I had painted over them. Nor did I want to leave gaps for the trees, as I find this inhibiting and

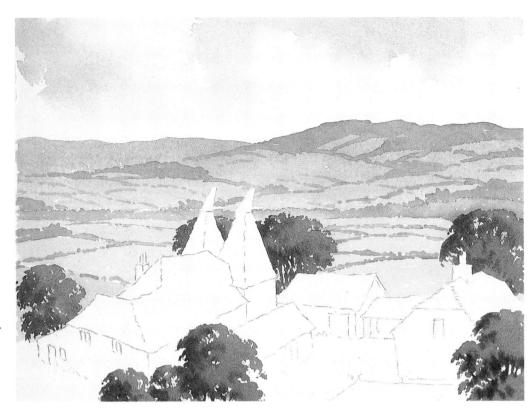

much prefer to establish tree forms with free brushwork that does not have to be fitted into

such spaces. The trees were varying mixtures of Payne's gray and raw and burnt sienna. When

they were dry, I put in the fields with a variety of pale washes to suggest pasture, grain, and

plowed fields. The hedges and the strip of woodland beyond were added quickly and freely.

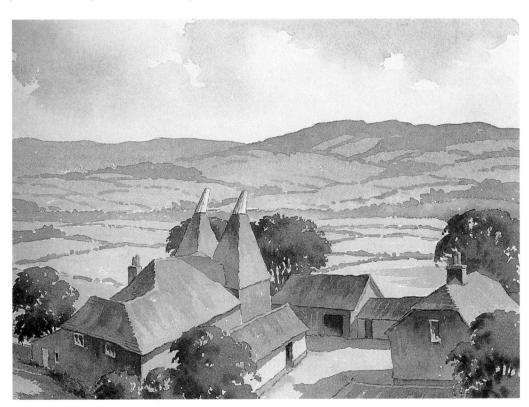

STEP 3

The colors of the weathered brick and tile of the farm buildings were rich and warm and contrasted effectively with the blue-gray of the distance to reinforce the feeling of recession. Three of the roofs were slate, and they provided another useful color contrast. The lateral shadows were important to the composition, and I took care to establish them early. The flat washes used for the various elevations of the farm buildings looked too flat on drying, so I added texture to most of them, taking care to make sure my brushwork followed the sloping lines of the roofs and the vertical lines of the walls.

6 All About Washes

The technique of watercolor painting is based firmly upon the application of washes of various types, and it is therefore essential that we know exactly what washes are and how to apply them. A wash is simply a pool of water into which a color,

or a combination of colors, has been mixed. They can be weak or strong, according to the amount of pigment they contain, and can be large or small, depending upon the area of paper to be covered. The important point to note is that all watercolor painting should be simply the application of washes of various kinds and never the application of the brush straight from the pan. There are three basic types of wash: the flat, the graded, and the variegated. In practice, they may be used separately or together.

TRANSLUCENCE

I have mentioned before, and it is such a fundamental point that it is worth repeating, that the beauty of watercolor stems from the white of the paper shining through transparent washes. You must therefore do all you can to preserve this lovely translucence and avoid anything that would spoil it. Even dark washes may be luminous, provided they have been prepared correctly and applied boldly. So take care to avoid the application of dry paint with small brushes and the dull and muddy results that follow, and aim to get the best out of the medium by the use of full washes of fresh color.

As we have seen, several colors may be

combined in one wash to produce the blend you want, but avoid including too many colors, or muddiness will begin to creep in. For this reason, it is usually a false economy to use residues left on the mixing palette even if they appear to be the right color, particularly if the wash you are preparing is destined for a luminous passage such as the sky or a sheet of water. Much better to start with fresh color that you can be confident will provide a really translucent wash.

Another enemy of freshness and luminosity is the use of water that has become dirty, and it is surprising how some painters continue using water that has begun to look more like soup. This can sometimes happen in the field if an insufficient supply has been taken, but there is no excuse for it

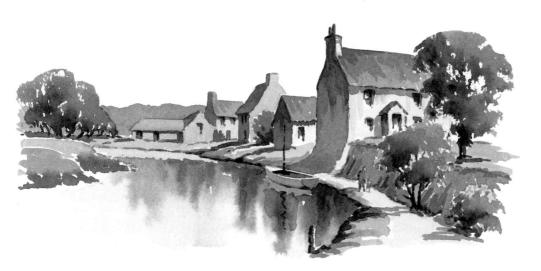

WINTER SUN

Although the sky in this painting appears a warm pinkish gray, the temperature was very low and the painting was done from memory in the comfort of the studio. My first step was to cut out a circle of masking tape and apply it to the paper where I wanted the sun to be (I could equally well have used masking fluid for this purpose). I prepared two sky washes, one of light red with just a touch of raw sienna, the other of ultramarine and light

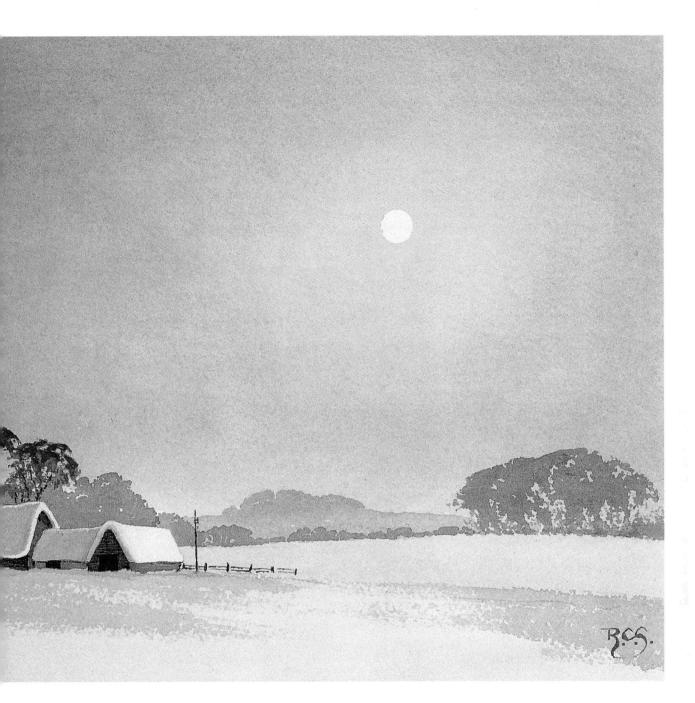

red. I started applying the first, in concentric circles around the masking tape, and when I had reached a point about 2 inches (5 cm) from my "sun," I began dipping my brush in the second wash. In this way I obtained a soft transition from the warmer to the cooler, deeper color. When this sky wash was dry, I removed the masking tape to reveal a circle of white paper, which made quite a convincing sun.

in the studio. I make a practice of having two jars of water, one for mixing with paint and the other for washing brushes.

A point to remember is that watercolor fades appreciably on drying and washes that look just right in the liquid state can easily dry out to look weak and unconvincing. Allowing for this factor becomes second nature with experience, but if you are in any doubt, first try out your wash on a scrap of the same paper you are using. This is much more satisfactory than applying a second wash to a weak initial wash, for in watercolor some freshness is lost with each subsequent application of paint. This is not to say that washes cannot be laid one over another to achieve particular effects, but as a

general principle it is better to say what you have to say in one wash rather than two or more.

One of the reasons why beginners are inclined to use rather dry color in their watercolor work is that they feel it is easier to control. Another is that they are eager to get on with their painting, and liquid washes do take much longer to dry. This is a problem, particularly when painting in a humid atmosphere. In the studio, a hairdryer can speed up the drying process and no harm will result, unless the blower is held so close to the paper that excessive heat dulls the paint. In the field, the only remedy for a slow-drying wash on a humid day is patience!

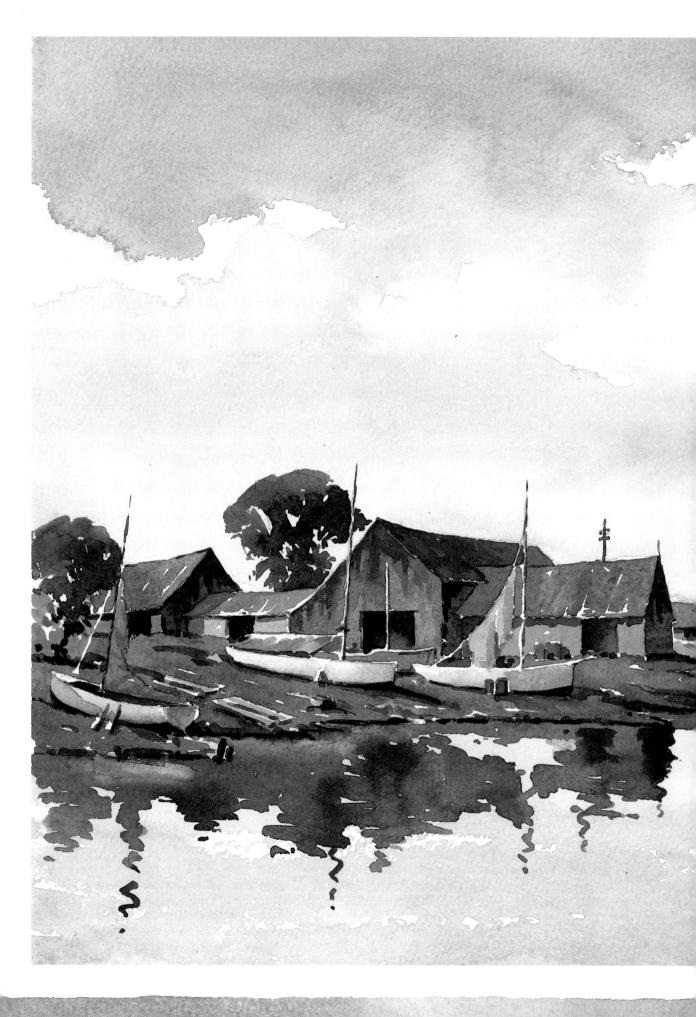

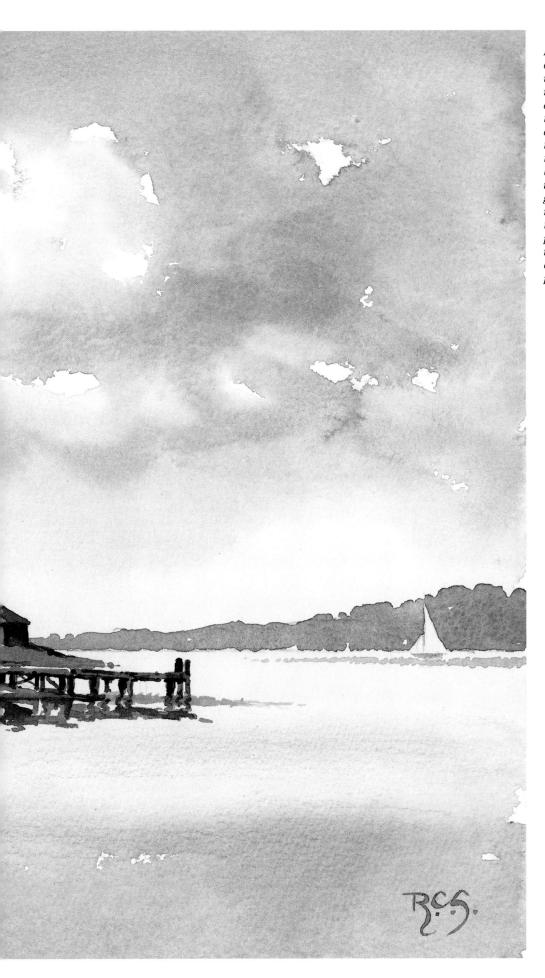

Much of this painting consists of a pale, variegated wash—a mixture of ultramarine and Payne's gray at the top, through raw sienna at the horizon and back, to pale blue at the base—though some clouds have been introduced to interrupt the smooth gradation of color. The nearer elements and their reflections were painted in strong tones in order to register effectively against the pale background wash.

SLACK TIDE

Once again I used masking tape, but this time I applied a strip right across the paper, to protect the horizon. The sky was basically a variegated wash, from dilute raw sienna at the top to ultramarine and light red above the horizon. While it was still

wet, I painted in the clouds on the right with a slightly cooler version of the second wash, and left it all to dry. With the same wash, I then painted in some more definite cloud shapes, softening some edges with clear water, but allowing others to remain hard.

I repeated the variegated wash procedure for the calm sea, but used marginally cooler versions of the original washes. When they were dry, I applied horizontal strokes of a large brush charged with the second wash to indicate cloud shadows in the distance and

smooth waveforms in the foreground.

The sailing barge and its reflection were added in deeper tones against an area of radiance and are balanced by the heavy clouds on the right.

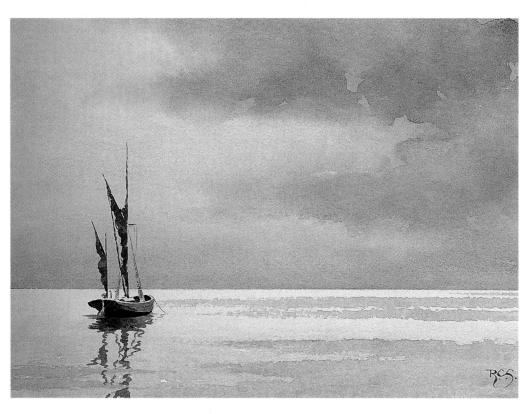

THE FLAT WASH

A flat wash is one in which the color is laid down evenly and uniformly.

To prepare a simple flat wash, first judge the amount you require and then pour that amount of water into a saucer or into one of the compartments in a mixing palette. It is better to overestimate the amount required than the reverse, for nothing is worse than running out before your wash is complete; a hastily mixed addition is unlikely to match the first exactly and the incomplete wash will in any case have started to dry. Add the pigment, a little at a time, until you are satisfied with the tone. Avoid applying too much paint to begin with, or you may have to add a lot more water and end up with far more of the wash than you require, resulting in waste. This is all too easily done with some of the stronger staining colors. Mix the

THE QUIET STREET
For this sky, I prepared

two washes, one of very dilute raw sienna, the other of Payne's gray, and applied them with two large brushes, allowing them to merge together softly, but carefully avoiding the church tower. When they were dry, I applied a second wash of Pavne's gray around the tower, softening it into the original wash with clear water in places, but leaving just a few hard edges for the sake of

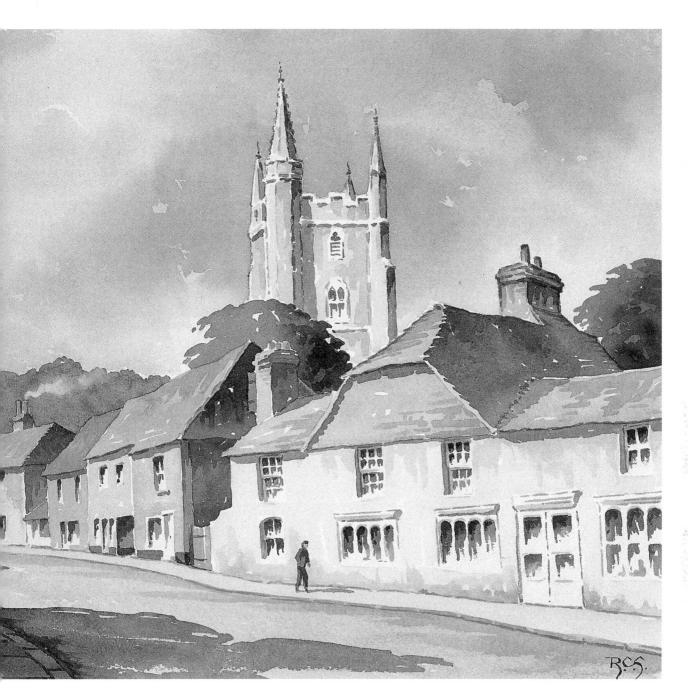

variety. The resulting deeper tone made the tower stand out boldly, even after I had painted it in pale washes of raw sienna, light red, and a touch of ultramarine.

The sunlit houses below were painted in pale tones, with stronger washes of much richer color for the shadowed sides. Notice the reflected light in the windows of the house on the left of the painting. paint and the water together thoroughly to make sure no traces of paint remain undissolved, for these can ruin the clarity of your wash.

Before beginning to apply the wash, it is important to decide upon the angle at which the drawing board should be held. If the angle is too steep, the wash will simply stream down the paper; if it is too level, there will not be enough gravity for it to flow at all. Artists differ widely in this respect, but I find an angle of about 15 degrees from the horizontal is about right.

Using a large brush, perhaps a 1-inch (2.5-cm) flat, start applying the wash in a horizontal band at the top of the paper. A bead of paint will collect at the lower edge of

this brushstroke—the effect of gravity—but it will be removed by the following stroke of the recharged brush. Continue in this way down the paper.

I normally start each brushstroke at the opposite end of the paper from the last, to give an even distribution of paint, since more paint is laid down at the beginning of the stroke than at the finish. If I am laying down a wash for a sky, I may well want one side to be paler than the other, to suggest the direction of the sun, and in this case all my brushstrokes will start at the edge I wish to be slightly darker.

Moistening your paper before starting to paint will overcome the possibility of unevenness occurring.

THE GRADED WASH

The next type of wash used in watercolor painting is the graded wash. This is simply a wash in which the tone varies evenly from dark to light, or vice versa. A graded wash is useful for tackling skies, where the effect of the atmosphere is to decrease the tone as the horizon is approached. The procedure is

similar to that of applying a flat wash, but here a little clean water is added and mixed into the wash for each succeeding brushstroke. If you are working from light to dark, the reverse applies, and more pigment is progressively added to the original pale wash. In the example below, the Payne's gray becomes paler toward the horizon.

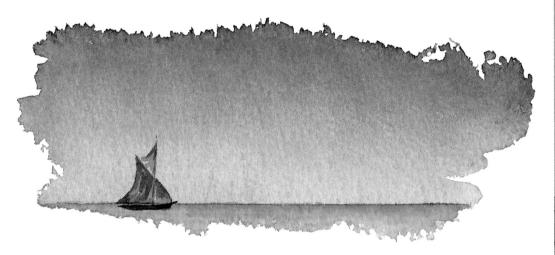

THE VARIEGATED WASH

The third kind of wash is the variegated type. This is similar to the graded wash, but instead of gradually changing to a paler (or deeper) tone, it merges evenly into a different color. To achieve this effect, washes of the

two desired colors are prepared in advance and the brush charged with the first. With each successive brushstroke, less of the first wash and more of the second is taken up until, at the bottom, little of the first color remains.

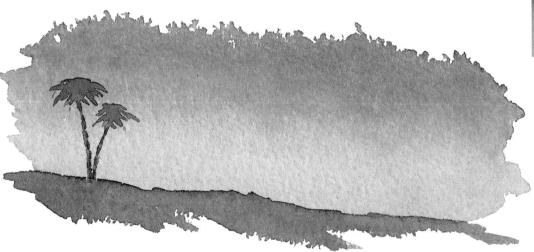

With practice you will master the wash technique, and you may wish to begin by trying your hand at the three washes I have demonstrated. With some, more absorbent papers, it is not easy to get a smooth gradation of tone or color and there may be some striping. One way of getting over this difficulty is to dampen the surface of the paper evenly before applying paint.

Mastery of these basic washes is fundamental to successful watercolor painting. They may, of course, be modified in all kinds of ways; for example, by adding further color, wet in wet. This is where the fascination of the medium really begins. We shall be considering this and other exciting watercolor techniques in later chapters.

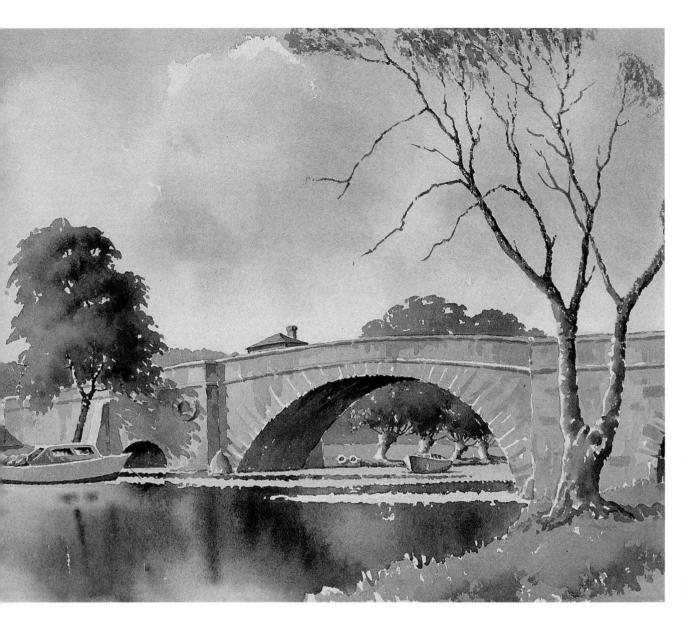

THE OLD RIVER BRIDGE

To create an atmosphere of tranquillity in this river scene, I opted for an understated sky with gentle cloud shadows, and a smooth expanse of water with soft reflections. The pale colors of the sky were allowed to blend, and only in two places are there any hard edges to the clouds. With the exception of the light-

toned bands of windruffled water below the bridge, the river was established in one variegated wash containing the colors of the objects above. These colors were applied quickly so that they merged together softly. I then added a few darker accents while the wash was still wet, to provide form.

EXERCISES TO TRY

Skill at handling washes is basic to good watercolor practice. The exercises that follow should help to develop your skill:

- 1 Lay down a full, flat wash of ultramarine.
- 2 Try a graded wash, using the same color, but adding water as you quickly work down the paper.
- 3 Now apply a variegated wash,
- starting with ultramarine and ending with raw sienna. Did these first three washes look fresh and even on drying, or did patchiness and unevenness creep in? Continue practicing until you become fluent!
- 4 Add a quick impression of trees and hills in deep tones to your last wash, which should then convincingly suggest a clear sky.

DEMONSTRATION

THE GRAND CANAL

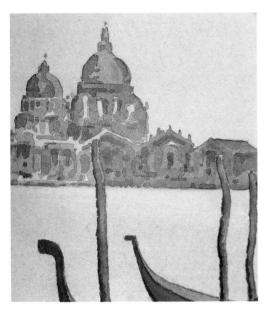

This much-painted view of Venice, copied from an old sketch, gave me the opportunity of applying a warm variegated wash over the whole paper, with a few local variations. The strong evening light becomes increasingly dim toward the left of the painting, and here the deeper tone helps to balance the main weight of the composition, which is on the right. The largely horizontal format is helped by the strong vertical form of the mooring poles, particularly that of the left-hand pole. This mooring pole, with its reflection below and the dome and cupola immediately above, ties the composition together.

Palette

raw sienna light red ultramarine burnt sienna Winsor blue

STEP 1

I prepared three generous washes for the sky and water. The palest was raw sienna with a little light red. The intermediate contained a bit more light red and just a touch of ultramarine, while in the third wash, the deepest in tone, the proportions of light red and ultramarine were both increased. I started applying the palest wash on the right and moved across the paper to the left, gradually increasing the proportions of the second wash, then the third, as I worked.

While the paper was still wet, I introduced a little of the deepest wash to the foreground water and put in a soft, horizontal shadow on the left. I then lifted out a little color, with a moist brush, just below the buildings on the right,

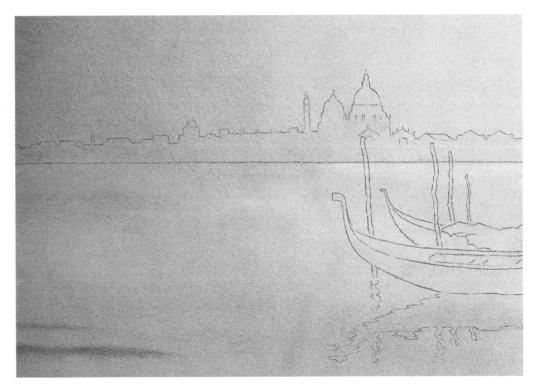

and added a couple of ripples, wet in wet, in the left foreground. I then allowed everything to dry.

STEP 2

The far shore contained a mass of buildings, and although I wished to indicate their presence, I did not want to get involved in a lot of meticulous detail. I therefore decided to adopt a shorthand approach that merely suggested form and left much to the imagination. For this purpose, I prepared three washes of ultramarine and light red, the palest being the warmest and the deepest being the coldest. I applied the pale wash first, starting on the right, but as I worked my way toward the left, I increased the proportion of blue in the wash, so that the cooler color would suggest recession. With the second wash, I picked out a few intermediate tones and

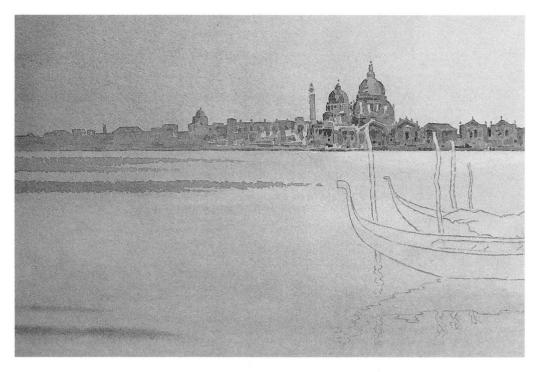

increased the proportion of light red in the center of the painting for the sake of variety. I finally

added a little of the deepest wash to indicate door and window openings and to give a

little more prominence to the domes of the Santa Maria della Salute.

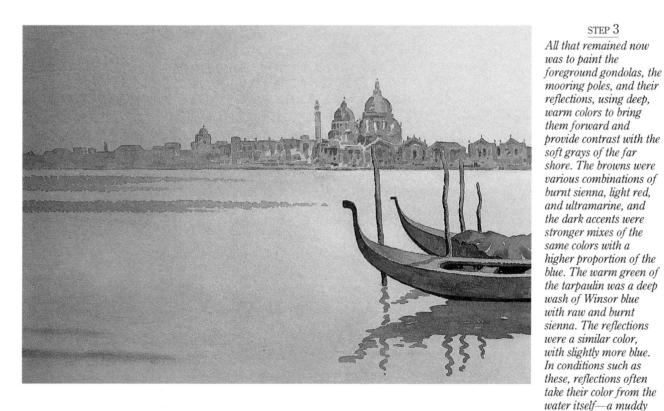

reflections, using deep, warm colors to bring them forward and provide contrast with the soft grays of the far shore. The browns were various combinations of burnt sienna, light red, and ultramarine, and the dark accents were stronger mixes of the same colors with a higher proportion of the blue. The warm green of the tarpaulin was a deep wash of Winsor blue with raw and burnt

STEP 3

7 More Watercolor Techniques

In the last chapter, we considered the basic washes of watercolor. We shall now turn our attention to the ways in which they may be employed in the painting process and how their treatment may be varied to obtain particular effects. Later in the

chapter, we shall examine additional watercolor techniques such as broken washes and drybrush.

We have already noted how the quality of the light influences the colors of the landscape and how vital it is to make sure that the two are in harmony. The warm colors of a late-summer evening cast a glow over the countryside, enhancing the rich hues of old brick and tile, russet foliage, and ripened grain. One way of making sure that all parts of the painting are harmonious in color is by carrying the warm color of the sky down over the whole paper. This basic wash will impart a warmth to washes laid over it, and the fragments that receive no

further color will help to unify the painting. A development of this technique is to vary the overall wash to take account of the local color in different parts of the painting. At this stage, you will be concerned only with the paler tones of these local colors, the deeper tones required for shadows and so on being applied later. This treatment really consists of a more complex version of the variegated wash.

To begin with, you need to analyze the paler local colors in all parts of the scene—sky, fields, trees, buildings, water, lanes, and

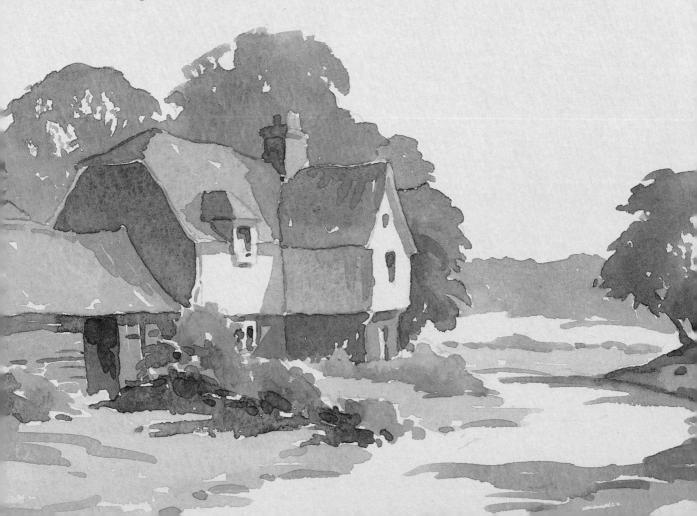

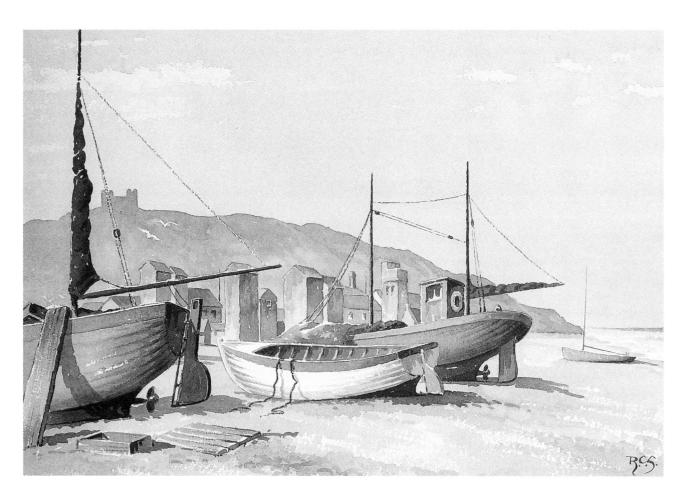

anything else in the landscape. You next prepare suitable washes for each of these local colors, remembering that you are interested at this stage only in broad areas and are not concerned with detail of any kind. You then apply these washes, quickly and boldly, over the whole paper, letting the colors merge softly where they meet. This is the point at which delightfully soft effects may be obtained by dropping in deeper colors to suggest the misty forms of distant hills, trees, and so on. This technique, known as wet in wet, is described more fully in the next chapter.

When the variegated wash is dry, you may lay further washes over it, working all the time from light to dark. In the watercolor medium, washes should always be liquid and should be laid quickly and with the lightest of touches. It is always good practice to lay washes in this way, with a minimum of modification; this applies with even greater force when working over an area that has already been painted. If the underwash is disturbed by too much fussy brushwork, the result is bound to be muddy and unsatisfactory.

A further advantage of applying a variegated wash to the whole of the paper is that you are no longer faced with areas of

white paper, which can be distracting. This broad approach is likely to result in a degree of inaccuracy, and some of the local colors may not end up precisely where they should be. Do not worry! This has to be accepted as part and parcel of the technique, and it would be a mistake to attempt any alteration—the increased accuracy would not compensate for the loss of freshness and spontaneity. If the painting method is kept free and loose, and any temptation to tightness resisted, little harm will be done.

EXPLORING WASHES

When we were considering washes of various types in the previous chapter, we noted that they could be modified to produce varying effects, and we shall now explore these techniques. Let us start with a variegated wash, with ultramarine at the top, blending gradually into raw sienna at the bottom. This could represent a clear sky. If vou now wished to introduce some softedged clouds, the appropriate colors—perhaps a mixture of ultramarine and light red—could be dropped into the still-wet wash. This is perhaps not quite as easy as it sounds, for success depends very much on correct timing. If you attempt to add the clouds while the variegated wash is

THE NET SHEDS

An underwash of raw sienna was carried down over the whole painting, with the exception of a few areas such as the sea and the white boat. where I wanted the color to remain cool. When this was dry, I applied a second wash to the sky. ultramarine with a little light red at the top, softly merging into raw sienna and light red above the horizon, with a few ragged shapes left unpainted to represent fleecy clouds. Broken washes of various combinations of raw and burnt sienna, light red, and ultramarine served for the rough texture of the foreground pebbles.

A variegated sky wash with gray cloud superimposed, wet in wet

still too wet, the gray will spread into the wash and be virtually lost. If, on the other hand, you leave it too long, and the background wash is beginning to dry, there will almost certainly be a thoroughly unsatisfactory mix of hard and soft edges to the clouds.

The effects that this technique *can* produce when properly handled are so useful in watercolor painting that conscientious practice to explore and master the technique is worthwhile. The above illustration is an example of a sky painted in this manner. If some of the gray is lifted out while still wet by pressing it gently with a dry brush or a tissue, and replaced with a wash of very pale raw sienna, the effect of sunlit clouds may be produced, as below.

Another problem we have to contend with is the effect known as blooming. This happens when we apply too liquid a wash to a background that is just beginning to dry. Here, the water in the second wash is carried by capillary action into the drying wash, taking pigment with it. When it reaches a still-drier area of the first wash and can travel no further, the pigment is deposited in unsightly concentrations. To prevent this unwanted state of affairs from occurring,

you must make sure the second wash is less liquid than the first. It is all a question of judgment, and judgment comes only with practice and experience.

The way in which these washes behave will depend not only on the artist's skill and sense of timing, but also upon the temperature and degree of humidity of the atmosphere. These are variables that we cannot control, but due allowance has to be made for them. In very dry conditions, for example, more water has to be mixed with the washes to compensate for the shorter drying time. Papers and paints react in different ways, and this is a good reason for sticking to watercolor papers and a limited palette of colors with which you are familiar.

MASKING FLUID

Full washes have to be applied quickly and boldly, and this makes it difficult to paint around small shapes you may wish to preserve—for example, white gulls against a stormy gray sky. Unless you resort to using opaque color, such as Chinese white, the only practical alternative is masking fluid. This is a liquid latex that you can paint over such small areas and then safely apply your broad wash on top. When everything is dry, $\rightarrow p.88$

Another variegated sky wash, but with a cloud showing sunlit areas.

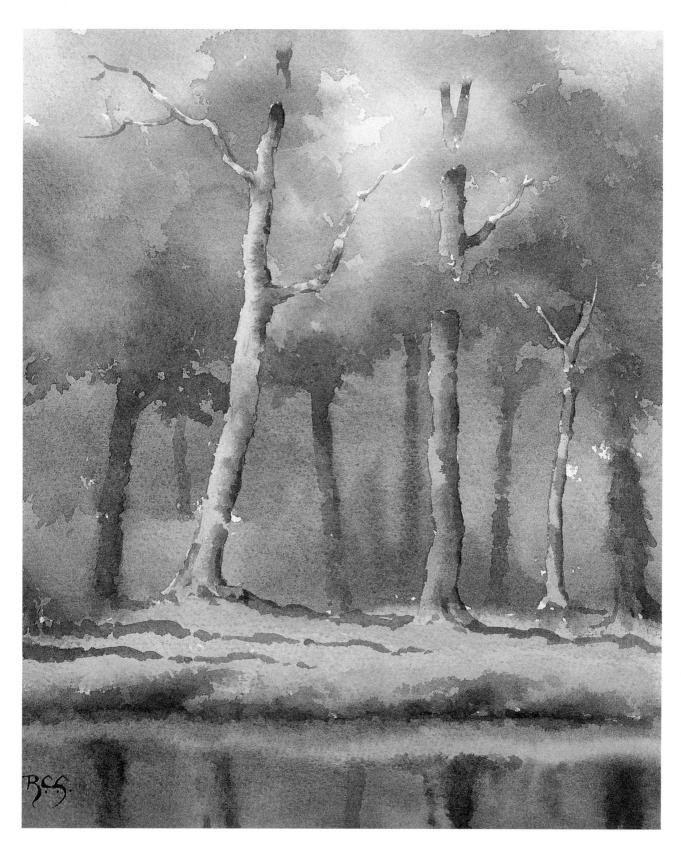

WOODLAND POOL

Once again, a wash of pale raw sienna was carried down over the whole paper and allowed to dry. Masking fluid was then applied with an old brush to the three

foreground tree trunks, so that they might stand out crisply against the misty effect I planned for the background. I used a variegated wash for the background foliage, with various combinations of

raw sienna, Winsor blue, ultramarine, and light red, with more raw sienna for the sunlit foreground grass. When the paper was beginning to dry, I painted in the dim tree shapes, using Payne's gray for the shadowy foliage and deep ultramarine and light red for the trunks, obtaining the desired variety of hard and soft edges. When everything was completely dry, I

rubbed off the masking fluid with my index finger and then applied a little color and shading to the tree trunks that it had protected.

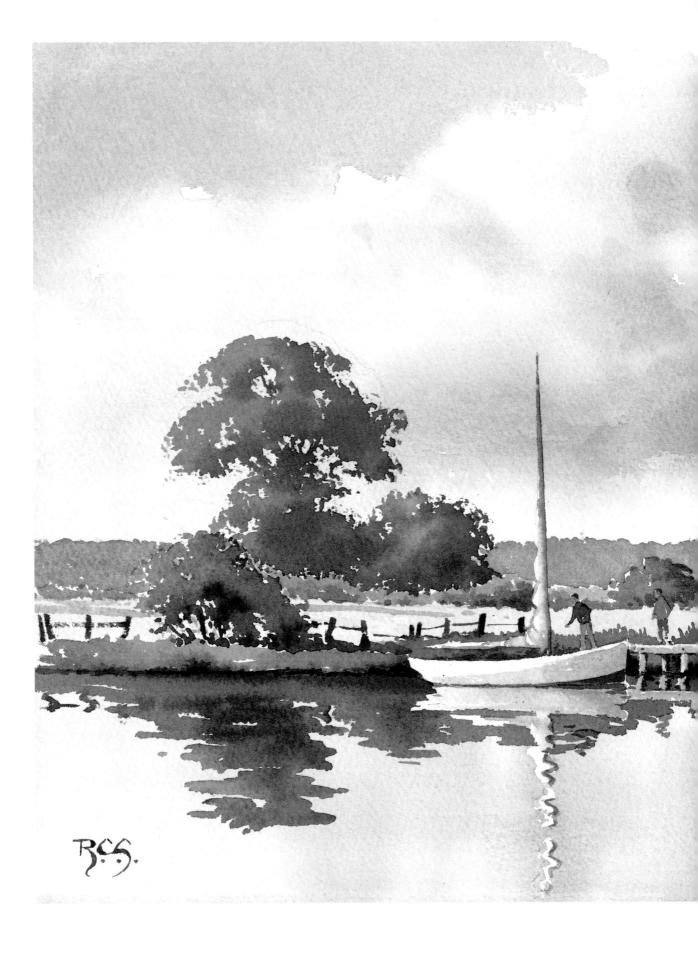

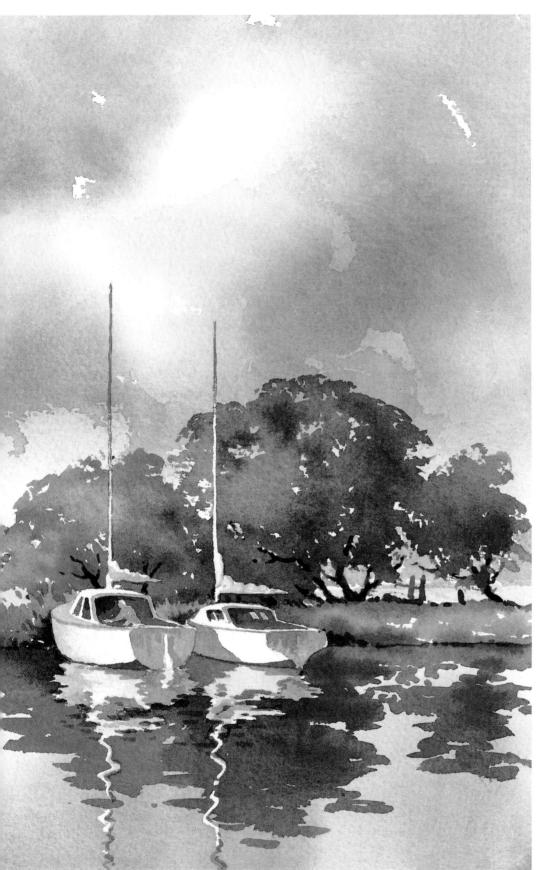

SAILBOATS AT REST

My aim in this painting was to contrast the pale tones of the boats with their background of dark foliage and to capture something of the limpid feeling of the water. The boats required fairly careful drawing, and I preserved the shapes of the masts and furled sails with masking fluid.

I used two washes for the water. The first established the soft reflection of the sky in pale tones. When this was dry, a stronger, hard-edged wash indicated the nearer reflections, with indented edges to suggest the rippling surface of the river.

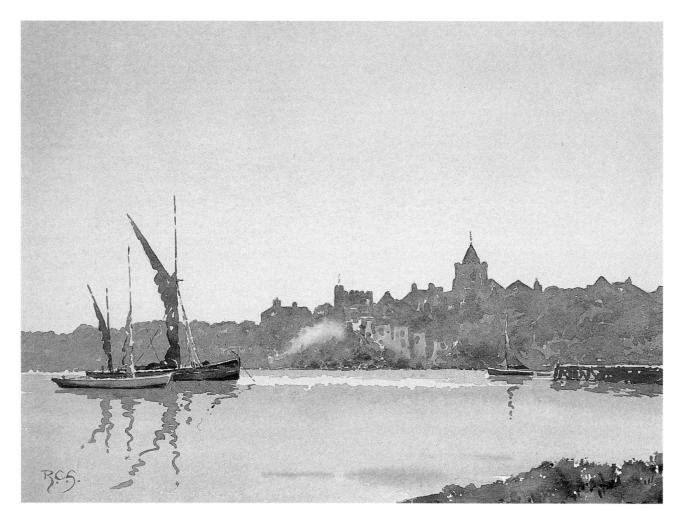

you can remove the latex by gently rubbing it with your index finger to reveal areas of untouched white paper.

Some words of warning here: masking fluid should not be used on the softer watercolor papers, which tend to lose surface fibers when the dried latex is removed. Also, however quickly the fluid is removed from brushes after use, some deterioration is inevitable, so only cheap or partly worn brushes should be used for this purpose.

THE BROKEN WASH

As the name suggests, broken washes are less continuous and complete than flat washes. They are produced when the brush is less fully charged and is dragged rapidly over the surface of the paper, leaving ragged edges, gaps, and chains of white dots where the paper remains untouched. Naturally, this effect is most easily obtained by using paper with a rough surface.

Broken washes, an example of which is shown below, can be extremely useful in suggesting textured surfaces. Portraying foreground detail is a perennial trap for the inexperienced, who all too easily become embroiled in painting individual pebbles, seed heads, blades of grass, and so on. Skillful handling of broken washes and drybrush technique will enable you to achieve bold and telling effects quickly and with little apparent effort. In watercolor, spontaneous techniques score every time over a more labored approach.

EVENING LIGHT

In this study of golden evening light, I applied a wash of raw sienna, slightly warmed with light red, over the whole of the paper, adding just a little Payne's gray toward the top. Small areas of this warm yellow appear in various parts of the composition, such as the narrow band of pale water, the tops of the boats, and the dock, helping to give the painting unity.

DRYBRUSH

With the technique called drybrush, the brush is less fully charged than for a broken wash and is again drawn quickly across the paper, engaging the little bumps in its surface but missing the little depressions. The drybrush effect is used to suggest texture, and it is a useful method of giving character to a surface which appears too bland. Despite the expression "drybrush,"

the brush should not be so dry that the marks it makes are dull and muddy. A fuller brush *is* more difficult to control, but held flat to the paper and handled with speed and dexterity, the effects it produces can be both textured and lively. Above is an impression of a rock before and after the application of some drybrush work. The second illustration demonstrates how the technique can indicate the forms of trees and bushes.

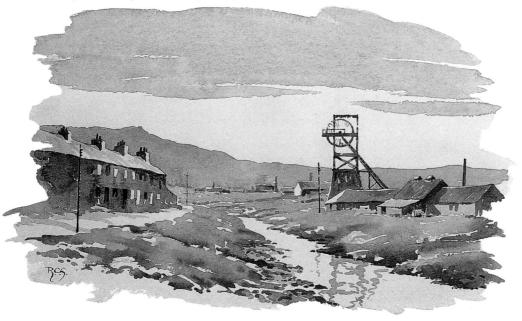

EXERCISES TO TRY

- 1 Lay down a variegated wash to represent a clear sky—perhaps Payne's gray merging into raw sienna—and while it is still wet, drop in some gray to represent soft-edged clouds.
- 2 Apply prepared washes of very pale raw sienna for sunlit clouds, ultramarine and light red for cloud shadows, and
- ultramarine for blue sky, and allow them to merge here and there.
- 3 Try a broken wash of raw and burnt sienna below one of these skies, to suggest stubble.
- 4 Add texturing to your stubble with some drybrush work, using burnt sienna with a touch of Payne's gray.

MINING VALLEY

In a rather obvious example of the overall preliminary wash, a variegated wash was applied over the whole paper here, with raw sienna at the top and an increasing proportion of light red as the wash was carried down. Quite a lot of this initial wash received no further color, particularly in the foreground, and this helped to give the painting a feeling of cohesion and unity. Even cool washes applied over the basic wash, such as the ultramarine and light red of the distant shoulder of hill, have a warmth that relates them to the rest of the bainting.

FARM BUILDINGS

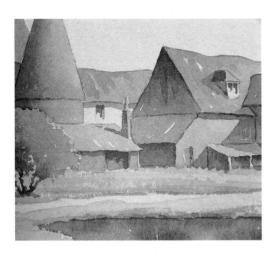

When there is a particularly strong color in the light—for example, when a golden evening glow suffuses the landscape—it sometimes helps to carry the colour of the sky down over the whole paper. This helps to unify the painting and means that the dominant sky color influences every part of the scene below.

In this group of farm buildings, reflected in the farm pond, this is what I have done. The overall warm yellow wash will, of course, influence the colors laid over it, and any bits of the

original wash left uncovered will help it all to hang together.

Palette

raw sienna light red ultramarine Payne's gray burnt sienna Winsor blue

STEP 1

I placed the group of buildings a little to the left of center and balanced them with a deep-toned oak tree on the right. The sky will be reflected in the pond below the gap between the farm buildings and this tree to give the water greater tonal contrast and interest. The farm track leads the eye right into the center of the group.

I prepared a generous wash of raw sienna and light red and applied it evenly over the whole paper. While it was still moist, I dropped in some warm gray (a mixture of ultramarine and light red) and produced the soft-edged clouds. I made very sure that the gray wash was less liquid than the overall wash, to avoid any danger of blooming. These soft clouds helped to relieve the rather insistent warm yellow of the sky.

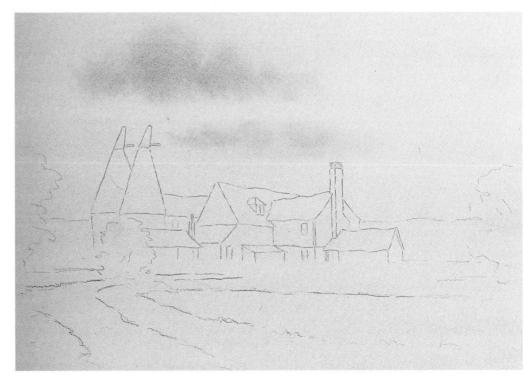

STEP 2

My first task at this step was to establish the two oaks and the hazel bush, again using the roughness of the paper to assist me in capturing the broken outlines of their foliage. The distant line of hills was a flat wash of ultramarine and light red.

Most of the farm buildings were old brick and tile, and for them I used varying washes of burnt sienna and light red, adding a hint of green (raw sienna and Winsor blue) to suggest moss and algae to the lower parts. The warm lateral lighting produced an interesting pattern of lights and darks, and I determined to make the most of these to obtain a threedimensional effect. The shadowed walls and roofs were deeper washes of light red and

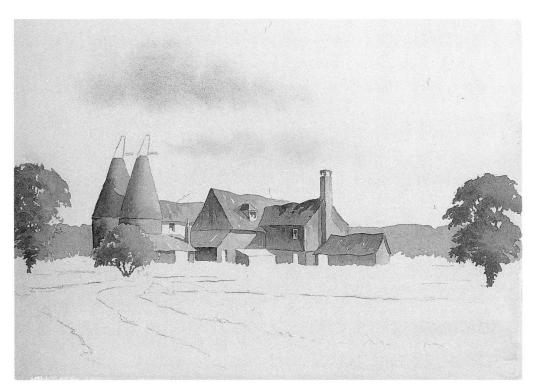

ultramarine. Some of the flat planes looked a bit too flat on drying, so I introduced a little

texturing here and there, taking care to follow the slope of each roof and the line of each wall.

STEP 3

The grass was put in with quick horizontal strokes of a large brush loaded with a mixture of Winsor blue and raw sienna. This left quite a lot of the base wash untouched, particularly in the foreground, to suggest the rough surface of the grass and link different parts of the painting together. A broken wash of a slightly warmer color was added to strengthen this textured effect, and then the shadows were established with a wash of Payne's gray and raw sienna. At this stage, the farm track was just the original pale wash of raw sienna and light red, and all it needed was a broken horizontal wash of light grav.

I left the water until last so that I would know exactly what had to be reflected. I then prepared several washes to correspond roughly with

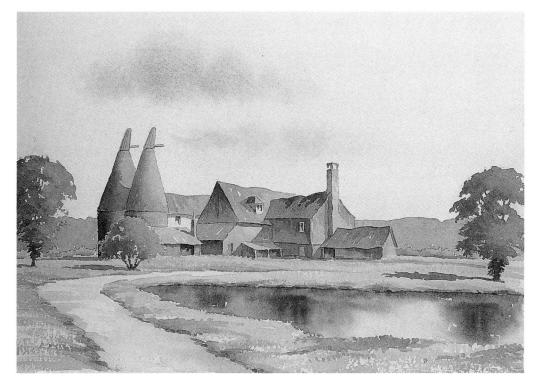

the colors of the objects above and applied them as quickly as possible, so that they all merged together. As this variegated wash was just

beginning to dry, I added a few darker accents with vertical strokes of the brush.

8 Mist and Mystery

The beauty of watercolor lies in its capacity to convey the soft effects of mist and fog and the subtleties of atmosphere. Imaginatively used, it can capture the pearly hues of light filtering through broken clouds or the brilliance of the noonday sun.

Some of Turner's watercolor sketches show us how, in the hands of a genius, the medium can create breathtaking images of light and color. When we see watercolor used in this masterly way, we realize afresh the vital importance of striving to interpret light and its effect on the landscape, and the relative unimportance of recording irrelevant detail. If we keep this conviction constantly in mind, it will help us to use the medium with feeling and imagination.

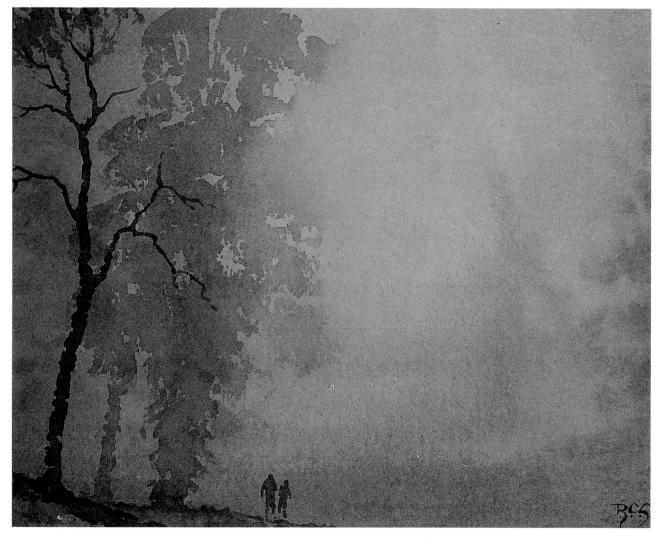

EVENING MISTS

In this painting, my aim was to capture, as simply as possible, something of the atmosphere of a warm evening sun filtering through misty woodland. A wash of very pale raw sienna merging into light red touched with ultramarine served for the sky, and while it was still wet, a stronger wash

of the last two colors was dropped in, to suggest the mysterious outlines of the distant trees. When the paper was dry, I painted in the nearer trees as warm gray silhouettes, having previously wetted the area of luminous sky to obtain a soft-edged effect and an impression of radiance. I then put in the left-hand tree in deeper tones of the same wash and the two small figures, which provide a focal point and give the painting scale. In the previous chapter, the technique known as wet in wet was noted, and although its detailed treatment and examination were deferred, one simple application was in fact described—the addition of gray pigment to a still-wet variegated wash to produce an impression of soft-edged clouds. In this chapter, we shall study the technique in greater detail and show how its mastery can add an entirely new dimension to watercolor painting.

EXPLORING WET IN WET

We have seen that the wet-in-wet method is simply the addition of a second wash to a wash that has already been applied and that, because both washes are in a liquid state, the colors and tones will merge at the margin, and everything will be soft-edged. We have established, too, that the second wash must be in a less liquid condition than the first or an unwelcome phenomenon known as blooming will result. So far so good. The next point to note is that the more liquid the washes, the softer and more diffuse the merging that takes place between the two will be.

This variation in edge definition has important implications for atmospheric painting, for it means you can vary the mistiness of your images at will. It is also easy to see how, properly handled, the wet-in-wet technique can indicate recession in an extremely effective manner. The paler, softer images will be more distant, and as definition increases, the objects so painted

will appear to come forward, until the nearest ones will be hard-edged.

If, for example, you wish to make a painting of a stretch of woodland in misty conditions, you would start with an overall wash of some suitably pearly color, and while this was still wet-but not too wetyou would drop in some pale gray to indicate the most distant trees. This would produce a soft, ethereal image, suggesting distance. Slightly nearer trees would be painted next in somewhat stronger tones, and because by then further drying would have taken place, the results would be less misty. You would use even stronger tones for still-nearer trees and would continue in this manner until the background wash was finally dry, when clearly no more wet-in-wet painting would be possible. The nearest trees could then be put in, hard-edged, in yet deeper tones, and these would contrast with the progressively softer treatment of the more distant trees to create a powerful feeling of recession. This would be reinforced by aerial perspective; the use of pale, cool colors to denote distance; and stronger, warmer colors, with greater tonal contrast, for foreground features. This feeling of recession would be further strengthened, of course, by the effects of linear perspective—the ever-decreasing size of the trees as they recede into the distance. The painting Woodland Track (see page 97). is an example of this sort of treatment. It was painted on the spot early one fall morning to illustrate a magazine article on painting.

WET-IN-WET WASHES: STAGES OF DRYING

If the washes are too wet, the second wash will be swallowed up by the first and will disappear.

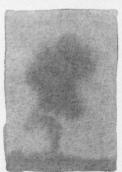

When only a little drying has occurred, the second wash will produce a soft and insubstantial image.

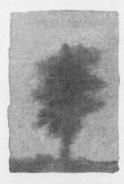

As further drying takes place, the image will become progressively more definite, though still soft-edged.

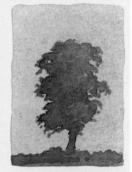

Only when drying is virtually complete will the addition of a second wash result in hard rather than soft edges.

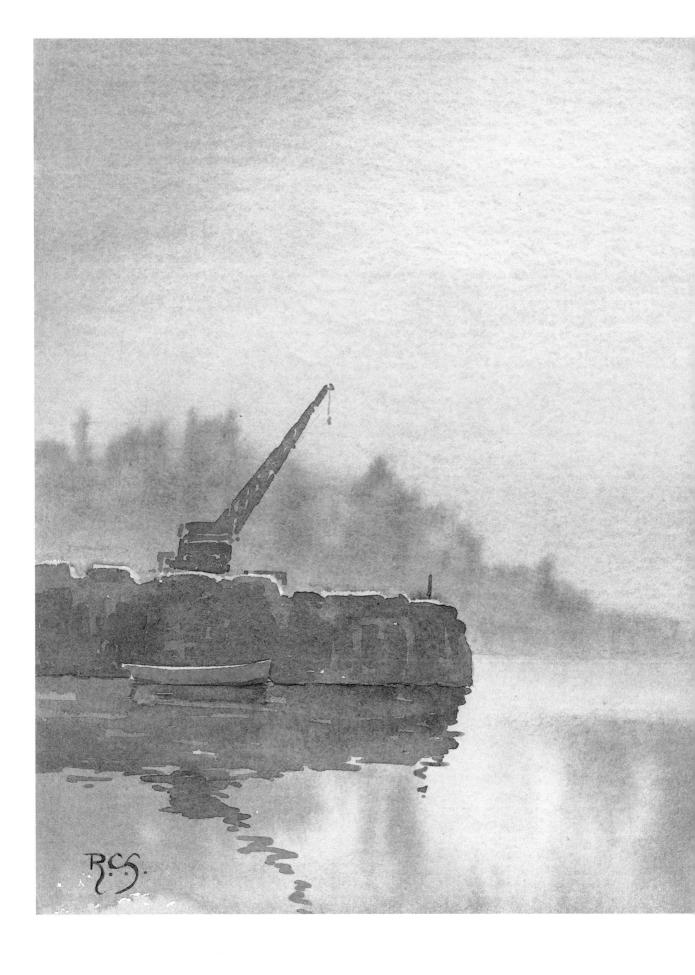

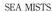

My objective in this painting was to capture the soft, pearly light and the misty outline of the distant headland. I used a pale, variegated wash of ultramarine and light red, cooler at the top, warmer just above the horizon, with an area in the center of dilute raw sienna plus a little light red. I brought this wash down to the top of the harbor walls, where I wished to preserve the line of light along the top of the stonework. I then added deeper tones of the same gray, wet in wet, for the misty headland. The stonework, the boats, and their reflections were painted more crisply, with increasing tonal contrast toward the foreground, in order to create a convincing feeling of recession.

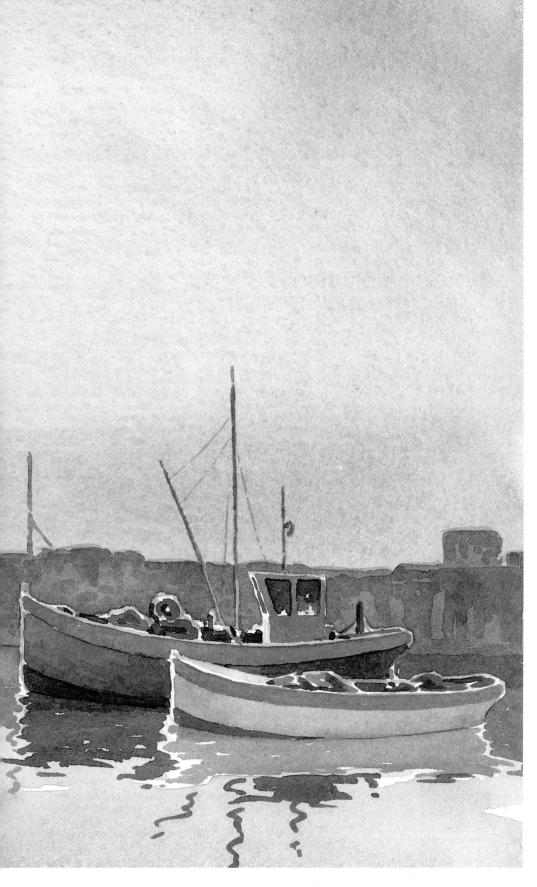

TIMING

Timing is all-important in wet-in-wet painting. The ability to judge the degree of dampness that will produce exactly the desired amount of merging will come only with practice and experience. If there is a lot of painting to be done before the background wash is dry, as there was in *Woodland Track*, speed is of the essence, and there is no time for fiddling detail. Fortunately for me, when I was painting this picture, the air was very humid, which slowed down the drying time and enabled me to put in all the soft tree outlines I wanted before drying was complete.

Drying speed varies considerably from paper to paper. With hard-surfaced papers,

WILLOW

A painting in which everything is soft and misty can look a bit too bland and formless. This is an example of a wetin-wet painting in which some hard edges have been retained to provide contrast. A wash of pale raw sienna was applied over the whole painting down to the edge of the foreground water and allowed to dry. Clear water was then laid over this initial wash, down to

the base of the trees, but some areas, particularly in the center, were allowed to remain dry. Consequently, when the gray-green wash for the willow and the russet washes for the background trees were applied, some edges remained hard. Deeper tones were then dropped in for the shadowed areas, but the dark willow trunks and branches were added only when everything was dry.

which have plenty of size in their makeup, drying tends to be slow; while with softer, more absorbent papers, the surface dries more quickly. This is another good reason for sticking to a narrow range of watercolor papers, so that you get to know their handling properties intimately. One way of judging the degree of dampness of your paper, and its readiness to accept a second wash, is to observe the precise moment when the wet shine of the initial wash just begins to dull, though it has to be said that the behavior of different papers varies considerably in this respect.

Wet-in-wet painting over a broad initial wash is not, of course, the only way to obtain soft-edged images. If, for example, you wish

WOODLAND TRACK

I painted this scene one beautiful fall morning, when the sun was just beginning to break through the mist. Once again, I began with a pale, variegated wash for the sky area and started to paint in the dim shapes of the trees, wet in wet. As the paper began to dry, I added the nearer trees, but only when it was quite dry did I put in the foreground trees.

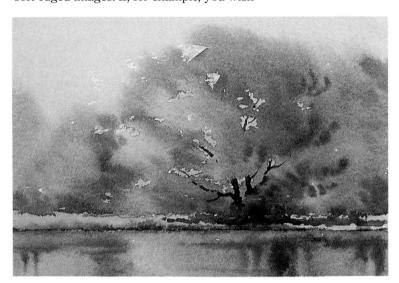

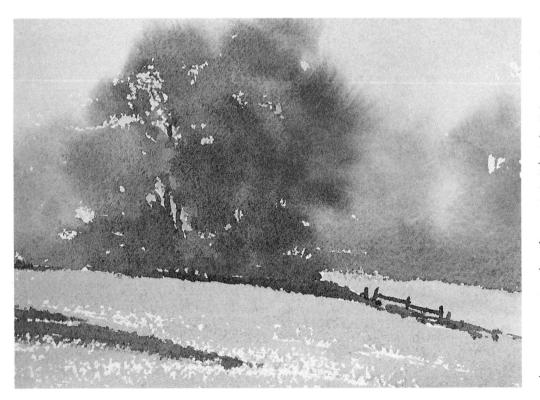

FALL MEADOW

This is another example of a painting in which hard and soft edges have been combined, the technique being very similar to that described in the caption to the painting entitled Willow (above). Here, all the foliage was warm russet in color—mainly burnt sienna—and the shadows were ultramarine and light red with some Payne's grav and raw sienna at the base of the near group. The field was a broken wash of raw sienna with a little Winsor blue added toward the top. The shadow cast by a tree off the painting to the left breaks up a rather featureless foreground.

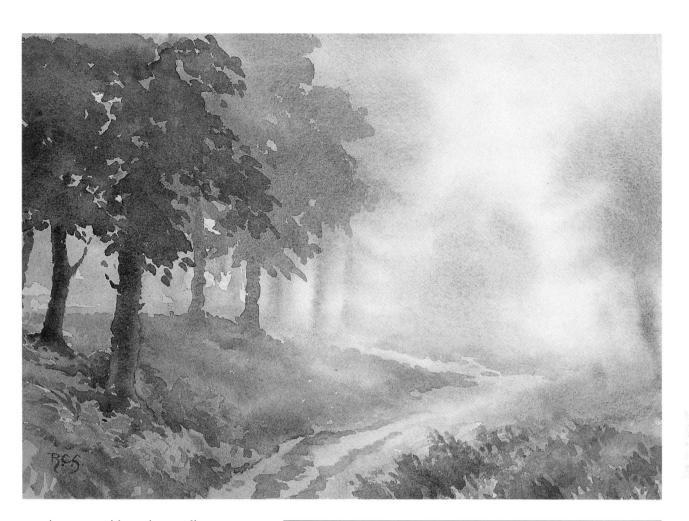

to paint a tree with a misty outline over a pale background that has already dried, it is perfectly possible to do this by dampening an area a bit larger than the tree you have in mind, and then applying pigment to this damp surface. Two warnings are necessary here! First, a very light touch is essential if the base wash is not to be disturbed and, second, the greatest care has to be taken to use clean water to dampen the area and to make sure that none of the applied wash finds its way to the edge of that area, or a hard ring will appear when drying is complete.

While the initial wash is still moist, color may safely be lifted out with a damp brush—never a wet brush, or the excess moisture will disturb the adjoining area and blooming will result. If a horizontal line of color is lifted from a wash depicting a stretch of calm water, it can create the impression of a foreshortened area of water disturbed by an errant breeze.

The paintings in this chapter are examples of the way in which the wet-in-wet method may be used, as described in the text. Try copying them or make up sketches of your own, to get practice in this all-important technique. With practice, your judgment and timing will improve.

EXERCISES TO TRY

Try putting the wet-in-wet technique into practice to produce misty effects:

- 1 Apply a pale wash of light red and raw sienna over most of your paper to represent an evening sky. Now paint a misty line of hills against it, perhaps using a mixture of ultramarine and light red.
- 2 While the sky is still moist, paint in some nearer trees in deeper tones of the same colors. They should appear more definite than the line of hills, but still soft-edged.
- 3 When everything has dried, paint in some still-nearer trees in deep, warm tones. These will be hard-edged and will help the mistier passages to recede.
- 4 Apply a broad, horizontal wash of Payne's gray to represent a sheet of water. While this is still wet, try lifting out a horizontal line of color with a damp brush to create the impression of a foreshortened area of wind-ruffled water.

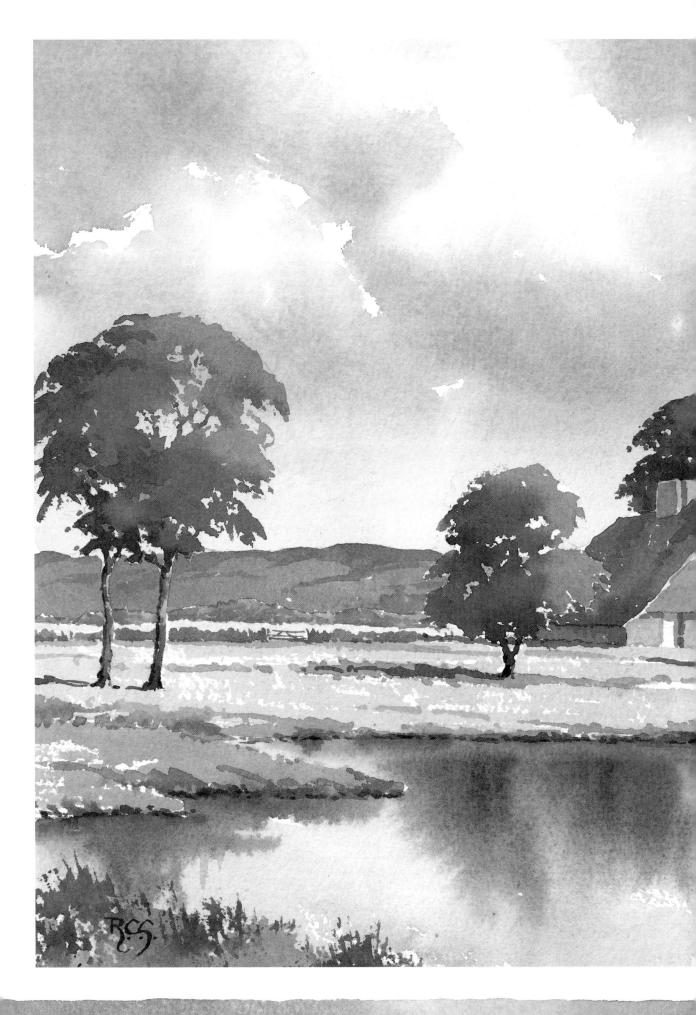

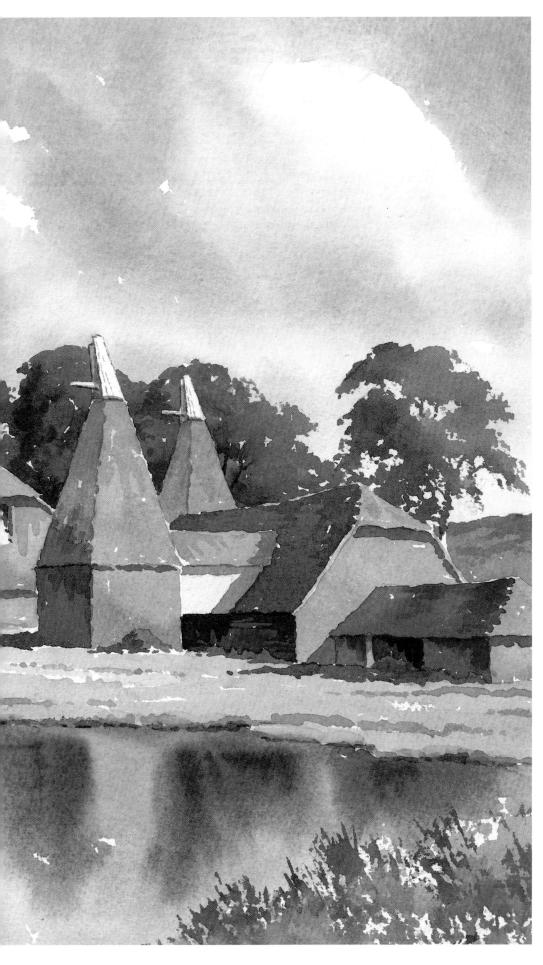

FARMHOUSE AND BUILDINGS

On my first visit to this delightful farm, the house, the oasthouses, and the barns were all in full sunlight and, although the dark trees formed a useful background, there was no tonal contrast in the buildings themselves. The following morning, with the sun in the east, there was both light and shade, which made for a far more interesting group. It often pays to be patient!

DEMONSTRATION

Trees in the Mist

This demonstration consists of a basic exercise in the watercolor technique known as wet-in-wet and if you have not tried your hand at it, why not have a shot at copying this simple example?

Because the technique produces a soft-edged effect, it is not wise to paint over a drawn outline. For the purpose of this demonstration, therefore, Step 1 is simply the rough preliminary sketch on which the exercise was based, with the painting itself beginning at Step 2. Working on a wet, or moist, surface is always a

chancy business, and success depends on timing and judgment, which come only with experience. The essential point to remember is this—the *wetter* the surface, the *more* the second wash will spread; the *drier* the surface, the *less* it will spread.

Palette

raw sienna light red ultramarine Payne's gray burnt sienna

STEP 1

This is simply the preliminary sketch. The distant trees on the right are very soft and diffuse, and without any tonal contrast. The nearer tree on the left, although also soft-edged, is more definite, with both tonal and color contrasts. Consequently, the righthand group will be tackled first, while the initial wash is still fairly wet. Only when this wash is beginning to dry, perhaps when the shine is just beginning to disappear from the paper, will the nearer tree and the line of hedge below it be painted.

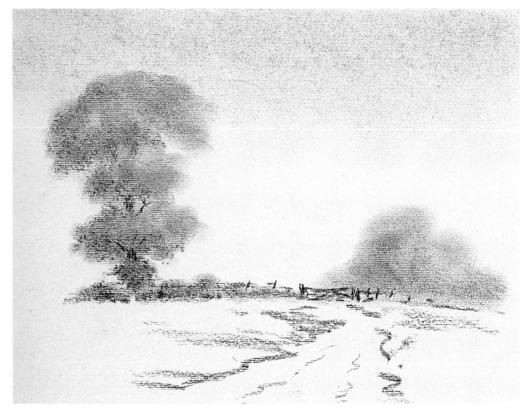

STEP 2

The sky needed a variegated wash of cool blue-gray softly merging into a warmer color above the horizon. I prepared two generous washes, one of ultramarine with a little light red, the other of raw sienna, also with a touch of light red, and applied them in the manner described in Chapter 6. I then prepared three further washes—a pale one of ultramarine and light red for the hazy tree form on the right, one of raw and burnt sienna, and a deeper one of ultramarine and light red for the larger tree on the left.

The sky area was still very moist when I tackled the more distant tree, using a wet-in-wet technique, and the color spread satisfactorily to produce an ethereal image. The drying process was under way

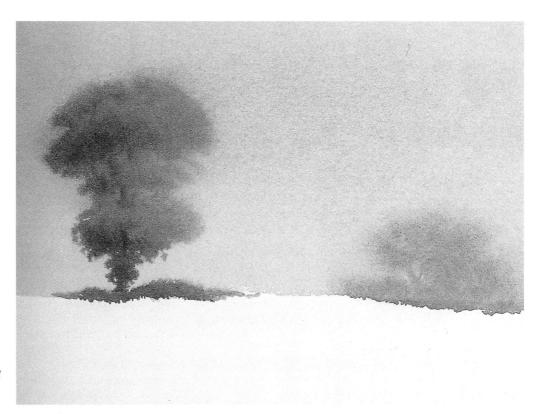

when I started applying the two washes for the nearer tree, so the spread here was

correspondingly less, as intended. By the time I had reached the ivy around the lower trunk

and the line of hedge below, the softening was minimal.

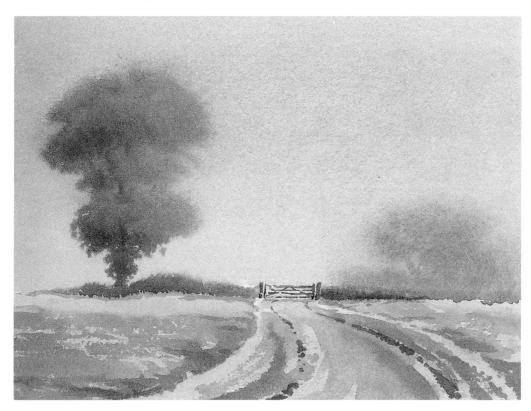

STEP 3

It was now just a matter of painting the foreground, and I decided to do this in a crisper manner, to provide contrast with the misty outlines of the trees. It sometimes happens that the mist hovers above ground level, softening the upper parts of trees, but leaving their bases relatively clear. The fields on either side of the track were boldly applied washes of raw sienna, to which I added a little Payne's gray in places, to produce a muted pale green. Finally, I put in the winding farm track with some raw sienna and a mixture of burnt sienna and ultramarine for the ruts and the gate, which provided a focal point.

9 Painting in the Open Air

Some artists do virtually all their painting in the studio, and their trips to the countryside are simply for the purpose of gathering material in the form of notes and sketches. Some isolate themselves from the outside scene by relying heavily on

photographs and other illustrations for their subject matter. Others—and I am one of them—believe that direct contact with nature is more important than the comfort and convenience of the studio.

There are, of course, many days when the weather makes it impossible for a watercolorist to paint in the open air, and then there is no practical alternative to working indoors. Provided you have enough sketches with adequate color notes, and the scenes to be painted are still fresh in your mind, good work can be done in this way. Photographs can be useful for recording detail that you may not have had time to sketch on the spot, but I would not

recommend using them as your sole source of information. Admittedly, they can make life easier for those who find it difficult to capture the three-dimensional world on two-dimensional paper, but if you seriously wish to improve your artwork, you should concentrate more on polishing up and developing your sketching skills.

Inexperienced painters do not normally produce their best work away from their source of inspiration; without their subject

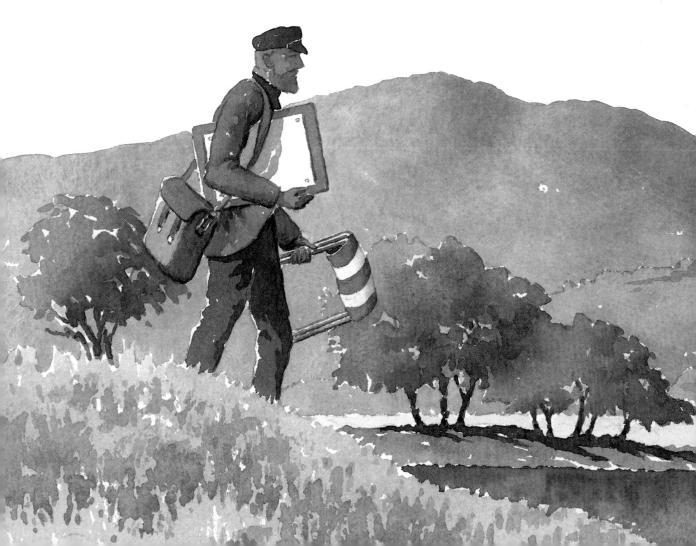

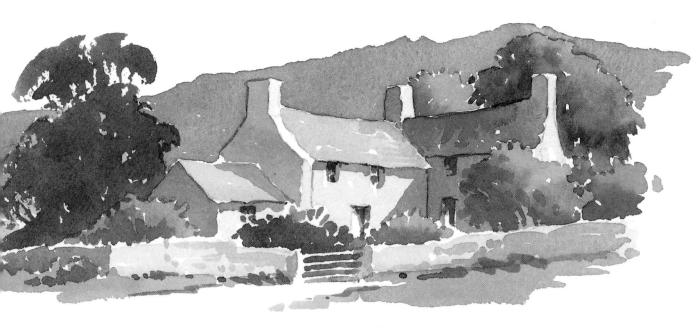

matter in front of them, they are inclined to play for safety in their treatment and choice of colors. Their old brick walls and tiled roofs tend to be flat washes of burnt sienna because they are not on the spot to observe the green of the moss, the yellow of the lichen, and the rich colors and patina of weathering. The remedy is to paint, whenever possible, in the open air, and to observe at first hand.

There is no reason why the outside scene should be the exclusive source of material and inspiration; it pays to be sensitive to visual stimuli of all kinds. Nothing should be ruled out if it sparks off a genuine artistic response. I once made a painting of a locomotive from a newspaper photograph. The reproduction was not a particularly good one, but the angle of the locomotive

was dramatic, and I felt the urge to paint it, almost in silhouette, against a patch of luminous sky, with the glow reflected in the shining curve of the foreground rails. Although the treatment was personal, the idea was sparked off by the photograph, and this is a very different matter from making a laborious and precise copy of some illustration.

EQUIPMENT

Let us now assume the sun is shining and you have promised yourself a wonderful day's painting in the country. However eager you are to make a start, do make sure you take everything you need with you, at the same time resisting the temptation to take too much. A heavy load discourages reconnaissance, and searching for the right subject and the best viewpoint is an important preliminary that should not be cut short.

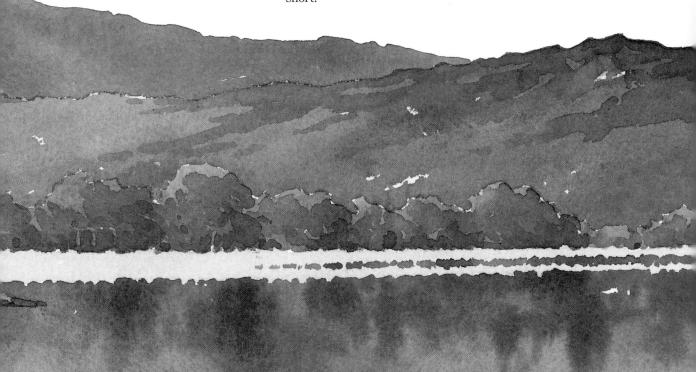

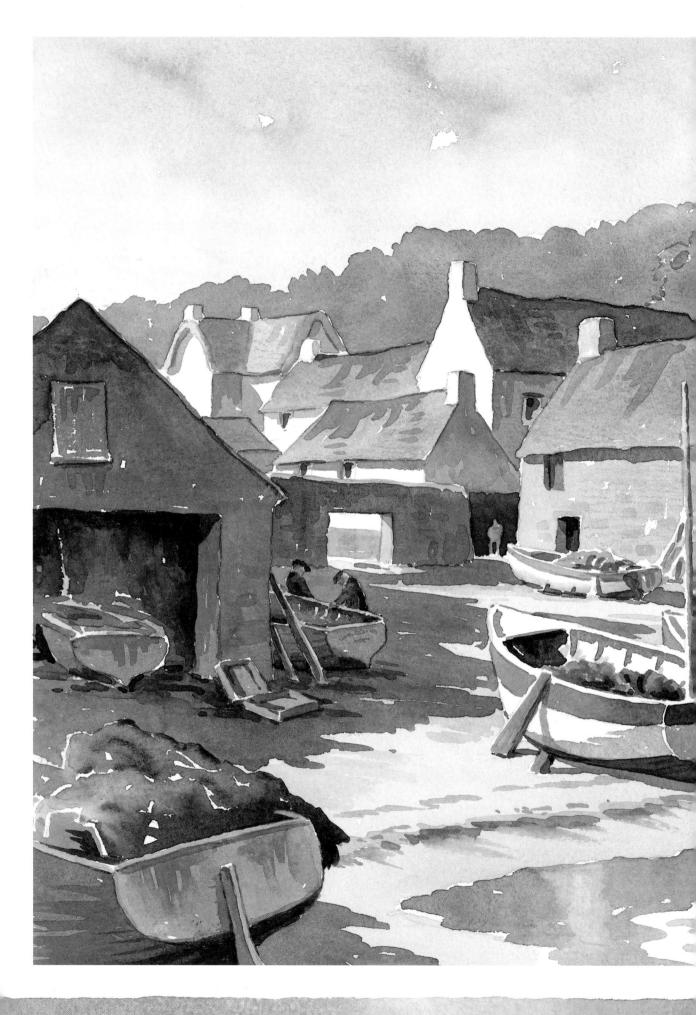

This painting, which first appeared as a limited-edition print, is all about the atmosphere of a small fishing village, with old boats pulled up on the sand and sturdy cottages clustering around the sea inlet. The fishing boats in the foreground have been given due prominence, and a few salty figures have been included to indicate some activity, although of the leisurely kind. Full advantage has been taken of opportunities for placing lights against darks, some of which show warm reflected light.

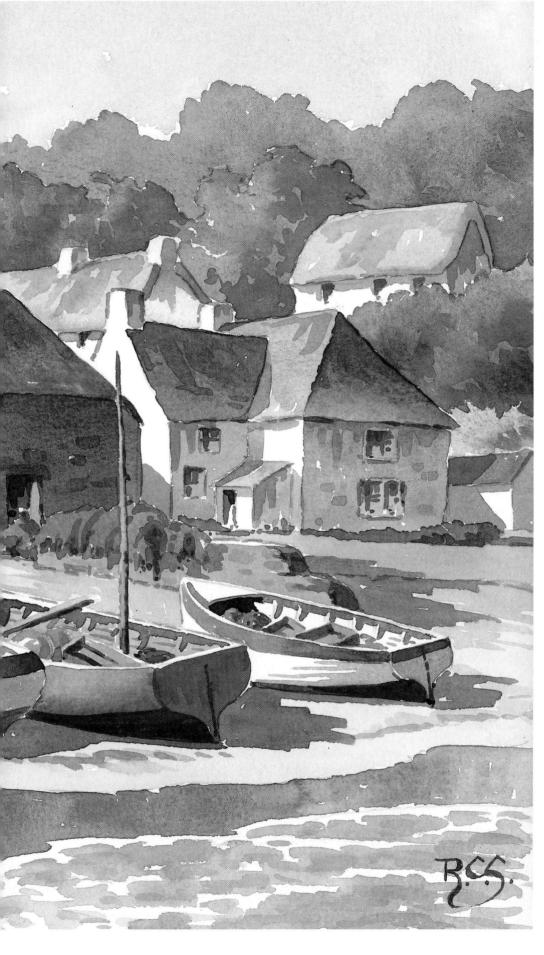

I have a reasonably capacious army surplus knapsack into which I can pack my paintbox, a box of tube colors, a cylindrical metal brush holder, two large jars of water (with watertight lids!), pencils, soft erasers, and paint rags. I also take a light folding stool and a drawing board with watercolor paper pinned to one side and sketching paper to the other. I do not need an easel as I always paint with my drawing board on my knees, and I find this helps me control the flow of liquid washes more effectively. My only concessions to personal comfort are a small bottle of insect repellent and a spare sweater.

If you prefer to work at an easel, make sure you have one of the light but sturdy

Avoid, if possible, painting in direct sunlight. The glare of the sun can be very distracting, and the speed at which your washes will dry in full sun can be phenomenal.

If there is no shade at all at the spot from which you wish to paint, it helps to turn your board so that the sun's rays strike it more obliquely. This will reduce both the glare and excessively quick drying.

If you are working in a hot, dry atmosphere, mix a little more water with your washes to compensate for the speed of drying, or alternatively dampen the surface of your paper before starting to paint. A drop or two of glycerin, available from all art-supply stores,

added to your water jar will also slow down the drying process.

models on the market, and take a length of string with you so that you can attach a convenient brick or rock to weight it down in breezy weather. If you have difficulty in isolating pleasing compositions from the expanse of landscape, remember to take your viewfinder with you!

MAKING A START

Imagine you have now found a subject that inspires you. However keen you are to start painting, do not be tempted to omit those preliminary exploratory sketches which will help you to decide which is the most pleasing composition. Nothing is more frustrating than discovering a far more interesting viewpoint *after* your painting is complete.

Another problem that needs careful thought is that of shadow movement. Shadows change continuously with the movement of the sun, and unless you work very quickly, you must give some thought to them, or you may end up with shadows lacking a consistent direction.

ONLOOKERS

Some painters detest the thought of people looking over their shoulder and find it puts them right off their stride. This reaction is usually a symptom of excessive modesty, and what they really fear is a critical reaction. They should remember that the average curious onlooker is not only well disposed toward artists, but usually has little artistic ability of his or her own, and your efforts, whatever you think, will no doubt appear as a work of genius. If you are still unconvinced, it is often possible to choose a spot that cannot be approached from the rear, though this stratagem will reduce your chances of locating the ideal

FIGURES IN THE LANDSCAPE

A question that often arises in landscape work is whether or not to include people in your painting. If, for example, you wish to emphasize the feeling of isolation and loneliness of a remote mountain lake, then obviously you do not need to include people. If, on the other hand, your subject is the sort of scene where you would expect to see people—a street corner, for instance—then they should be included.

Unless you have really made a study of the human figure, it would probably be wiser to avoid including any close-ups in which anatomical faults would be all too obvious. Impressions of more distant figures are

What struck me about this seaside scene was the depth of tone of the figures viewed against a backdrop of pale sky and shining water. It was a warm evening, and the tinge of purple just above the horizon indicated the haze of heat. I kept the sky very simple, with just a few summery clouds. The sea was calm, and I have shown only one small waveform in any detail. The light catching the tops of the wavelets and the foreground foam are simply the white of the unpainted paper.

viewpoint.

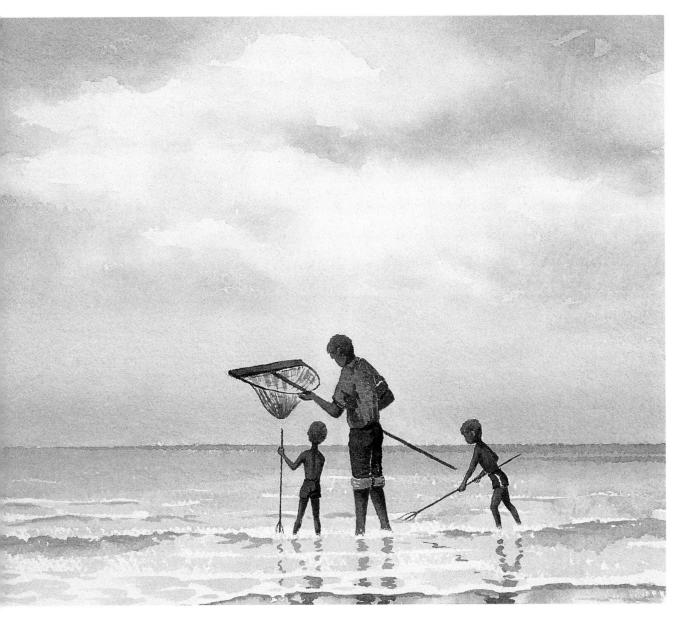

A thorough knowledge of human anatomy is not necessary for the inclusion of a few figures in the landscape, provided you remember that posture is more important than detail. Quick sketchbook studies will help you here—models are not always on hand when required.

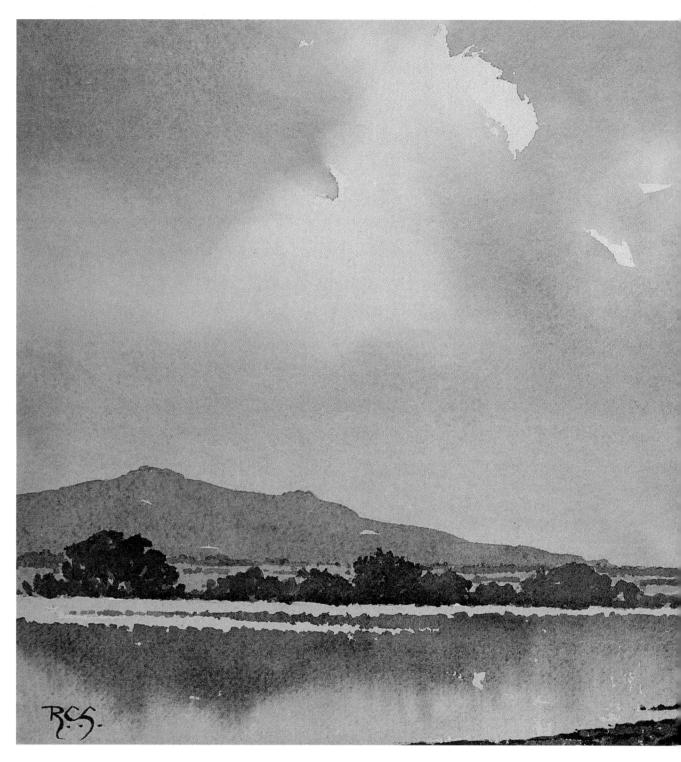

another matter, and it is not too difficult to learn how to suggest groups of people with a few calligraphic dots and dashes.

WATER

Many students find painting water a problem and try to avoid it if they possibly can. This is a pity, because water in a landscape can add an extra dimension to a painting. Of course, it is not always possible to paint water exactly as it appears. In some conditions, it can consist of a mass of tiny

ripples, and any attempt to paint such minute detail would be doomed to failure. In such a case, it is better to soften its splintered appearance by viewing it through half-closed eyes and then paint the more diffuse image that results. When ripples are larger and more manageable, they should be painted more literally, but remember that the nearer forms will be of greater depth than the more distant (*see* page 112). Too many beginners forget that the laws of perspective apply to water as well as dry land. $\rightarrow p.113$

THUNDER CLOUD

In this quick watercolor sketch, the object was to capture the fleeting moment. The sky was put in with a single wash and indicates, with some economy, the towering mass of clouds. The somber blues and grays suggest the sultry lull before a storm, while the lower sky indicates a distant rainstorm. A line of pale, disturbed water separates the distant shore from its reflection in the calmer water below.

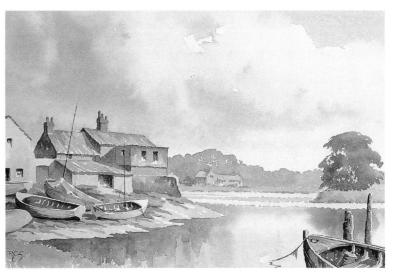

COASTAL VILLAGE

Those who enjoy painting coastal scenes will find plenty of attractive subject matter along remote, rocky coasts, with sea inlets, salt marshes, and a rich variety of boats. Today, the majority will be pleasure boats, but there are still plenty of the

sturdy working variety to be seen in some places.

I blended plenty of water into my sky washes to capture the effect of softly billowing clouds. I used single washes whenever possible, the line of distant trees being one example.

The detail on the left of the painting is balanced by the tree on the right and the deep tones of the moored boat below it.

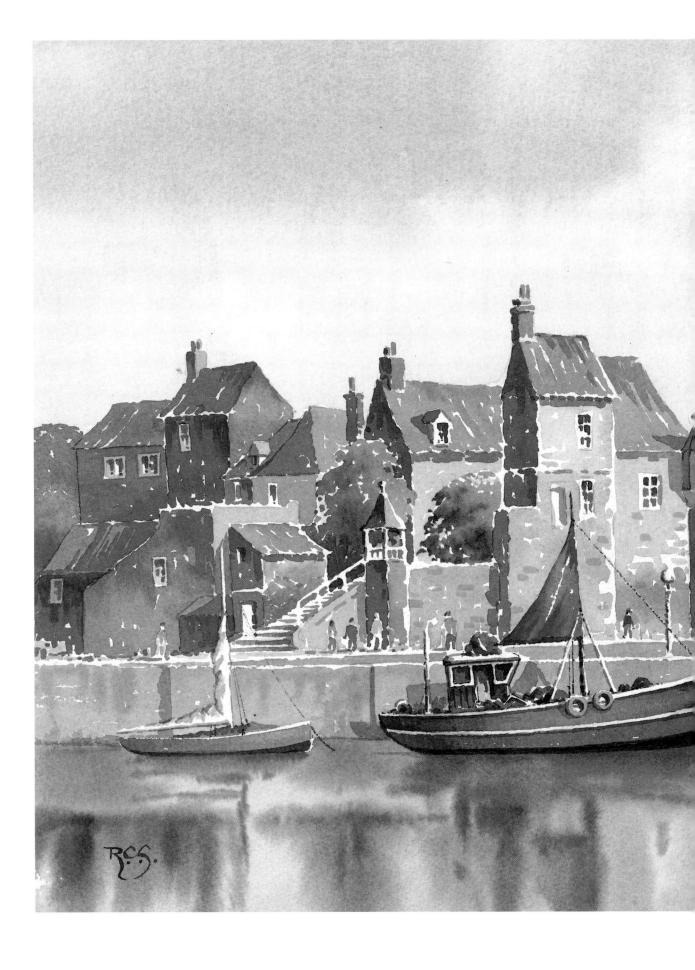

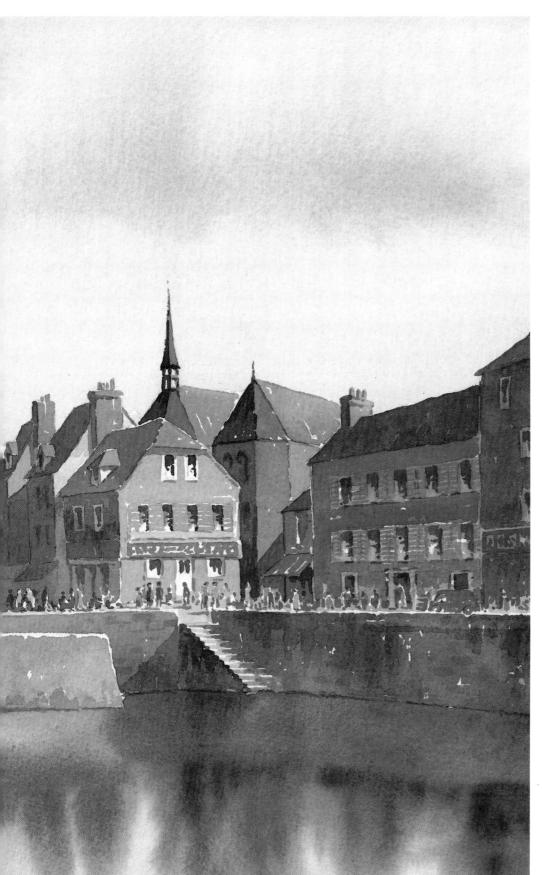

FRENCH PORT

This must be one of the most painted spots in France, and it is easy to see why—the jumble of old harborside houses, the boats, and the reflections have an irresistible appeal. The complexity of the subject suggested a very simple treatment of sky and water, to avoid too much complication. The soft, diffuse reflections were painted wet in wet, roughly following the tones and colors of the objects above. The buildings are strung out in a line, so it was vital to break them up by emphasizing the tonal contrasts of sunlight and shadow. The people, mainly vacationers, were little more than multicolored blobs of paint.

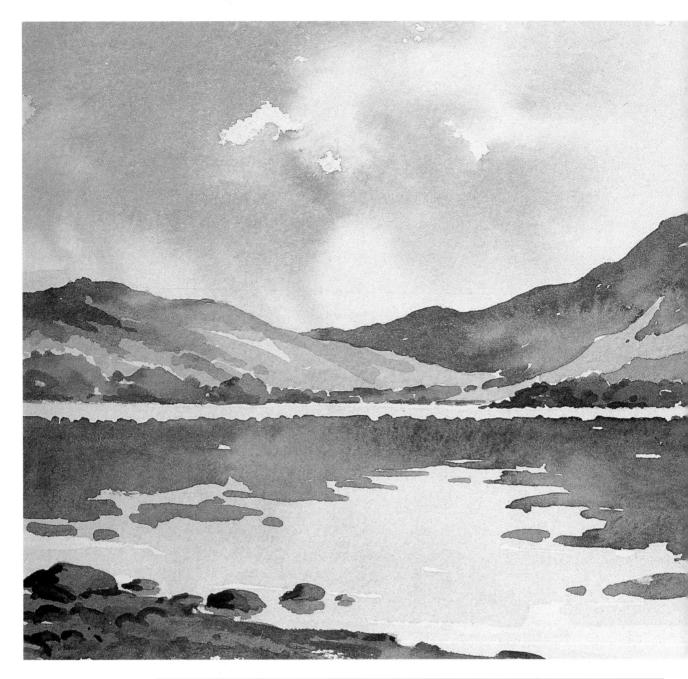

LAKESIDE

Notice how the ripples in this quick watercolor sketch diminish in size as they recede and how a pale line of wind-ruffled water separates the distant scene from its reflection.

EXERCISES TO TRY

Here are some exercises you can try while working in the open air:

- 1 Choose a sunny day and a subject with plenty of side shadows. Make a quick sketch of the scene on watercolor paper, taking particular care to establish the position and form of the shadows.
- 2 Now apply paint in the form of bold, liquid washes, and then add the darker accents, including the shadows. Study the colors in
- the shadowed areas carefully, and do them full justice.
- 3 Whenever possible, make quick impressions in your sketchbook of figures that come and go. The more successful ones will serve you well in future paintings.
- 4 Find a stretch of smooth water in your neighborhood, and practice painting the reflections you see.

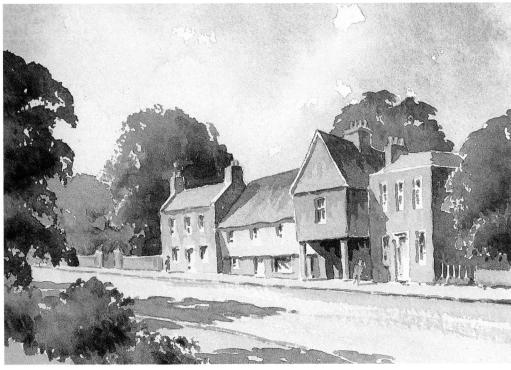

COUNTRY HOUSES In this watercolor sketch of a village street, a little texturing has been added to the walls and roofs of the buildings to give them a feeling of age and character.

The difficulty with ripples, as with waves, is that they will never keep still to allow you to paint them in comfort. The only solution is to freeze an instant in time in your mind's eve and then paint the remembered image. Remember, too, the old rule that lights are reflected darker and darks reflected lighter—in other words, there is less tonal contrast in reflections. It holds true most of the time, but it is not a substitute for careful observation.

Do not worry if your work in the field has a rather unfinished look to it—this tends to happen when working conditions are not ideal—but firmly resist the temptation to start tidying things up. However rough the result, if you have managed to capture the feeling and the atmosphere of your subject,

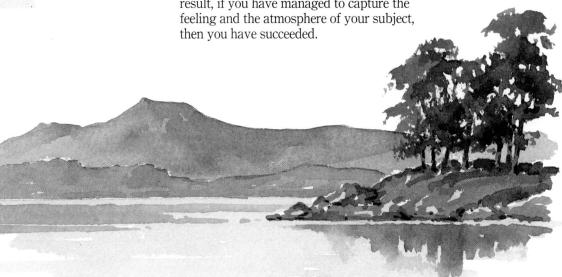

DEMONSTRATION

Mr. Perkins Gardening

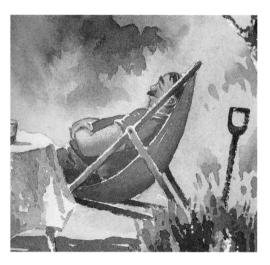

A subject such as this requires quick execution—and perhaps a convenient escape route! It is an example of a lighthearted attempt to capture a fleeting moment. The original watercolor sketch was very hastily executed, and I have adopted a similar approach here. Working at speed can be a useful exercise in loosening up, particularly if you feel tightness and overattention to detail beginning to creep into your work.

The figure was seated under the shade of a small tree and so was mainly in shadow. It was necessary, therefore,

to make sure that the immediate background remained fairly light, to provide tonal contrast. There was some dappled sunlight on the white tablecloth, so here the background could be a little darker, also for the sake of contrast.

STEP 1

For once I did not make a number of exploratory sketches—I did not know how much time I hadand so relied upon my first quick impression. The setting was simply sunlit lawn, with some cast shadows in the foreground, and shrubs and trees beyond. I decided to indicate it all in one quick variegated wash, using mainly raw sienna and Payne's grav. with a little alizarin crimson and ultramarine on the left to suggest some wild rhododendrons in flower. I added a few darker accents, wet in wet, and left it all to dry in the sun.

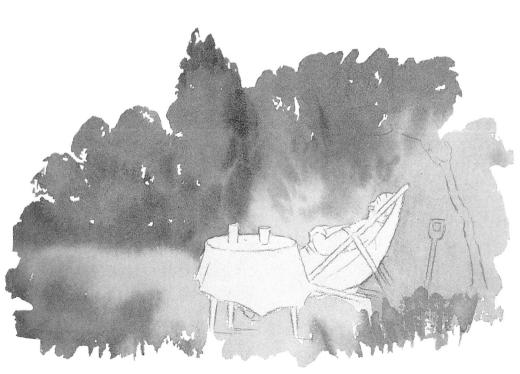

Palette

raw sienna light red ultramarine Payne's gray burnt sienna alizarin crimson STEP 2

I decided to add a few darker accents to the background, to give the trees and shrubs a little more form and definition, using a mixture of Payne's gray and burnt sienna on the left and ultramarine and light red on the right. A mixture of Payne's gray and raw sienna served for the shadows on the lawn and, with a little burnt sienna added, for the small foreground tree on the right, while some drybrush work suggested the rough texture of the trunk. For the shadows on the white tablecloth, I used ultramarine with a little light red.

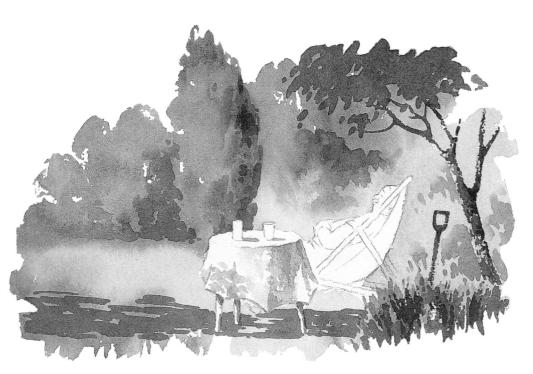

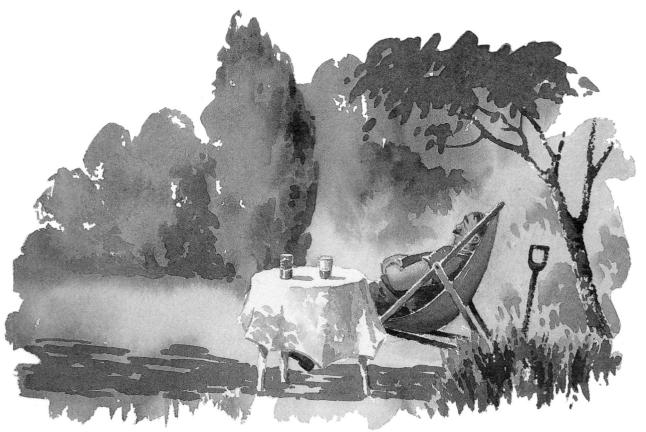

STEP 3

The reclining figure was in shadow, so fairly deep tones were required, with a suggestion of reflected light to provide warmth. I had

intentionally left the immediate background very pale and simple so that the deeper colors of the figure would stand out boldly. It also called for more precise

treatment than its loosely handled surroundings, and this also helped to make it the focal point.

This quick little painting is admittedly something of a caricature, but is none the worse for that. Painting need not always be a solemn business!

10 To Sum Up

The greater part of this book has been concerned with the technique of watercolor painting, for I believe that all painters anxious to raise their standards and go on to better things must strive to improve the manner in which they apply paint. This

is not to imply that technique is the be-all and end-all of art—that would be very far from the truth. It is, however, an important means to an end, and in the watercolor medium particularly, it is hard for you, as an artist, to get your message across if you fail, through technical shortcomings, to take full advantage of its wonderful potential. You therefore have to learn how to apply fresh, clear, and translucent washes, so that the white of the paper shines through, to impart a luminous quality to your work. This is the first and most important lesson.

Freshness in watercolor painting is a delicate and vulnerable quality. As you know, it is easily destroyed by attempted alteration, overworking, and fussing over detail, and it is for this reason that you should not allow yourself to be lured into attempting subjects of excessive complexity. Simple subject matter will allow you to express yourself directly and spontaneously, and your work will be all the better for it. As you progress, you will be able to tackle more complex subjects, for you will have acquired the skill to simplify and to describe more complicated forms in a direct and painterly manner. You will find that you rely less and less on careful preliminary drawing and will express yourself with increasingly lively brushwork. Through a growing skill with the brush, your style will crystallize, and your work will gain individuality and originality.

One of the watercolor painter's vital skills, the ability to simplify subject matter and distinguish the essential from the inessential, will have an important by-product. Instead of all of the paper being

taken up with detail of one sort or another, there will be plain areas, and the painter will learn to value them for the contrast and feeling of space they provide. They will act as a foil to the busy areas and assist in the general pattern of the painting, which, as we noted earlier, stems from the arrangement of its component shapes, colors, and tones.

An ability to suggest space is of particular value to the watercolorist primarily interested in landscape, and he or she should never lose an opportunity of studying the work of painters who possess this enviable skill. We all learn a great deal by finding out how artists whose work we admire solve problems of composition and technique, and it is fascinating to study their choice of subject matter and the manner in which they tell us something of their personal reaction to it. Artists see things in individual and intensely personal ways, and

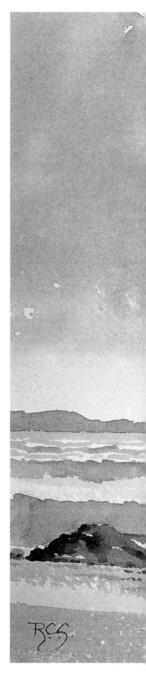

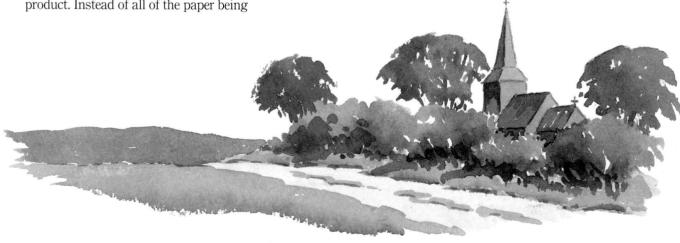

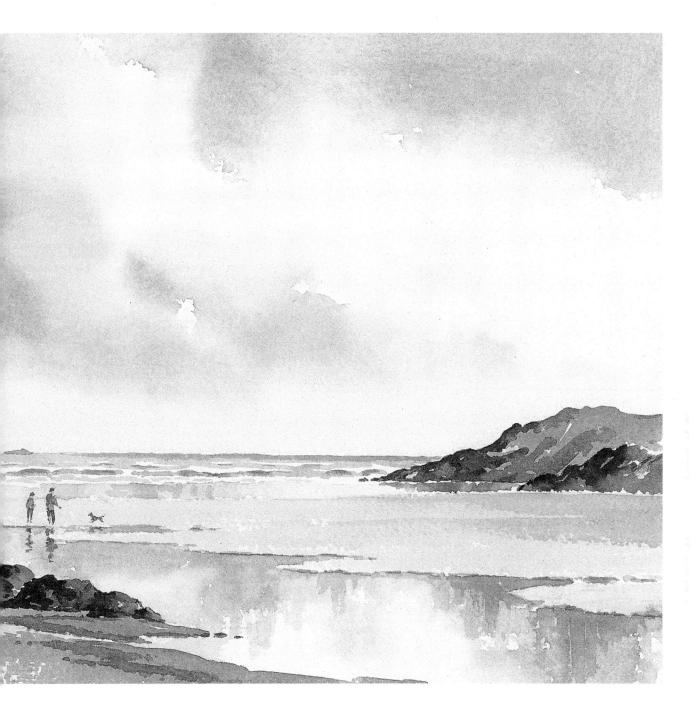

when this is apparent in their paintings, it can open our eyes and tell us something of their inner feelings.

I find the choice of subject matter of other painters a source of endless fascination, particularly when they see possibilities and find inspiration in the most unpromising scenes. A mean backstreet, with apparently little to offer, can be touched with magic by the skill and insight of an artist of sensitivity and imagination. Such examples inspire us to look at our surroundings with fresh eyes and to find meaning in the dullest of scenes. The development of our ability to observe greatly enhances our enjoyment and appreciation of the world around us, for everything we see

SEA AND SAND

In this painting, I tried to capture something of the atmosphere of a blustery day by the sea and to convey a feeling of freedom and space. The lively sky, the low horizon, and the stretch of pale sand all the way across the paper each make a contribution,

and the two small figures also help by providing scale. The technique is loose and fluid, and with the exception of the headland and the foreground rocks, the tones are light. These darker features provide tonal contrast and help to balance the composition.

→ p.122

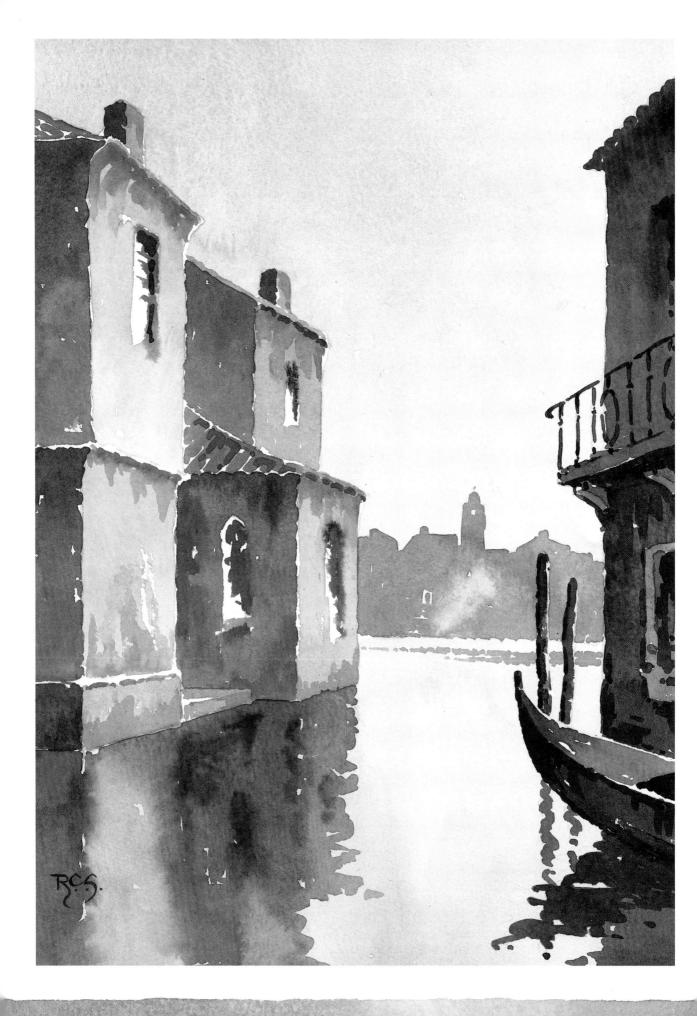

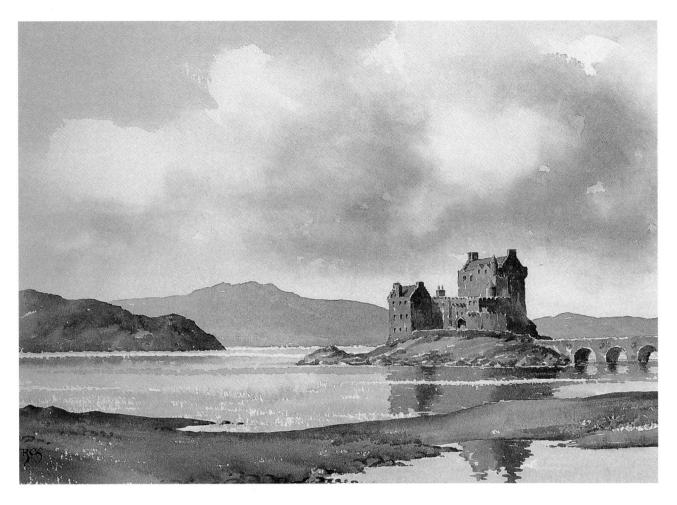

CANAL REFLECTIONS

The distant tower in this simple Venetian scene makes a useful focal point to which all perspective lines seem to lead. The sun was in the right position to provide plenty of tonal contrast in the left-hand building, while the shadowed building on the right, the gondola, the mooring poles, and their reflections make a strong statement against the pale sky and smooth water.

THE TEN "COMMANDMENTS"

- Preserve freshness at all costs no watercolor can succeed without it.
- 2 Avoid overelaborate subjects at least until you have acquired the experience to handle them.
- 3 Learn to simplify and to omit unnecessary detail.
- 4 Cultivate lively and expressive brushwork.
- Try to reduce the amount of detailed preliminary drawing—this will help you to obey 4.

- 6 Preserve some plain areas in your work, to provide contrast with the busier ones.
- 7 Learn to suggest space. Study and analyze the work of the masters.
- 8 Do not confine yourself to the picturesque—look for possibilities in unlikely subjects.
- 9 Strive to convey mood, feeling, and atmosphere.
- 10 Only paint when you feel in the mood.

SCOTTISH CASTLE

This is another painting in which I made a conscious effort to create the illusion of space. Once again, a prominent sky occupies more than half the paper and a low viewpoint has the effect of foreshortening the waters of the loch. This foreshortening, combined with the fact that the water stretches right across the paper, helps to emphasize the feeling of space.

The loch was a broken wash of pale gray, and the resulting chains of white dots, where the brush missed the little indentations in the surface of the paper, suggest light sparkling on the water. The much deeper tones of the foreground, the castle, and the left-hand promontory provide strong tonal contrast and help to make the water shine.

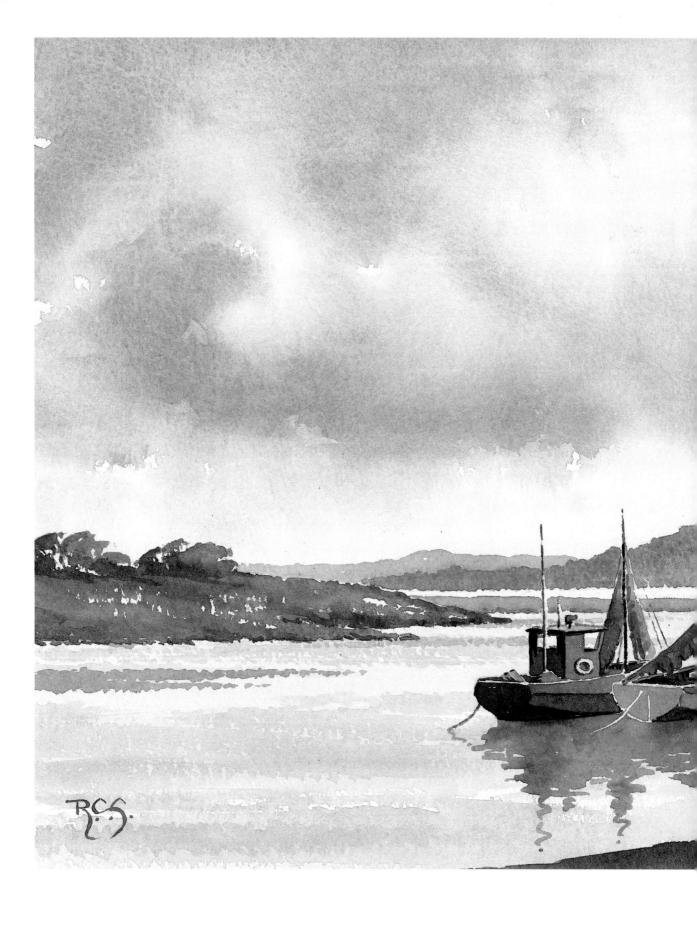

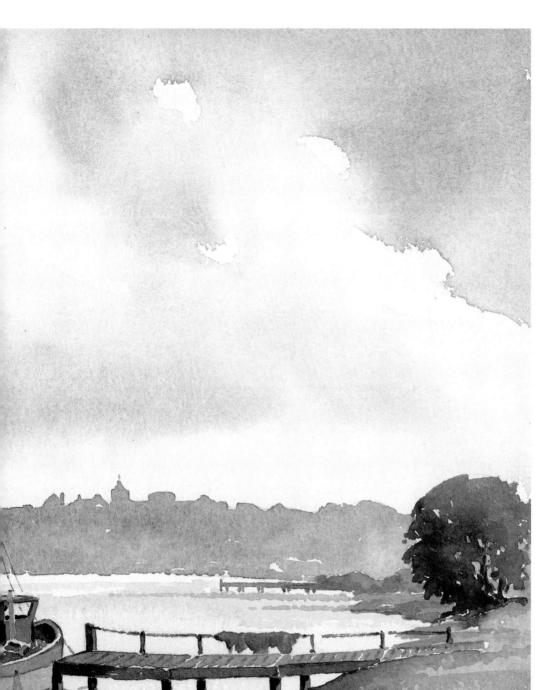

FLOOD TIDE

Foreshortened sheets of pale water usually create a feeling of space, and this broad estuary at high tide is no exception. The town in the distance, with its splendid church tower making a focal point, is a pale blue-gray silhouette into which several local colors have been introduced. The deep tones of the nearer landforms, the dock, the boats, and their greenish reflections all contrast with the pale tones of the water and help to make it shine.

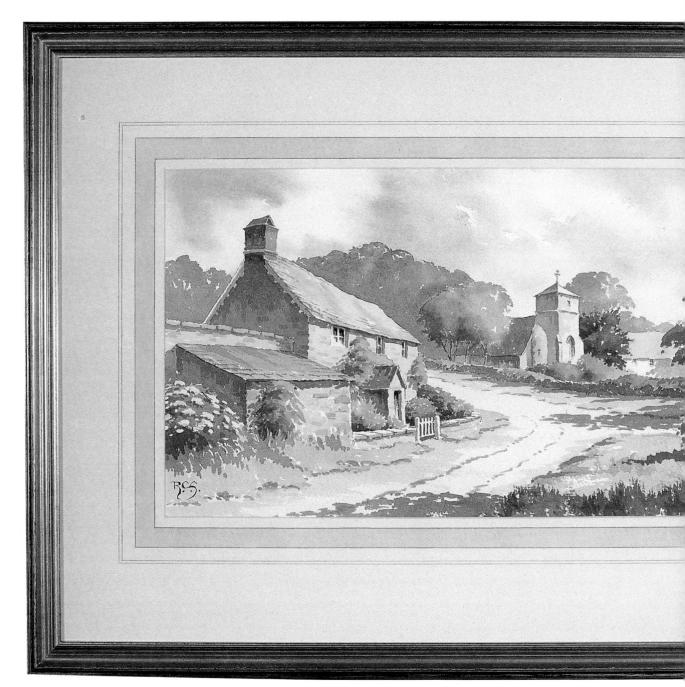

begins to acquire meaning and significance. Let us do our best, then, to capture mood and feeling in our work, to look at everything with greater insight, and above all, to paint with excitement and enjoyment.

There are many boring but necessary tasks in the workaday world that can be carried out with efficiency, but without interest or enjoyment. Painting is not one of them. If the excitement and the enjoyment have gone—stop! Never go on working at a painting just for the sake of finishing it. Far better to wait until inspiration returns, as it surely will, and in the meantime, seek fresh stimulation from the wonderful world around you.

SETTING IT OFF

Once you have produced a painting you feel is worthy of framing, the questions arisewhat sort of mat, what type of molding? Tastes and opinions differ widely, and there can be no single "correct" answer. After much experimentation, I have settled on a traditional format that suits much of my work and, I believe, that of the majority of mainstream watercolorists. This mat and molding style is illustrated in the painting above. The color of the mat is champagne, which contains less yellow than ivory or cream, and it measures 31/2 inches (9 cm) at the top and sides and 4 inches (10 cm) at the bottom. The pale gray-green watercolor wash line is ¾ inch (2 cm) in width, and a

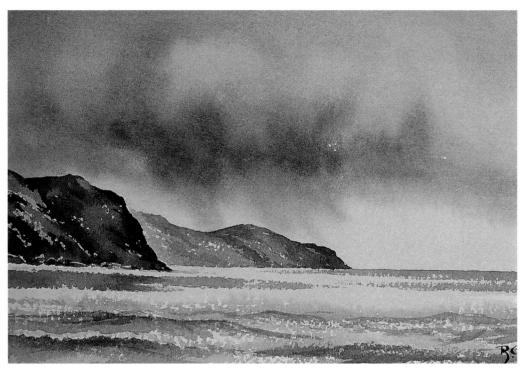

stronger mix of watercolor, not ink, is applied with an adjustable ruling pen to produce the gray lines. The molding is a 1-inch (2.5-cm) antique gilt.

The width of the mat will naturally vary with the size of the painting and with individual taste. The color of the wash line can help to pick out some color in the painting, but should always be kept pale—strong color never looks attractive and can easily overwhelm the painting. The ruled lines can be just one color or several different colors—the permutations are endless. For large paintings, I use light hardboard backing, for small ones, gray cardboard. The front of the painting is protected using glass or plastic.

Frame making does not appeal to everyone, but those naturally handy with a saw may find it a rewarding occupation.

I do my own mats and frames partly for economic reasons, partly because I enjoy it, and partly because I can do it exactly to my own taste. I do not subscribe to the view that a lot of expensive equipment is necessary. I find a sharp craft knife and a firm metal straightedge, preferably with a rubber inset base, are all I need for cutting mats, while my modestly-priced miter cutter produces perfect corners. A simple gadget consisting of four plastic pieces, bound by a nylon cord, clamps the four glued sections of molding together very satisfactorily, and when the wood adhesive has dried, brass-finish brads complete the job almost invisibly.

STORM CLOUD

I was impressed by the manner in which the deep slate-gray of the cloud formation contrasted with the pale tones of the area of luminous sky just above the horizon, and I tried to capture something of this dramatic counterpoint. The soft gray slanting down from

the underside of the dark cloud indicates a heavy rainstorm. The landforms are in deep shadow, but the bluegray of the distant headland contrasts with the warmer coloring of the nearer headland, to create a strong feeling of recession and an illusion of space.

EXERCISES TO TRY

A few final suggestions to help you on your way:

- 1 Select a stretch of country that appeals to you, and give yourself thirty minutes to capture its essence in watercolor. This time limit will mean you have to simplify and concentrate on essentials. Pay particular attention to the broad areas of tone and color.
- 2 Choose a stretch of coastal scenery, perhaps one with a broad expanse of sand, and try to convey an impression of space.
- 3 Choose a subject with strong atmospheric overtones, such as a waterfront scene on a murky evening, and concentrate on capturing its mood and feeling.

FOG AND DRIZZLE

A group of backstreet stores on a miserable evening is not everyone's idea of an inspiring subject, but if you look at a scene simply as an arrangement of shapes, tones, and colors and nothing more, then what it actually is ceases to matter. On another plane, the effects of light shining through mist and reflected on a wet surface have a different but equally strong appeal. There is also the

through mist and reflected on a wet surface have a different but equally strong appeal. There is also the challenge of making something interesting of unlikely subject matter. If you keep these considerations in view and cultivate an open and receptive mind, your imagination will begin to enliven the most unpromising material, and you will

realize that idyllic landscapes are not the only suitable subjects for watercolor.

This particular scene was painted from memory. My objective was to capture something of the halo effect of streetlights in the mist and lights reflected on a wet road.

STEP 1

I adopted a fairly low viewpoint and sketched in the main lines of the buildings and road. The figures were mostly placed against rectangles of light representing store windows. In contrast to the coldness of the evening, the foggy air imparted a warmth to the overall color, and this was reinforced by the artificial light from the buildings. I prepared two washes for the sky and the misty area to the right of the buildings. The first was dilute raw sienna and light red, for the area immediately around the streetlight. and the second was a stronger mix of ultramarine and light red. I applied these variegated washes quickly and boldly and achieved a gradual transition from the warm, pale tone by the source of light, to the

cooler, deeper color beyond it.

Palette

raw sienna light red ultramarine burnt sienna

STEP 2

I began by painting the top-floor windows in pale raw sienna with a touch of light red to suggest curtains. I used the same colors for the stores, but added more warmth. The fronts of the buildings were varying mixes of burnt sienna, light red, and ultramarine, with a paler area of raw sienna and light red to represent the misty radiance, around the left-hand streetlight. I then added darker accents with various combinations of the same range of colors to indicate weather-staining on the fronts of the buildings and such details as window sashes, rainpipes, various small areas of shadow, and a little detailed brickwork.

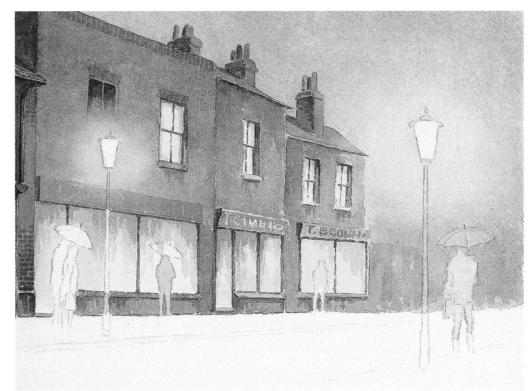

STEP 3

I now began to paint in the five figures and their umbrellas. The more distant ones are just deep gray silhouettes, and the others show only slightly more detail. I decided to make the reflections in the wet road soft-edged rather than attempt any sort of mirror image, first because the unevenness of the surface would break up anything too precise, and second, because I did not want the road to compete with the rest of the painting.

I prepared several washes, corresponding to the colors of the objects above, and applied them with quick, vertical brushstrokes, so that they merged together. As the paper was beginning to dry, I added a few darker accents in a deep gray (ultramarine and light red) and let the whole thing dry. I then added the curbstones, some indication of the paving stones, and a few tire tracks in the wet surface of the road.

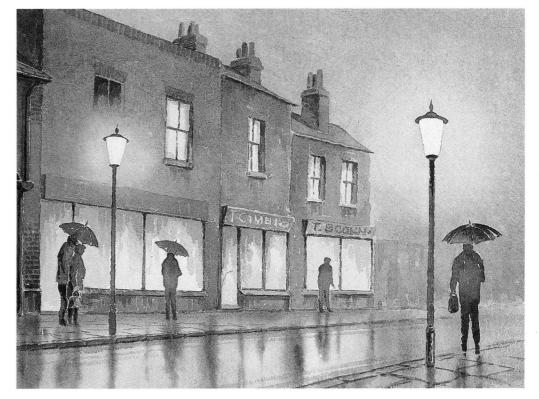

GLOSSARY

Aerial perspective

Water vapor, smoke, and dust in the atmosphere make distant objects appear pale and grayish. This makes them recede and is termed aerial perspective.

After-image

If you look fixedly at a patch of color and then transfer your gaze to a white surface, you will see that color's complementary, or opposite (sometimes called the after-image).

Broken colors

Colors containing all three primaries. When the proportions are roughly equal, dull browns and grays result. Varying the proportions can produce subtle and often beautiful colors.

Broken wash

Large brushstrokes of wash are drawn across rough paper, leaving little white dots of untouched paper.

Charged brush

A "charged brush" is one that has been fully loaded with paint.

Cold press

The unheated flat metal plate applied to sheets of paper in the manufacturing process to produce a cold-pressed surface.

Color temperatures

Reds and oranges are said to be hot colors (of high temperature), blues and grays, cool (of low temperature).

Complementary color

This simply means the opposite color, or the color occupying the opposite position on the color wheel (red and green, purple and yellow, blue and orange).

Composition

The arrangement of the elements of a subject on the support. If the composition is good, the arrangement will appear harmonious.

Definition

Some objects in the landscape may appear hard-edged, some soft-edged. The term *definition* refers to their degree of clarity.

Flat wash

A wash that is laid down evenly and uniformly.

Flowering

If a liquid pigment is applied to a drying wash, the pigment will be carried by capillary action into that wash and deposited in unsightly concentrations.

Foreshortening

If a plane is viewed obliquely, its depth appears much reduced. Thus a distant field may appear as a thin strip, the effect of foreshortening.

Golden mean/golden section

The position on a rectangular support, found by geometric

construction held to possess special compositional significance for the placement of important features.

Graded wash

A wash that varies evenly in tone from light to dark, or vice versa.

Hot press

The heated flat metal plate applied to sheets of paper in the manufacturing process to produce a smooth surface.

Linear perspective

A system of geometric constructions for achieving accurate recession, based on the fact that objects appear progressively smaller with distance.

Local color

The true color of an object when unaffected by the quality of the light or shade or the proximity of other objects.

Luminosity

The quality of emitting light. In watercolor, clear washes permit the white of the paper to shine through, creating an impression of light.

Masking fluid

A form of liquid latex applied to watercolor paper to protect specified areas from overall washes. When everything is dry, the latex can be removed with the index finger.

Passage

The term given to a

particular section of a painting, particularly a homogeneous area such as a single wash.

Patina

Surface appearance or texture. In the watercolor context, a good-quality paper will reveal a pleasing patina when clear washes are applied.

Primary color

The three primary colors are red, yellow, and blue, from which all the other colors are derived.

Recession

If an artist has conveyed a feeling of recession, he or she has succeeded in making the distance appear distant and the foreground advanced.

Secondary color

The color that results from mixing two primaries (red and yellow make orange, blue and yellow make green, red and blue make purple).

Size

In the watercolor context, a weak glue used in the manufacture of paper. Generally speaking, the greater the amount used, the harder and less absorbent the surface.

Support

The name given to any paper, board, canvas, etc., used for drawing and painting.

Tertiary color

Color formed by mixing all three primaries.

Sometimes called broken color.

Tightness

A term given to the quality of a very precise and labored painting.

Tonal contrast

The effect obtained by placing lights and darks in close proximity.

Tonal weight

Depth of color. If you say the tonal weight of a painting is all on one side, it means the darker colors are concentrated there.

Tone

In art, tone simply means lightness or darkness, not color as in popular usage.

Vanishing point

The point on the true horizon at which pairs of parallel lines on a level plane will appear to converge when projected.

Variegated wash

Similar to a graded wash, but instead of changing tone, it merges evenly into a different color.

Wash

A wash is a mix of pigment and water. See also Broken wash, Flat wash, Graded wash, Variegated wash.

Wet in wet

The technique of painting into a wash that is still wet to achieve a soft-edged effect.

INDEX

Numbers in **bold** denote illustrations

Accuracy, 68, 83
After-image, 26
Alizarin crimson, 15
Alterations, 18, 19, 83,
116
Animals, 13, 43, 43
Atmosphere, 64, 66, 119
see also Mood
T

Backing, 123 Barges, 76, 76 Barns, 34-5, **34-5** Blooming, 84, 90, 93, 97 Boats, 18, 28-9, 44, 46, 46-9, 49, 68, 68, 74-5, 83, 86-8, 94-5, 104-5, 108-11, 120 - 21Bridges, 16, 30-1, 68, 68, 78-9 Brushes, 16–17, 17, 88 Care of, 73 Chinese, 17, 17 Size, 17 Brushwork, 7, 16, 20, 21, 68, 71, 77, 116, 119 Dry, 19, 60, 63, 89, 115 Buildings, 6-7, 20, 22-3, **22-3**, **38-40**. 40, 41, 45, **46–55**, **59**,

62-3, **62-3**, 67, **67**,

68, **71**, **80–1**, 81, 82,

90-1, 110-11,

Bushes, 12, 12, 13, 13,

124-25

Burnt umber, 15

61, 89, **89**, 91 Cadmium orange/ yellow, 15 Castles, 67, 67, 118 Chimneys, 60, 62-3 Chinese white, 84 Churches, 30-1, 34-5, 34-5, 38-9, 59, 62-3, **62-3**, 76-7, 76-7, 80-1, 80-1, 120 - 21Clarity, 6, 7 Cliffs, 33, 33, 66, 67 Clouds, 8-10, 20, 22, **22-3**, **74-6**, 76, **78-9**, 83-4, **83-4**,

89, 90, 108-9, 123

Coastal scenes, 40, 44,

46-9, 66, 74-6, 83, 94-5, 104-11, **116–17**, 123 Colors, 15, 16, 24-35 see also Palette Complementary, 26-7, 29, 33, 66 Primary, 15, 25 Secondary, 15, 25 Temperature, 26 Tertiary/broken, 15, 25 Wheel, 25, 26 Composition, 7, 50-63, 66, 68, 106 Faults, 56-9 Contrast, 20, 22, 26-7, 28-9, 29, 31, 33, **38-9**, **50-1**, 66, 67, 70, 101, **104-5**, **110–11**, 114–15, **116–19**, 119, 123 Cottages, 34-5, 34-5, 60-3, 104-5 Dampening, 22, 97, 106

90-1, 100-1, 114-15, 124 - 25Depth, 26, 44 see also Recession Design, 50-63, 66 Detail, 7, 64, 67, 81, 83, 96, 119 Distances, 44 see also Recession Docks, 88, 120-21 Draftsmanship, 68 Drawing board, 106 Angle, 77 Drybrush, 89, 89 Drying, 7, 33, 73, 84, 93, 96, 106

Demonstrations, 12–13,

22-3, 34-5, 46-9,

60-3, 70-1, 80-1,

Easel, 106
Edge definition, 12, 93, 94–6, 96
Equipment, 14–21
Framing, 123
Outdoor, 103, 106
Estuary, 46–9
Euclid, 54
Exercises, 21, 31, 45, 59, 69, 79, 89, 97, 112, 123

Farmhouses, **10**, 12–13, **12–13**, 22–3, **22–3**, **98–9**

Farms, 7, 10–13, 20, 22–3, 22–3, 50–3, 70–1, 90–1, 90–1, 98–9

Fences, 23, 23, 37 Fields, 10, 21, 23, 68, 70, 70–1, 82, 96, 101 see also Grass; Plowed land Figures, 12, 13, 13, 26,

26-7, 31, 35, 35, 44, 66, 67, 92, 92, 104-7, 106, 108, 110-11, 112, 114-15, 114-17, 124-25
Fishermen's huts, 46-7,

46–7 Flowers, 15, 18, **18** Foliage, 18, **18**, 20, 23,

30, 31, 85 see also Bushes; Trees Foreground, 10–12, 23, 30, 31, 45, 60, 61, 66, 67, 81, 85, 88, 88, 91, 101

Frames/Framing, 123 Freshness, 6, 7, 64, 72, 73, 83, 116, 119

Garden, 114–15
Gates, 12, 12, 35, 35, 101
Geometry, 36, 54
Glycerin, 106
Golden mean/section, 54
Gondolas, 80, 80–1
Grass, 10, 28–9, 31, 33, 47, 47, 61, 85, 85, 91
Gravestones, 60, 62–3
Gulls, 84

Harborside, 8–9, 40, 40, 110–11
Hedges, 8–9, 12, 13, 13, 23, 23, 31, 34–5, 68, 71, 101
Hills, 26–7, 34–5, 34–5, 71, 79, 89, 97
Horizon, 22, 37, 40, 41, 45, 46, 56, 68, 70, 76–7
Houses, 12, 30–1, 41, 54, 60–3, 76–7, 77,

110–11 see also Farmhouses Humidity, 84, 96

Impressionists, 27

Landscapes, 6, 64, 68 Lanes, 12, 12, 82 Lifting out, color, 84, 97 Light, 30, 33, 82, 92 Evening, 42–3, 67, 82, 88, 90–1, 92 Light red, 12, 15, 22, 34, 46, 60, 70, 80, 90, 124 Lochs, 118–19 Locomotive, 103

Mail truck, 59 Marshes, 108-9 Masking fluid, 43, 60, 72, 84, 85, 88 Tape, 72, 76 Masts, 46, 46 Mats. 122 Mirror, use of, 41 Mist, 12, 26, 40-3, 45, **68**, 69, 85, 92–101, 92, 94-5, 98-101 Molding, 122-23 Mood, 119, 122, 123 see also Atmosphere Moor, 10

Onlookers, 106 Outdoors, painting, 102-15

Mountains, 40, 40-1

Muddiness, 6, 30, 72,

83

Paints, 14, 15
Palettes, 12, 15, 22, 34, 46, 60, 70, 80, 90, 124
Paper, 19, 88, 96
Cold-pressed (CP), 18, 19
Hot-pressed (HP), 19
Rough, 19, 88
Smooth, 19
Stretching, 19, 20
Tinted, 30
Patchiness, 79
Payne's gray, 9, 12, 15, 22, 34, 60, 70, 90
Pebbles, 66, 67, 88, 83

Pen and ink work, 19
Pencil, watercolor, 18
Perspective, 36–49, 70, 108
Aerial, 41–3, 44, 45, 93
Linear, 36–41, 38–40, 44, 93
Photographs, 102
Planning, 7, 10–11 see also Composition
Plowed land, 8–9, 23, 71
Pointillism, 27
Pond, farm, 11, 50–1, 90–1

Rain, 40-1, 123-25

Recession, 26, 27, 34,

Red, see Light red

44, 71, 80-1, 93, **94–5**, 123 Reflections, 31, 31-3, **44**, 46, 47, **47–51**, 49, **66**, 67, 69, **69**, **74–6**, 80-1, 90-1, 94-5, 109-13, 124-25 Rigger, 17, 17 Ripples, 49, 80, 80, 86-7, 108, 112-13 River, 16, 44, 68-9, 69, 78-9, 120-21 Roads, 38-9, 52-3, 55, 59, 124-25 Rocks, 33, 33, 89, 89, 116 - 17Roofs, 23, 55, 70, 71, 90-1, 91, 103, 113

116–17, 123 Sea, 33, **33**, **44**, **66–7**, 76, 76, 83, 94-5, 116 - 17Seurat, Georges, 27 Shadows, 13, 13, 21-3, **27**, 30, **34–5**, **55**, 57, 63, 66, 68, 71, 76, 91, **96**, 106, 112, **114–15** Sienna, burnt/raw, 12, 15, 22, 34, 46, 60, 70, 80, 90, 124 Sketches, 51, 54, 55, 59, 60, 67, 68, 69, 102, 106_112 Sky, 9, 12, 12, 16,

Sand, 44, 44, 66-7,

17, 18, 21, 22, 22-3, **27**, 30, **33–5**, 46, **46**. 60, 66, 67, 72-3, 76-9, 82-4, **83**, **90-1**. 97, 101, 116-19 Smoke, 68 Snow, 12-13, 12, 13, 26, 27, 27 Space, 116, 116-19. 119, 123 Speed, 6, 18, 67, 96 Stores, 124-25 Streets, 55, 59, 76-7, 117, 124-25 Village, 59, 67, 113 Stretching, 19, 20 Striping, 78 Stubble, 89 Subjects, 51, 64-71, 116, 119 Choosing, 65–7, 116-17, 122 Developing, 68 Urban, 69, 117 Sun, 20, 67, 67, 72-3, **72–3**, 106 see also

Techniques, 19, 82–102 Temperature, 84 Color, 26 Texture, paper, 19 Texturing, 11, 23, 29, 31, 33, 89, 91, 113 Tips, 7, 10, 26, 41, 66, 68 Tone, 6, 29, 33, 44, 57, 64,68 Track, farm, 18, 23, 50-1, 90-1, 101 Translucence, 72-3, 116 Trees, 12, 12, 13, 13, 21, 23, **30-5**, **42-3**, 45, 61, 66, 68, 69, **71**, 79, 82, 85, **85**, **89**, **91-2**, 92-3, 97, **97**, 100 - 1Turner, J.M.W., 92

Ultramarine, 12, 15, 22, 34, 46, 60, 70, 80, 90, 124

Vanishing point, 37, 40, 41, 45 see also Horizon Venice, **80–1**, **118** Viewfinder, 51, **65**, 69, 106 Villages, **60–1** Green, **34–5** Street, **55**, **59**, **67**, **113**

Walls, **61–3**, 103 Wash line, 122–23 Washes, 6, 19, 21–3, 30, 72–91, 116 Broken, 11, **11**, 19, 21, 23, 67, 83, 88, **88–9**, 89, 91

Flat, 76-7, 79, 89 Graded, 78, 79 Mixing/preparation, 6, 7, 12 Variegated, 78-80, 82-3, 85, 89 Water 8-9, 16, 28-9, **31-3**, 33, 46-7, **46-**9, 49, 68, 69, 74-6. **78-81**, 79, 82, **88**, **90–1**, **96**, 97, 108, 108-13, 112-13, 118-21 Water, for painting, 72 - 3Wet in wet, 12, 12, 23, 45, 61, 76, 78, 80, 83-4, 89, 90, 92, 93-101, 93-7, 100-1, 110-11, 114-15 Timing, 83-4, 96-7, Winsor blue, 15, 34, 46, 60, 80, 90 Wintry scenes, 11, 12-13, 12-13, 27, 72-3 Woodland, 8-9, 32-3, **45**, 66, **71**, **85**, 92, 92, 93, 97 Wrinkling, 19, 20

Yacht, 48-9, 49